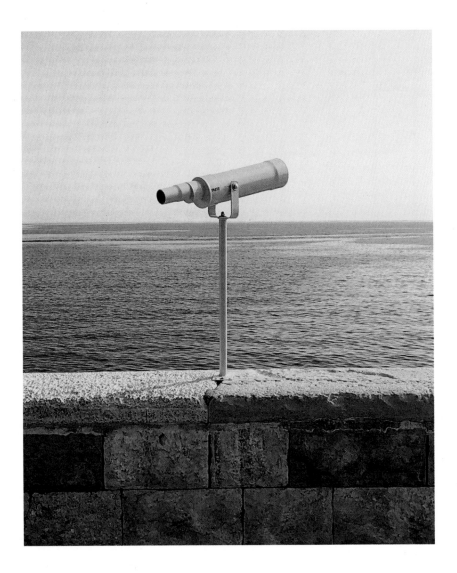

VIEWFINDER

Monopoli, Italy | c. 2018

Photo by Ky Allport

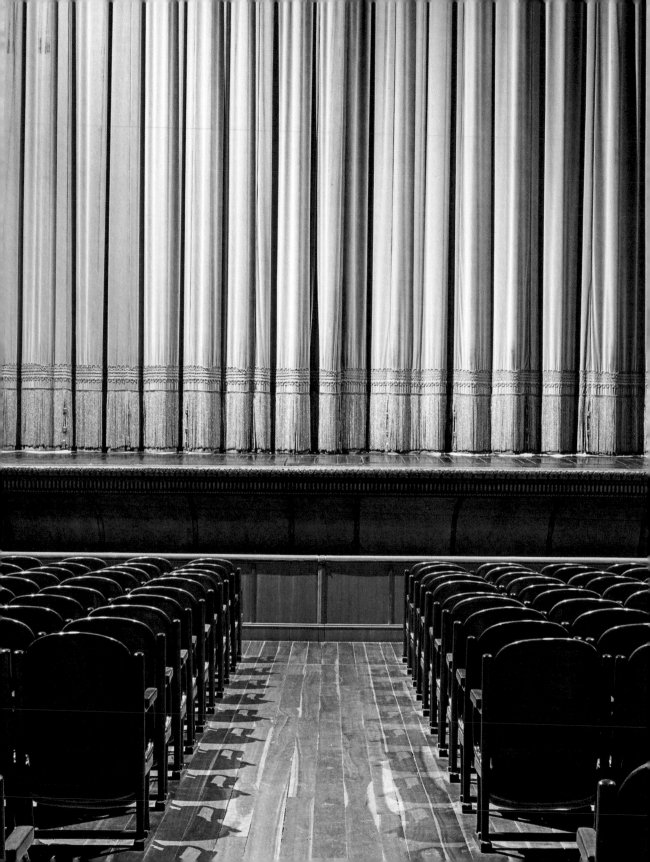

ACCIDENTALLY
Wes Anderson

WALLY KOVAL

with Amanda Koval

Foreword by
WES ANDERSON

with research and editing by
Domenica Alioto

VORACIOUS
Little, Brown and Company
New York Boston London

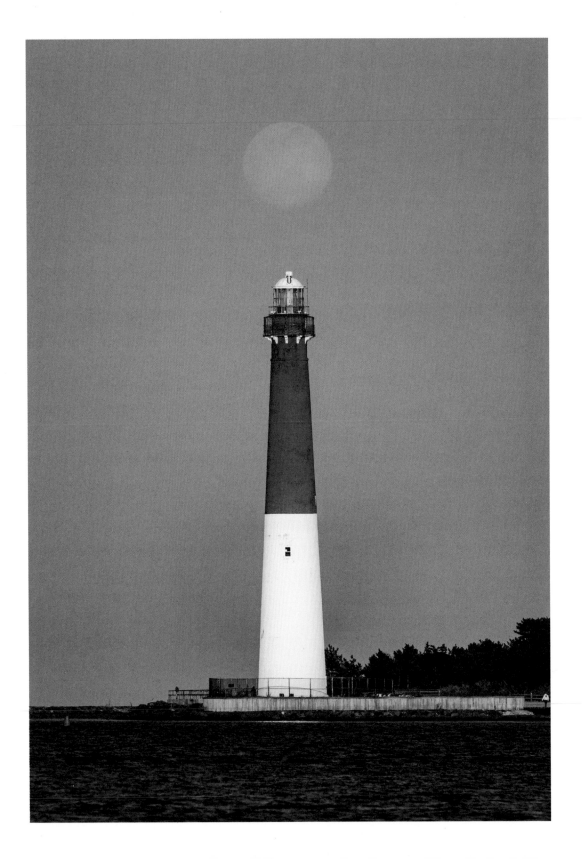

For my dad

Forever my editor-in-chief

<3

←

"OLD BARNEY"

Long Beach Island, New Jersey | c. 1835

Photo by Kevin Plant

Contents

FOREWORD

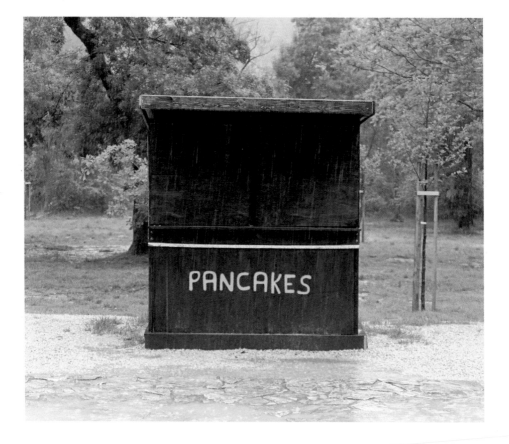

PANCAKES STAND

Krka National Park, Croatia | c. 1985

Photo by Cathy Tideswell

The photographs in this book were taken by people I have never met, of places and things I have, almost without exception, never seen—but I must say: I intend to.

Wally Koval and his collaborators have put together both a very entertaining collection of images and also an especially alluring travel guide (at least in the opinion of this actual Wes Anderson). There must be about 200 locations here, which should keep me busy for several decades, but I plan not to let any of these experiences escape me, especially the Croatian pancakes stand (page 95).

I now understand what it means to be accidentally myself. Thank you. I am still confused what it means to be deliberately me, if that is even what I am, but that is not important. I send my very best wishes and much gratitude to this group for discovering and sharing all these peculiar and fascinating vistas.

—Wes Anderson

ACCIDENTALLY

WES ANDERSON

THIS IS AN ADVENTURE

YOU KNOW IT WHEN YOU SEE IT: whether it's the symmetrical lines, pastel hues, immaculate composition, or something idiosyncratic and beautiful that you can and cannot describe at once, the director Wes Anderson has an immediately identifiable style to his films. How fantastic, then, to discover *real* places around the world that look like *accidental* captures from one of his films?

AccidentallyWesAnderson is now a global community of more than one million Adventurers who seek the most beautiful, idiosyncratic, and interesting places on earth—perhaps places they may have passed by, or others they have always wanted to explore—to find the unique and unexpected stories behind the facades.

I started this project as a personal travel bucket list for my wife, Amanda, and me back in 2017, after happening upon a series of photos of places that shared a resemblance to the look of a Wes Anderson film. As a fan of the director's work and an avid, curious traveler, I was intrigued by these places that seemed "just so," and I wanted to learn more about them. So, I set out to find where the photos had been taken. Slowly a community grew around this idea; we began sharing our own adventures, and soon thousands of submissions were pouring in from all around the world. The photos were beautiful, the narratives were intriguing, and the community was the positive, engaging, curious cherry on top.

My life has been immeasurably enriched by the opportunity to travel and experience other parts of the world, other cultures, and other people. And while we may think we need to venture far from home to find something extraordinary, there are so many amazing things in our own backyard waiting to be found.

Growing up in Delaware, I went to the Grand Opera House (page 49) on school field trips and for performances. I have been there countless times—but never knew the intriguing story of its past until this project drove me to discover it. I urge you not *just* to use this book as inspiration for where you might travel next, but to look at your own hometown with a new perspective. There's surely something fascinating to discover once you start looking for it.

I am so inspired by the vibrant, active community of photographers, designers, artists, historians, and friends who have come together to share their discoveries. We are each Adventurers, joined together by a similar interest in learning more about the world we share. Think of this book as a source of visual and intellectual inspiration, and an invitation to look for the story behind every facade.

Get ready to explore!

IMPORTANT NOTE BEFORE EMBARKING

Accidentally Wes Anderson was created in the spirit of adventure and exploration. We encourage you to use this collection to find your next adventure and guide your travels. However, locations close, train departure times change, and hours of operation may vary—be sure to call, email, or send a telegram to confirm all details before you make any travel plans.

And when you do explore, please obey all local laws and treat every place—and every person—with kindness and respect.

Additionally, each story begins with a Name, Location, and Date. Each date, preceded by a "c.", is meant to be provided as a point in time at which the structure or location was founded, established, built, manufactured, or opened to the public. Some locations have been built and rebuilt, or closed and reopened numerous times. We did our best to pinpoint the date that would not only be accurate but also true to the story.

Finally, if you come across any outdated or incorrect information, please let us know at Book@AccidentallyWesAnderson.com, or you can update the information directly at www.AccidentallyWesAnderson.com.

UNITED STATES & CANADA

The Airstream trailer was created by Wally Byam, a true visionary imbued with a fervent sense of adventure. He was born on Independence Day in 1896, in Baker City, a town along the Oregon Trail, where his grandparents had decided to tie up their wagon and mule on their westward search for a new life. Wally spent the early years of his upbringing working on a sheep farm, living in a wooden wagon equipped with a stove and all basic necessities—the genesis of his signature trailer.

By the late 1920s, Wally had married and was an avid camper, although his first wife was never as comfortable as he was sleeping on the ground. Always one to make things better, Wally fashioned a contraption that made it possible to place their tent atop his Model T. Though functional, it was not sufficiently weatherproof, and having to set it up each time wasn't very efficient, so he continued to tinker with the design. He switched out the tent for a covering shaped like a teardrop and, having already gone far, added a stove and ice chest, making it a proper trailer. So many passing travelers marveled at his model mini-home that Wally decided that mass-producing it might prove "a pretty good business to get into."

After he was satisfied with his own setup, Wally published instructions for creating one's own trailer in *Popular Mechanics*. Soon after, requests started pouring in to build trailers like the one parked in front of his home. By 1931, after receiving enough orders (not to mention noise complaints from neighbors), he opened Airstream's first factory, in Culver City, California.

The Airstream trailers built there were—and still are—visually distinct, identified by their bright aluminum shell and rounded corners, lending to the iconic silver bullet shape. The riveted aluminum panels that helped create the earliest trailers were made from material similar to what was used to build airplanes at the time.

Byam took adventure to the next level when he started shipping trailers across the ocean while acting as the principal organizer of Airstream Caravans. He led cavalcades of trailer-travelers on other continents, often in challenging terrain, for spans as long as six months.

Wally passed away in 1962 and did not witness the moon landing—or the role that his brainchild played in that historic event. Unsure of what chemicals the astronauts might be carrying home on them, NASA took every precaution: upon their return, the Apollo 11 trio were brought directly to an Airstream, which had been repurposed as a mobile quarantine unit. According to Airstream, NASA opted for the trailer based on its "aircraft-like construction, self-containment features, and high-quality living quarters that could withstand the rigors of transportation."

The Airstream legacy lives on today in a number of ways, as Wally's company, headquartered in Jackson Center, Ohio, continues innovating in his style. Embracing both the traditional and the alternative, adventurers have created waves of renewed demand for the vintage trailers, which owners decorate according to changing tastes.

Wally's passion for bringing people together and igniting their enthusiasm for travel has also continued to be honored: the Wally Byam Caravan Club International, founded in the 1950s, holds rallies and continues to caravan widely. Enthusiasts wear identifying blue berets (just as Wally did) and adhere to their mission to be "a diverse community of Airstream owners with a commitment to Fun, Fellowship and Adventure."

It's not hard to understand adherents' fervor for this pioneer, especially when one reads the Creed and Code of Ethics left behind by the man himself. It begins:

In the heart of these words is an entire life's dream. To those of you who find in the promise of these words your promise, I bequeath this creed...my dream belongs to you.

The code that follows helps one appreciate why Byam's vision is timelessly appealing. Its tenets include:

- *To open a whole world of new experiences...a new dimension in enjoyment where travel adventure and good fellowship are your constant companions.*

- *To lead caravans wherever the four winds blow... over twinkling boulevards, across trackless deserts...to the traveled and untraveled corners of the earth.*

- *To strive endlessly to stir the venturesome spirit that moves you to follow a rainbow to its end...and thus make your travel dreams come true.*

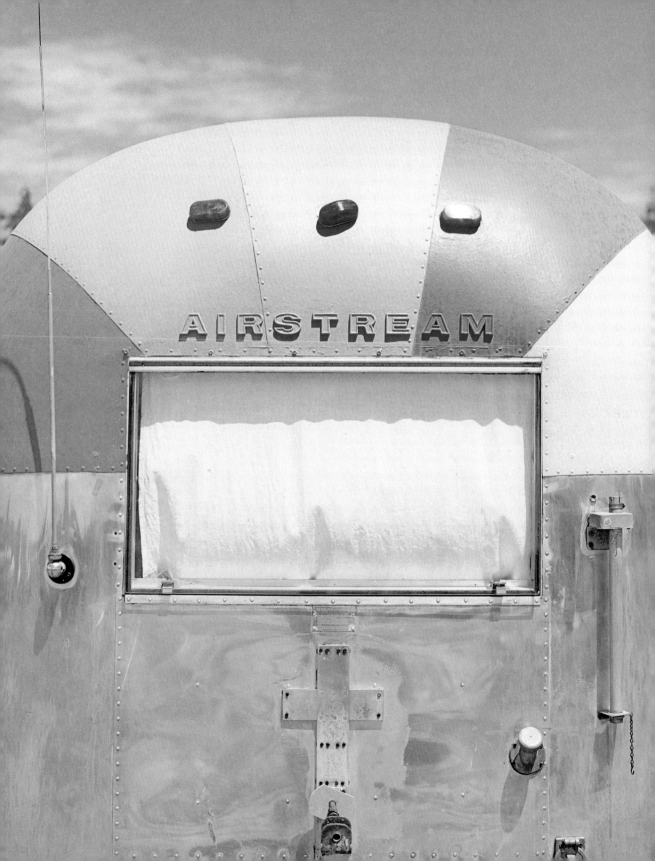

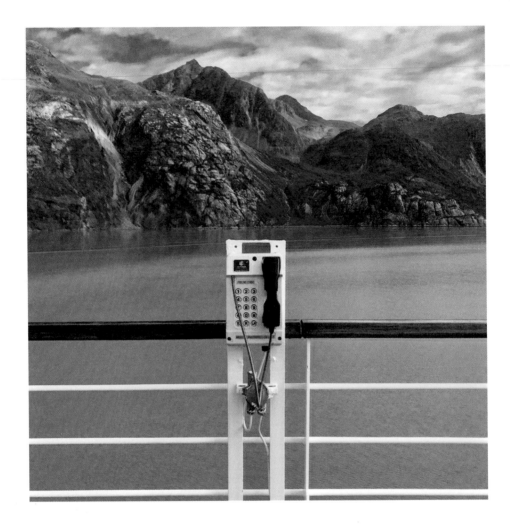

GLACIER BAY NATIONAL PARK & PRESERVE

Gustavus, Alaska | c. 1794

Photo by Alice Brooker

Located within Alaska's Inside Passage, Glacier Bay National Park is part of a 25-million-acre World Heritage Site—one of the world's most expansive sprawls of protected wilderness. It serves as a national park, a living laboratory and research center, a biosphere reserve, and a globally essential marine and terrestrial sanctuary.

The Park is treated as a sanctuary for one species of particular note: the rare blue bear, also known as the glacier bear. Little is known about these sought-after creatures. A subspecies of black bears, they remain one of the world's mysteries.

Should you visit the vast national park and happen to spot a blue bear—or any bear—do not approach it, do not let it approach you, and definitely do not choose that moment to phone a friend.

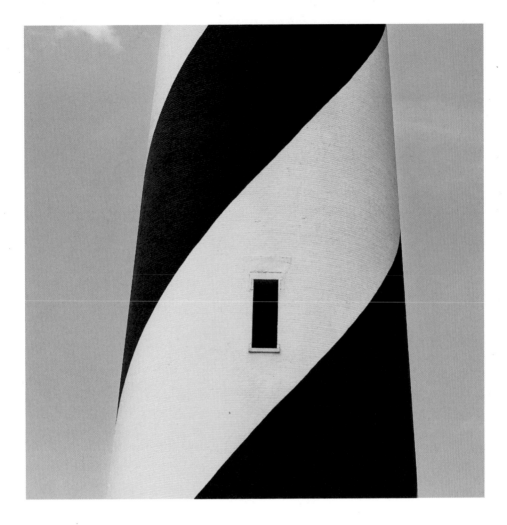

CAPE HATTERAS LIGHTHOUSE
Buxton, North Carolina | c. 1803

Photo by Wendy Quiroa

The waters off Cape Hatteras are so treacherous that they are known as the "graveyard of the Atlantic." There is no reliable tally of the many ships wrecked here, but estimates exceed two thousand.

When the warm waters of the Gulf Stream meet the Arctic waters of the Labrador Current here, the results are often violent. Heavy fog, quick-forming storms with sudden thirty-foot waves, and an ever-shifting sea floor create truly hazardous navigational challenges.

As early as 1794, Congress appropriated $44,000—then an exorbitant sum—to build a warning lighthouse on the headland of Cape Hatteras.

Over the next two centuries, the sea eroded the coastline, and in 1999 the lighthouse was moved to safer ground 2,900 feet from the water's edge. The 200-foot, 5,000-ton Cape Hatteras Lighthouse became one of the tallest, heaviest masonry structures ever moved.

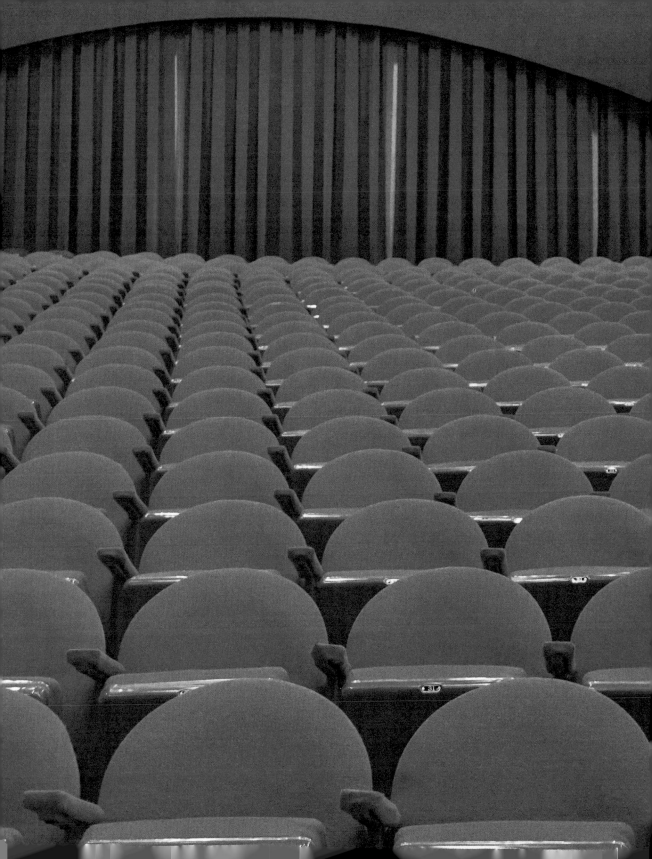

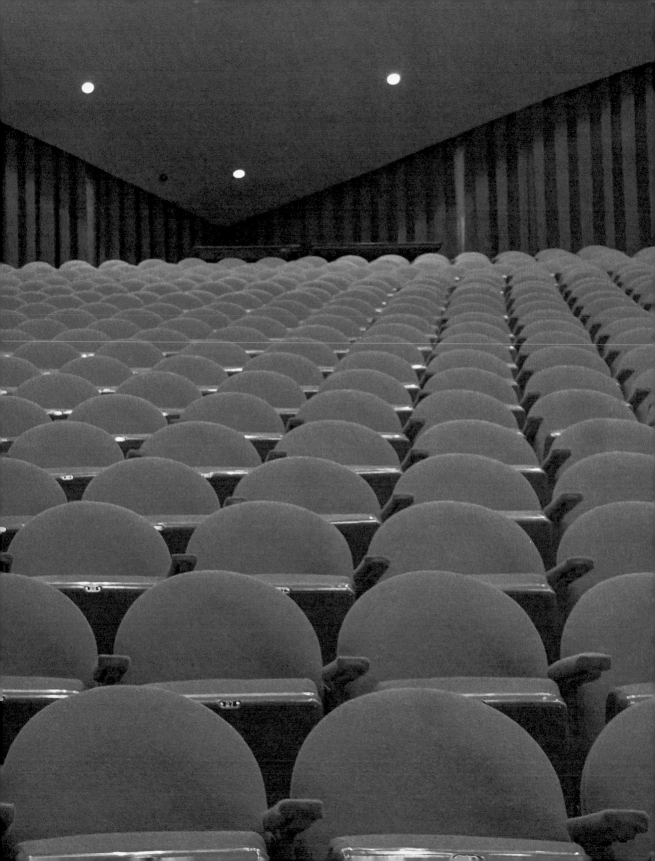

BARTLESVILLE COMMUNITY CENTER
Bartlesville, Oklahoma | c. 1982
Photo by Samantha Smith

THE GEORGIAN HOTEL
Santa Monica, California | c. 1933
Photo by Paul Fuentes

In the green heart of the Osage Hills in northeast Oklahoma sits the small town of Bartlesville. Surveying its sights, one could easily get distracted by Frank Lloyd Wright's Price Tower (1956), the only skyscraper ever built to the design specifications of the legendary architect. But most locals would redirect you to its neighbor, the earth-toned Bartlesville Community Center.

The center was designed to be a public nucleus—not merely Oklahoma's finest performing arts hall, but an intriguing and inviting space for every kind of event: symphonies, beauty pageants, church services, Weight Watchers meetings, and antique shows (to name just a few entries from its community calendar). Some patrons even come to view the original art, including a 25-foot-long mural revealing rural Oklahoma through the four seasons.

Opened in 1982, the building's modern curves and bold orange interior were the vision of architect William Wesley Peters, a protégé of Wright. That influence is evident in its curving walkway and unique seating arrangement, which wraps around the stage. There is no center aisle in the 1,700-seat hall, so attendees beware: it's advised that you use the facilities before the show begins.

White-gloved attendants first swung open the doors of Santa Monica's Georgian Hotel in 1933. Run by Judge Harry J. Borde, the exclusive hotel was nicknamed "The Lady" in honor of Borde's late mother, Rosamond—the true visionary of The Georgian and its adjacent sister hotel.

Rosamond was an audaciously modern, enterprising woman who bought the land and commissioned an upscale establishment in a style that married Romanesque revival and art deco. Much like "the lady" who dreamed it up, The Georgian was ahead of its time, enticing A-list celebrities and gangsters with its refined speakeasy at the height of Prohibition.

Santa Monica was still inventing itself at the time, and The Georgian's stately elegance helped establish Southern California's coastal aesthetic. While retaining its original charm, the hotel moved with the tides, later becoming a summer residence for first mother Rose Kennedy; creating a beauty parlor and playground before such amenities were commonplace; and consistently offering discretionary martinis on the veranda to Hollywood's elite.

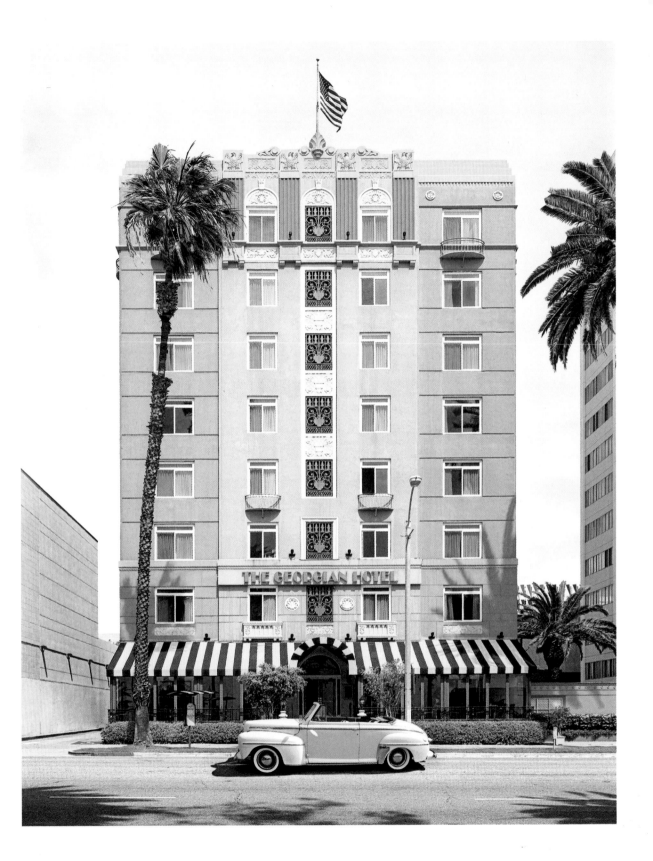

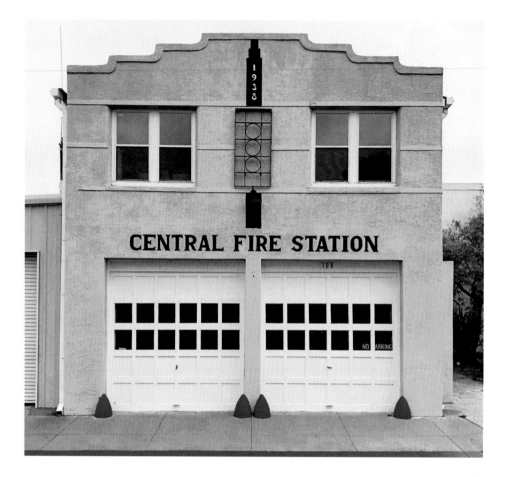

CENTRAL FIRE STATION
Marfa, Texas | c. 1938
Photo by Emily Prestridge

Founded in 1883 as a water stop to replenish the steam engines running trains between San Antonio and El Paso, Marfa (Russian for "Martha") was named by Hanna Maria Strobridge. Hanna, the wife of a Southern Pacific Railroad executive, was given the task of naming water stops along the new line by her husband. A voracious reader, she was inspired by a character in Jules Verne's *Michael Strogoff* (a handful of other water stops also bear the names of characters from Verne's work).

Over time, Marfa grew into a small community—one of such limited proportions that everybody has to do their part. The Marfa Volunteer Fire Department (MVFD) demonstrates that. Made up of seventeen volunteer firefighters, the department runs on donations and the limited funds it receives from the county and the town (which budgets a mere $20,000 for the entirety of MVFD's operating expenses).

Every year, the capacity of the fire department is tested during the Marfa Open Art Festival. This three-week annual event attracts roughly 40,000 artists, collectors, and enthusiasts from around the world to what was once a water stop, and whose year-round population rests at roughly 1,700 people—in other words, the entire town could fit comfortably into an eight-car New York City subway train.

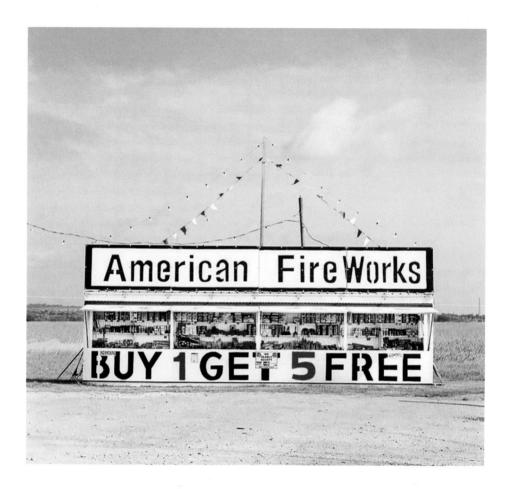

AMERICAN FIREWORKS

Bastrop, Texas | c. 1990

Photo by Matthew Johnson

American Fireworks operates more than 200 fireworks outlets throughout the state of Texas, with stands and stores open for business only in the days leading up to New Year's Eve and the Fourth of July.

The well-established American Independence Day tradition of a fleeting skyward spectacle originally began in ninth-century medieval China, where fireworks were invented for the purpose of scaring away evil spirits (using a natural application of gunpowder).

With greater safety measures being placed on celebratory explosives today than existed in medieval China, American Fireworks' multiple outlets are quick to promote a pithy and professional mission statement. Found on their website, just beside the company's animated logo, it reads: FEEL THE THUNDER!!

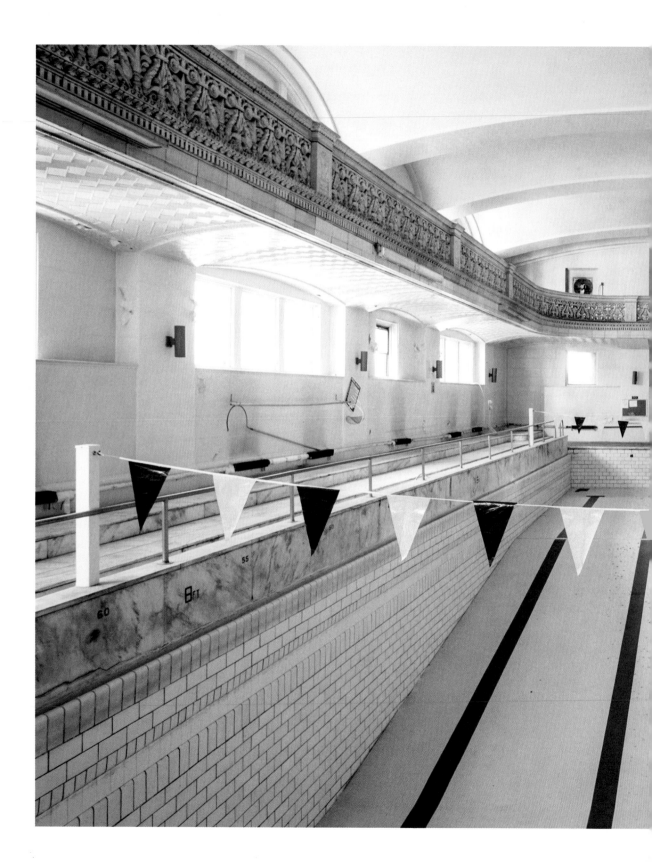

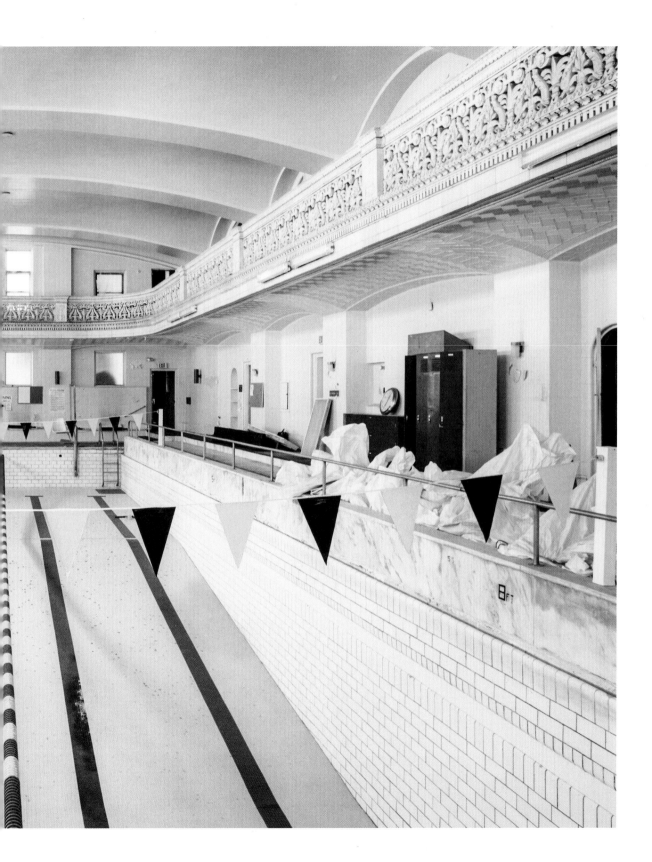

PITTSBURGH ATHLETIC ASSOCIATION
Pittsburgh, Pennsylvania | c. 1911
Photo by Eric Reichbaum

A private social and athletic club, the Pittsburgh Athletic Association was developed by aesthete and real estate maven Franklin Nicola and modeled after a Venetian Renaissance palazzo. This impressive five-story structure officially opened in 1911, offering top-of-the-line spa and athletic facilities, white tablecloth dining, and guest lodging. Some of its more innovative perks included billiard and fencing rooms, rifle ranges, Turkish baths, a sleek bowling alley, and a magnificent 75-foot pool on the third floor.

The PAA quickly developed into a mainstay for those with ties to Pittsburgh, at one point boasting more than 2,500 members. It was a hub for annual social events and served as a lively meeting place for some of the most iconic figures to call Pittsburgh home, with a membership log that included names such as Heinz, Mellon, and Mesta. Most notably, it was visited with near-daily regularity by America's most special neighbor, Fred Rogers. The American television personality and creator/star of *Mister Rogers' Neighborhood* kept a strict daily routine, one that centered on the club's pool (pages 14–15).

Fred Rogers grew up in Latrobe, Pennsylvania, forty miles east of Pittsburgh. He had a difficult childhood, which is perhaps why his capacity for empathy became seemingly limitless. Young Fred was shy, painfully introverted, and frequently homebound due to severe asthma. He was bullied for being overweight and taunted by the nickname "Fat Freddy" in his early years. After high school, he left Latrobe, earned a degree in musical composition in Florida, and then moved to New York to work on a variety of shows for NBC.

In his mid-twenties, Rogers returned to Pennsylvania in response to a request from the country's first community-supported educational TV station, WQED Pittsburgh. He was tasked with developing their initial schedule, but his natural instincts for performance brought him onto the set as well. On one of those programs, *The Children's Corner*, Rogers wore the caps of puppeteer, composer, and organist. During this span he found the time and will to attend the Graduate School of Child Development at the University of Pittsburgh and the Pittsburgh Theological Seminary; he became an ordained Presbyterian minister but was urged to keep working with children through mass media. In 1968, the iconic *Mister Rogers' Neighborhood* became available on what is now PBS, and Rogers went on to represent the comforting face of kindness for children across America. Over the course of his life he was honored with every accolade imaginable, from honorary degrees to the Presidential Medal of Freedom.

Throughout, Rogers kept a disciplined private life, with his wife and two sons present to witness his methodical rituals. While he was a man of devout faith, waking each morning at 5:00 to read the Bible, often in Hebrew or Greek, he was also something of a numerologist, for whom the number 143 was exceedingly important. On the show, Rogers's character points out that the number represents "I Love You": one letter in "I," four in "love," and three in "you." Love was his message, and invoking 143 was among the myriad of ways he broadcast it: the number appears frequently on his program; donating to the Fred Rogers Center means joining the 143 Club; the number was stitched into his trademark sweaters; and, astonishingly, he kept himself at that exact weight for the majority of his adult life.

And how? By checking into the Pittsburgh Athletic Association every morning at 7:00 and walking up to the third floor. Over the course of twenty-five minutes, he would swim a mile in the club's pool, at a leisurely yet intentional pace. Rogers would then head to the scale to ensure that it read precisely 143 pounds. He proudly maintained the practice, the weight, the determination, and the affinity for the number for decades.

Mister Rogers once explained to children and parents alike: "Love isn't a state of perfect caring. It is an active noun, like struggle. To love someone is to strive to accept that person exactly the way he or she is, right here and now." For his part, love was also a verb, one he actively exemplified in both body and soul.

GEORGIAN TERRACE HOTEL
Atlanta, Georgia | c. 1911
Photo by Toby Huss

When Gilded Age entrepreneur and investor Joseph Francis Gatins Sr. decided to build a hotel in his hometown of Atlanta, Georgia, he drew inspiration from the lodgings he'd enjoyed on trips to Paris. Gatins commissioned a hotel in the popular Beaux-Arts style, complete with an elegant café terrace, meant to resemble those found in European cities.

The Georgian Terrace opened in 1911 to a crowd of five thousand people arriving for a glimpse of its marble lobby adorned with Italian bronze chandeliers. In the grand ballroom, an orchestra from Spain provided entertainment while bellboys and maids serviced the waves of visitors.

In 1935, book editor Harold Latham was staying at the hotel when an unknown author named Margaret Mitchell Marsh handed him a copy of her manuscript, *Gone with the Wind*, in the lobby. The stack of pages was so substantial Latham had to buy an extra suitcase to transport it back to his offices in New York.

Over the next four decades, the Georgian Terrace became a residential hotel, an unfortunately unsuccessful music venue, and ultimately was converted into luxury apartments in the eighties. Finally, thanks to a great many Georgian devotees who, frankly, gave a damn, right before the turn of the century the hotel was fully restored to its original use.

NAVY PIER

Chicago, Illinois | c. 1916

Photo by Sam Abrahams

The Navy Pier has served the city of Chicago for well over a century. Encompassing almost fifty-five acres of parks, gardens, and sights, it is the Midwest's top tourist and leisure destination, with around two million annual visitors.

In 1909, Daniel Burnham, architect of the World's Fair, ambitiously envisioned five piers in his "Plan of Chicago," but Navy was the only one built. Reaching 3,300 feet along the shoreline of Lake Michigan, it was the world's largest pier, supported by 20,000 logs felled in Oregon. The surrounding area would also become the original home of the first-ever Ferris wheel.

Although Burnham's plans called it the "People's Pier," instead it was inaugurated in 1916 as the Municipal Pier, and wouldn't receive its current name until 1927, honoring the military housed there during the Great War. But it wasn't just for personnel—the pier also served as a prison for draft dodgers, and became an army base and pilot training center in World War II as Lake Michigan offered landlocked protection against Nazi U-boats and Japanese Zeros.

After decades of underutilization, the pier was revitalized in 1989 as a tourist destination, changing the scene significantly since days when the huge wharf teemed with some 15,000 young aircraft carrier pilots. Among them was a future president: George H. W. Bush.

Today, Navy Pier might well be renamed its intended "People's Pier": among the busiest attractions in Chicago, it features a mix of shops, restaurants, rides and even a World Record. In May 2013, park operations manager Clinton Shepherd spent 48 hours, 8 minutes, and 25 seconds on the Ferris wheel without sleeping—and made the Guinness Book of World Records for the "longest marathon on a fairground/theme park attraction."

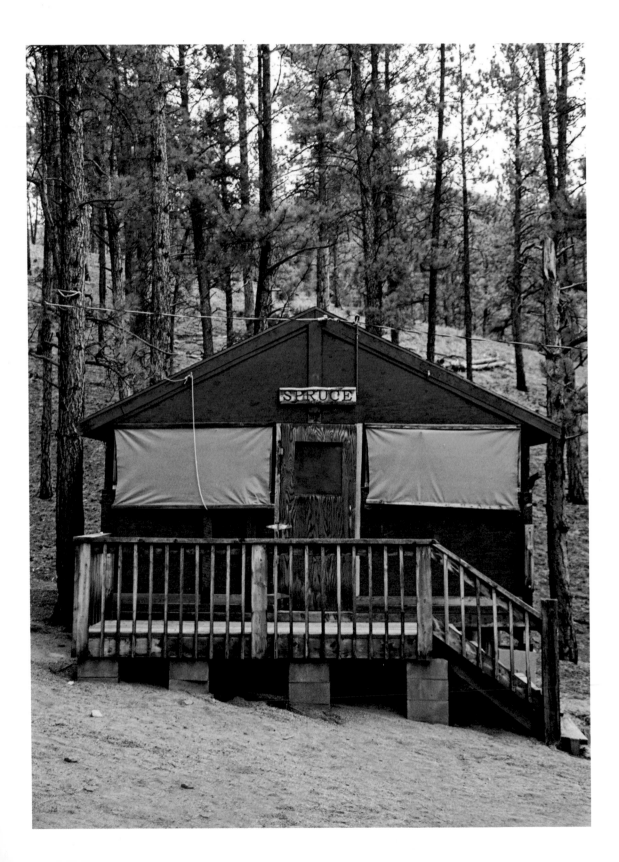

←

CAMP SHADY BROOK
Deckers, Colorado | c. 1894

Photo by Timothy Li

In 1871, twenty-year-old Robert Bandhauer rode by horseback from Missouri to Denver to start a new life. He served on Denver's first fire department and eventually opened a blacksmith and carriage shop that employed more than 100 men, providing the ironwork for the Tabor Opera House and Denver Stock Yards.

Robert met his beloved wife, Lizzie, while she was working toward a degree in music, specializing in the piano. They married, had seven children, and enjoyed a comfortable life until the United States switched its monetary system to the gold standard. The couple's savings, which was invested in silver, swiftly depreciated, and the Bandhauers lost everything—except for one another.

In 1894, the family of nine (plus their dog) packed their belongings, including Lizzie's dismantled baby grand piano, into two horse-drawn wagons and journeyed toward the mountains. They settled forty miles southwest in Daffodil (later renamed Deckers), Colorado, and began setting the scaffolding for what is today known as Camp Shady Brook.

By the dawn of the twentieth century, the family had built a barn, an icehouse, and a handful of guest cabins that they opened to the public, christening their property Shady Brook Farm. Thanks to an increasing number of visitors, the family was able to continue developing their property, which eventually centered around a new dance hall, serving as a hub for community activities and weekly dances. Local miners and lumberjacks ventured to Shady Brook every Saturday, finally providing Lizzie with a venue to play her reconstructed piano. Her placement on the bench also offered an ideal vantage point to scan the room for potential suitors for her five daughters. Eventually, all seven of their children met their spouses in the family dance hall, to the soundtrack of their mother's piano playing.

Shady Brook Farm was sold in the 1920s and became a dude ranch until being purchased by the YMCA. Just over a century after the Bandhauers' resettlement, the property was hit twice by forest fire. Almost all of Shady Brook Farm went up in flames.

The YMCA recognized the importance of the farm and its quintessentially American origins. They replaced buildings and restored life to what is now Camp Shady Brook, which serves thousands of kids each summer. The original cabin, the family's eventual home, and the matchmaking dance hall somehow made it through the fires and remain standing today.

→

ROBERTS COTTAGES
Oceanside, California | c. 1928

Photo by Paul Fuentes

Shortly after the town layout was completed in 1883, Oceanside, California, was marketed as a seaside resort. A book titled *Oceanside* was even published, with a doctor's decree: "The invalid finds health and bright spirits, the pleasure seeker finds variety and amusement."

Investors bought up land along the beach, and visitors arrived in droves, quickly leading to a housing shortage. Entrepreneurial denizens converted garages into tiny homes and temporary trailer parks into permanent residences, and began scouting the coast for new development opportunities.

Soon after, in 1928, A. J. Clark bought a sizable strip of land, secured a permit, and built twenty-four beach cottages. The small pastel-colored homes, framed by the carnations and geraniums planted throughout Oceanside, opened for business by midsummer.

Harry and Virginia Roberts purchased the iconic double row of homes in 1941. Within a dozen years, investors began to sell the quaint cottages individually. Ocean view homes sold for $5,950, while second-row units went for $700 less.

The buildings, now rental bungalows, still stand, representing an important moment in Oceanside's nascent days, a time when the town enticed visitors with the tremendous promise that "If you long for a beautiful country, with a matchless climate, come to Oceanside, where life is worth living."

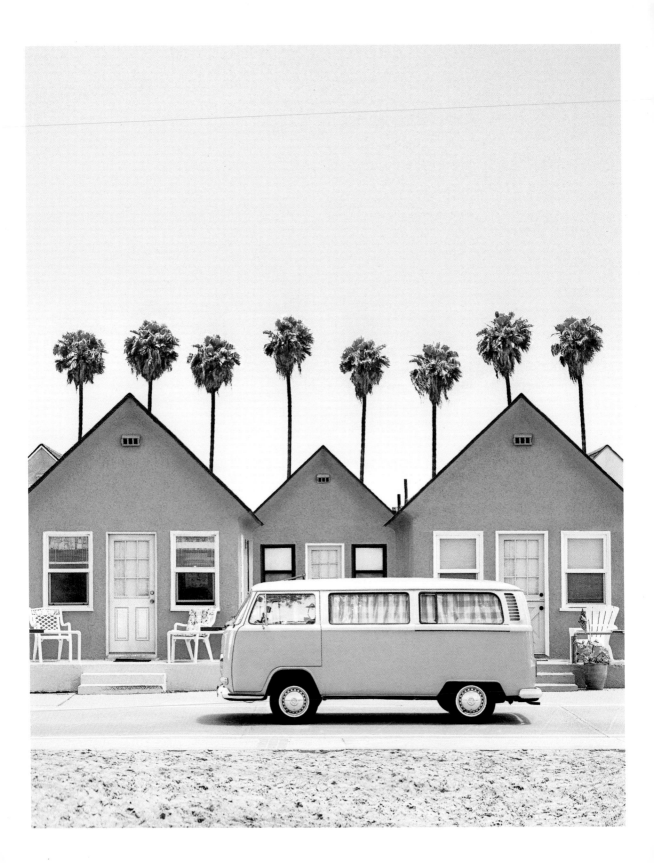

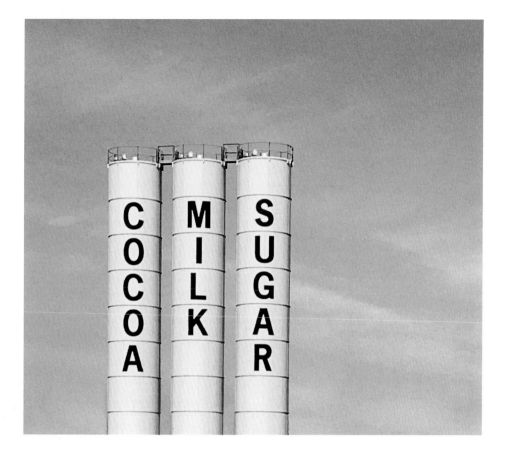

MALLEY'S CHOCOLATES
Cleveland, Ohio | c. 1935
Photo by Aubrey Meadows

Towering over Interstate 480 on the outskirts of Cleveland, Ohio, written in large letters on the pink cylindrical storage tanks of Malley's Chocolates, are the three ingredients that make chocolate delicious: cocoa, milk, sugar.

The popular local confectionery churns out mass assortments of chocolates, classic wafers, and candy bars—as well as local favorites like peanut butter and chocolate "buckeyes."

Founder Albert "Mike" Malley learned to create handmade chocolates as a boy in Meadville, Pennsylvania, by using a simple copper pot over an open flame. In 1935 he borrowed $500, rented a small store in Lakewood, Ohio, and moved his family into its living quarters in the back. Out front he began to build his chocolate empire.

Within fifteen years, he was putting the finishing touches on his second establishment, which made headlines for being the first all-aluminum-clad retail store in America. On opening night, the eager masses resembled crowds outside Willy Wonka's gates. They were so rowdy that the police arrived to keep the peace.

Each 88-foot silo holds roughly 100,000 pounds of its respective raw ingredient, and is fitted with a pump system that pipes directly into the factory. Such enormous quantities are especially necessary around Valentine's Day, when a special fifty-person crew comes in to work around-the-clock with Oompa-Loompa–style devotion to prepare the company's signature chocolate-covered strawberries.

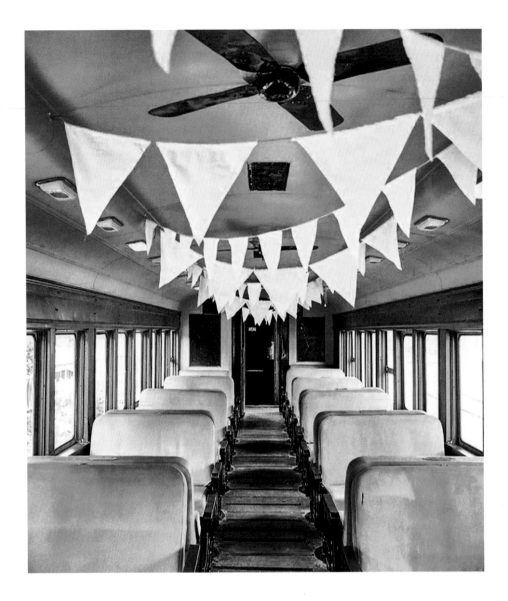

DELAWARE & ULSTER RAILROAD
Arkville, New York | c. 1866
Photo by Christian Harder

Headquartered in Rondout—a small hamlet on the Hudson River—the original Ulster & Delaware Railroad Company was founded in 1866 and advertised as "The Only All-Rail Route to the Catskill Mountains."

Though small, it was significant in stature, with trains noted for their elegance. These "engines that could" wielded great influence in the region, shuttling passengers to destinations that otherwise couldn't be reached (at least not by all-rail routes), and giving a steady boost to businesses along its path, especially in Delaware County.

Today, these trains, such as the Rip Van Winkle Flyer, have been lovingly restored to transport passengers back to the golden age of railroading.

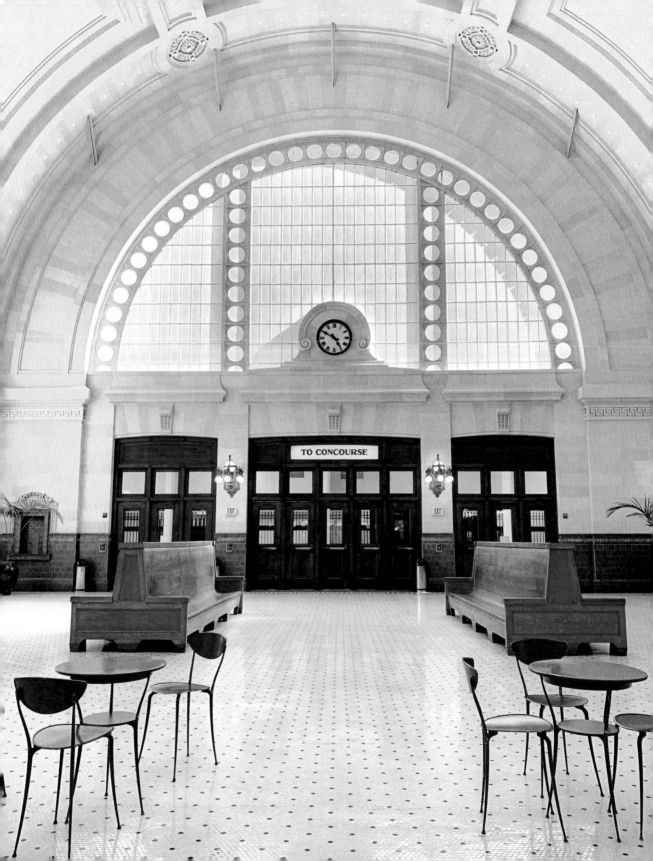

←

UNION STATION
Seattle, Washington | c. 1911
Photo by Rachel Bishop

→

ADVANCE WOOD SHOP
Los Angeles, California | c. 1947
Photo by Pat McCoy

Entering the Great Hall of Union Station in Seattle, Washington, you may find yourself so taken by its 55-foot vaulted ceilings, arched concourse, and hypnotic, hexagonally tiled floors that you don't notice that there are no train tracks leading into or out of the station. Despite its visual splendor and apparent purpose, it has long ceased to serve as a railway hub.

At the turn of the century, the Klondike gold rush attracted 200,000 seekers of fortune to Seattle, and by 1911 the city's population had quadrupled. With little warning, this Pacific Northwest town was no longer a small outpost. To look the part, Seattle embellished its packed new streets with architecture that would make the town appear to be a sophisticated metropolis. Union Station, in all its Beaux-Arts elegance, was built to place the city on a cultural par with San Francisco and other West Coast destinations.

However, Union Station struggled to keep up with increased automobile and ferry traffic. By 1971, the building was abandoned, with six inches of bird droppings blanketing its water-damaged floors and walls on the verge of collapse. It remained in this state of neglect until the late 1990s, when a resurgence of Seattle urban renewal projects brought about a recognition that there might be value in a restored Union Station.

Devoted individuals stepped forward to make this endeavor possible, including the seventy-eight-year-old man who had serviced the station's clock decades earlier. Volunteering his skills, he repaired the face and arms of the iconic timepiece, allowing it to tick and tock just as it once had.

Advance Wood Shop is a third-generation family-owned business based in the Highland Park neighborhood of Los Angeles. Highland Park has a legacy of local businesses, some of which have been community staples for decades.

In 1947, Italian immigrant Mike Tenerelli established Advance Wood Shop, specializing in residential, commercial, and custom shelving and cabinetry. After running the business for roughly thirty years, Mike passed it on to his son Stan—who took over for thirty years himself. His son, Mike Tenerelli II, has been at the helm for the last decade. If tradition holds, Mike II has another twenty years before he passes it on to the next generation.

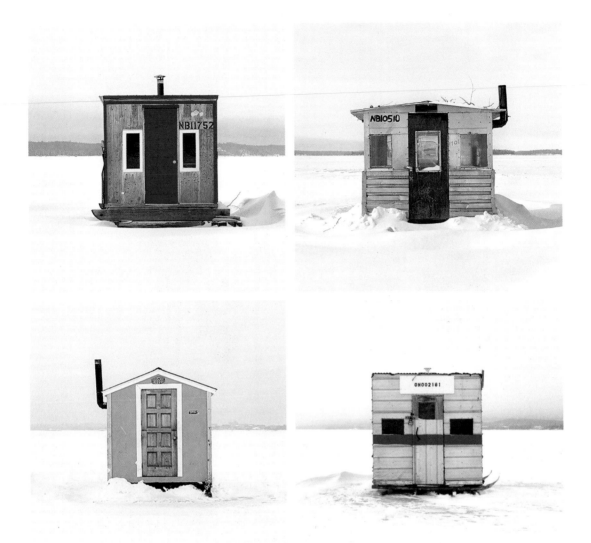

ICE-FISHING SHACKS
Lake Nipissing, Ontario, Canada | c. 1600s
Photos by Stephan Graveline

Devoted owners of ice shanties agree: "We do not have ice-fishing seasons in Ontario—only fishing seasons." In other words, these humble winter homes do not merely provide accommodation for some sort of recreational activity. They enable a way of life.

With approximately 250,000 lakes in Ontario, there's no shortage of those who live for the frost and bemoan the thawing of their home base. And though these huts on Lake Nipissing may appear to be structural embodiments of solitude, they actually foster a strong sense of community.

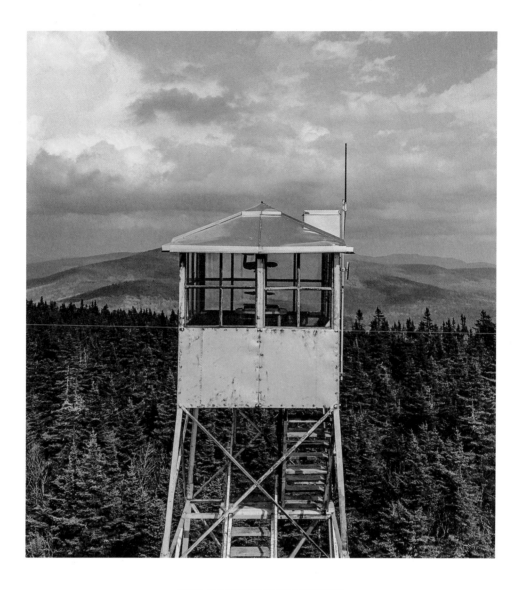

FIRE OBSERVATION TOWER

Catskills, New York | c. 1887

Photo by Peter Crosby

At the stroke of midnight on New Year's Day, 1885, a new forest preserve was created, ensuring that the 3 million acres of New York woodlands would be kept "forever wild." Exploitation by loggers had left behind dry, barren land that was especially susceptible to fire.

Two years later, the first mountaintop fire observation station was erected by a local sportsman's club to protect their land. Constructed of timber, the inaugural tower stood tall for a few years until it was destroyed in an incident as tragic as it was ironic, as a presumed bolt of lightning struck, causing it...to burn down.

The state would later take over operations, and for nearly a century, more than 100 fire towers kept watch until 1988, when the first tower and cabin—in its official capacity—was closed. It still stands, however, stretching skyward to nearly fifty feet, and made of steel.

FOLLY BEACH FISHING PIER

Folly Beach, South Carolina | c. 1995

Photo by Joshua Gregory

Known by locals as the "edge of America," the barrier island of Folly Beach offers access to the ocean just fifteen minutes from downtown Charleston. The pier juts 1,045 feet into the Atlantic, offering views of loggerhead turtles making their nests and dolphins playing in the surf, while bald eagles soar above the fishermen that line the pier. These waters were once home to the infamous pirate Blackbeard, and the island itself served as a supply depot and staging ground for the Union army during the Civil War.

Folly also played a role in the creation of an American classic, George Gershwin's *Porgy and Bess*. The successful young Broadway composer yearned to prove his mettle by writing an opera. He hadn't settled on a worthy subject until he picked up DuBose Heyward's 1925 novel, *Porgy,* set in the tenements of Charleston. Gershwin, himself not an avid reader, was blown away by the narrative.

Heyward, a native of Charleston, agreed to the adaptation—on the condition that Gershwin spend time there to attune his ear to the Gullah and their music. That's how city slicker George Gershwin came to spend the early summer of 1934 on Folly Beach, in a rented cottage with a grand piano, working on what would become his great—and controversial—musical. He actively mingled with residents, and the time spent not only writing but swimming and taking leisurely walks along the beach allowed him to hone the music for his iconic tune from *Porgy and Bess,* "Summertime." Heyward, who felt that the season on Folly offered "livin' that's easy," even gave Gershwin his first line.

Gershwin was especially inspired by the rhythmic "ring shout" dances he observed, and the music he heard in Gullah churches on nearby James Island. As his biographer Walter Rimler explained, "Here, in southern black churches, he had arrived at the heart of American music."

HEARST CASTLE
San Simeon, California | c. 1919

Photo by Moa Boyer

William Randolph Hearst, the newspaper tycoon who played no small role in shaping twentieth-century media, was the only child of George and Phoebe Hearst. Shortly after William's birth, his father purchased forty thousand acres of ranchland in San Simeon, California, to be used as a camping retreat.

Young William was given extraordinary opportunities throughout his life, and distinguished himself by not wasting them. At ten years old, his mother took him on a grand tour of Europe for a year and a half. Inspiration was planted by the grandeur of the castles he saw, along with the array of architectural styles and artwork he absorbed. This experience fueled his lifelong aspiration to recreate such majesty for himself, and Hearst Castle became the realization of this dream.

In 1919, as a fifty-six-year-old owner of a media empire—including newspapers, magazines, and film studios—William walked into Julia Morgan's office. Morgan, forty-seven, was a pioneer herself. Called "America's first truly independent female architect" by her biographer, she was the first woman to enroll in the architecture department at Paris's School of Beaux-Arts, and the first to create her own practice back out West. Hearst wanted her help in building a more comfortable outpost on the camping grounds of his youth.

Nothing if not ambitious, Hearst's initial vision expanded into La Cuesta Encantada ("The Enchanted Hill"), more commonly referred to as "the ranch," an estate encompassing more than 165 rooms, including several libraries, pools, a banquet hall, and even an airstrip. Its gardens occupied more than 5 million square feet.

Hearst's bungalow became a castle, or—to his mind—a museum of his collections. Since childhood, he'd had a manic compulsion to accumulate treasures. Morgan was there to help him place paneling, entire monasteries, fireplaces, and the medieval tithe barn that he had acquired in Western Europe. Together, the unlikely pair went on to spend decades filling his estate with an estimated 25,000 global artifacts, including thirty painted ceilings from Renaissance Italy and Spain.

As Morgan orchestrated the development, Hearst continued to reside there, hosting extravagant soirees and spending lavishly—even building a private power plant—to ensure that the Who's Who of the nation could observe the wonderland he had created.

The main reception room boasts a ceiling moved from an Italian palazzo and paneling that's actually a concealed door of an elevator that goes to Hearst's third-floor Gothic suite. He loved surprising guests by entering unannounced. Such rooms are so similar to those found in European castles that set designers for *Harry Potter* used them as inspiration for Hogwarts.

As for the outside, its palm trees, mountain ranges, and views of the water all serve as postcards of the California ideal. The tennis courts are perhaps the estate's most modest feature. Beyond them are stables to breed Arabian horses and an impressive zoo—though most of the animals, such as the elephant, are gone. Zebras, elk, sheep, and goats still roam freely.

One hundred telephones were placed around the premises so Hearst would never be out of touch. He even had one installed behind a tree, to enable him to keep up with business mid-horseback ride or post-swim. It took three tries to get his renowned Neptune Pool just right; it was twice enlarged and then extended a third time to host an imported Roman temple facade. The pool, which holds over 300,000 gallons of water, also features a group sculpture depicting *The Birth of Venus*.

In 1947, Hearst's ailing health forced him to leave the "ranch," and he passed away in 1951. In 1958 the palace was designated a California state park. While it was never completely finished, it stands as an unmatched achievement, one that guest George Bernard Shaw identified as "what God would have built if he had had the money."

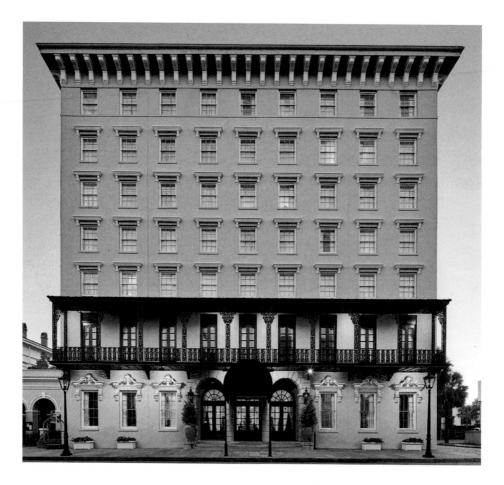

MILLS HOUSE HOTEL
Charleston, South Carolina | c. 1853
Photo (above) by Nicholas Gore, photo (right) by Leyla Tran

First opened in 1853 by grain merchant Otis Mills, the Mills House Hotel has survived catastrophes such as the Great Fire of 1861 and relentless bombardment by the Union army during the Civil War.

Confederate General Robert E. Lee was actually present during the raging fire. Decades later, President Theodore Roosevelt enjoyed a more relaxed stay, as did glamorous visitors like Elizabeth Taylor. Many grand hotels have hosted eminent National leaders and Hollywood stars. Very few, however, have the distinction of having employed Jerry Thomas, or, as he referred to himself, the "Jupiter Olympus of the bar."

Jerry Thomas is an unsung American legend. Both a bartender and a showman, he did not invent the cocktail, but he certainly raised it as his own and helped usher it into the world. "Professor" Jerry played a crucial role in the evolution of drink when he wrote the *Bar-tender's Guide* (also titled *How to Mix Drinks* and *The Bon-Vivant's Companion*). It included 236 drink recipes, under categories including Punch, Julep, Smash, Cobbler, Mull, Toddy, Sling, Sour, Flip, and many others. This bible of the bar, published in 1862, defined basic practices for mixing drinks, and cast a light on bartenders as creative professionals (who—in Jerry's case—could take home a higher

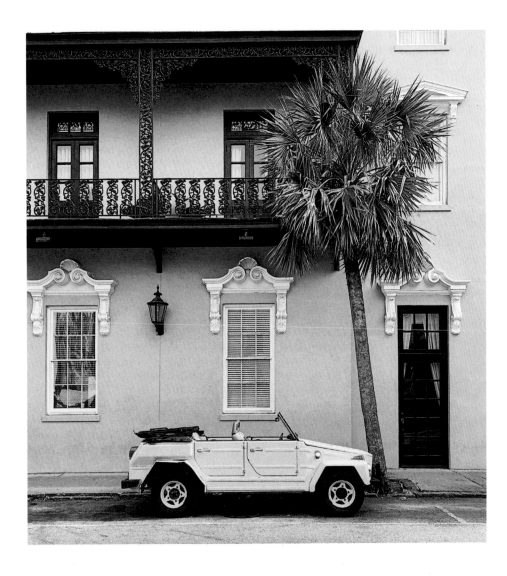

wage than some high-ranking political figures).

Jerry briefly tended bar at Mills's Best Friend Lounge, a small, cozy room named in honor of the first steam-powered passenger train built entirely in the United States. He visited the Best Friend on one of his many tours through the United States and Europe, likely carrying along his personal set of solid silver, gem-encrusted bar tools.

Neither the original hotel nor the original bar is still standing. The passage of time proved more destructive than fire or war, and by 1968 Mills House had fallen into a state of disrepair and was demolished. The first structure had clearly done something

right, however, so when the establishment was rebuilt in 1970, it reopened as a larger but otherwise faithful replica of the historic lodging, including the Best Friend Lounge, paneled with the same dark wood, tucked behind the lobby, tastefully decorated with railway artifacts.

The lounge closed at the beginning of the 2000s and remained shuttered for a decade until veteran bartender Roger Gelis, eager to honor the legacy of the "Father of Cocktail," reopened it, serving classic cocktails, local beers, and fortified wines. "Studying and tasting them have pulled me into a rabbit hole," Gelis said. "I'll keep going and sharing along the way."

UNITED STATES & CANADA

DETROIT INSTITUTE OF ARTS

Detroit, Michigan | c. 1885

Photo by Erol Ahmed

The Detroit Institute of Arts (DIA) is home to one of the most extensive and significant collections of art in America—and with close to 700,000 annual visitors, it ranks among the most visited museums in the world.

The idea for the museum dates back to an 1881 European trip made by local media mogul James E. Scripps, who recorded the nearly half-year art tour in his journal. Portions of it were published in the *Detroit News*, and the series inspired William H. Brearley, manager of the newspaper's advertising, to organize an art exhibit. Shortly after, a campaign was launched to convince influential members of the city to establish a landmark museum. By 1888, the Detroit Museum of Arts was home to more than seventy unique pieces that Scripps had collected while traveling through Europe, and he and Brearley incorporated the establishment.

The era of the automobile brought wealth and population to Detroit—and a museum collection that grew fast enough to require far more space. In 1919, the museum was renamed the Detroit Institute of Arts, "with the museum and its valuable collections actually belonging to the people." Indeed, the art became Detroit's property by year's end, and the new Beaux-Arts institution was completed in 1927, garnering acclaim as an urban "temple of art."

The DIA's global collection of 65,000 pieces is also peppered with nods to the city that owns it. One such example is *First State Election in Detroit, Michigan, 1837*, in which several of the figures appear to be inebriated. The work of a nineteen-year-old former sign painter, the painting is said to faithfully depict a boisterous election in which Democrats defended their governorship against the Whig challenger. Others insist that the painting was Whig propaganda—showing a governor buying votes from a band of drunks while a child, whose very face is "crooked," panhandles; in the distance, a parade of Democrats ride into Capitol Square, led by a gilded pony.

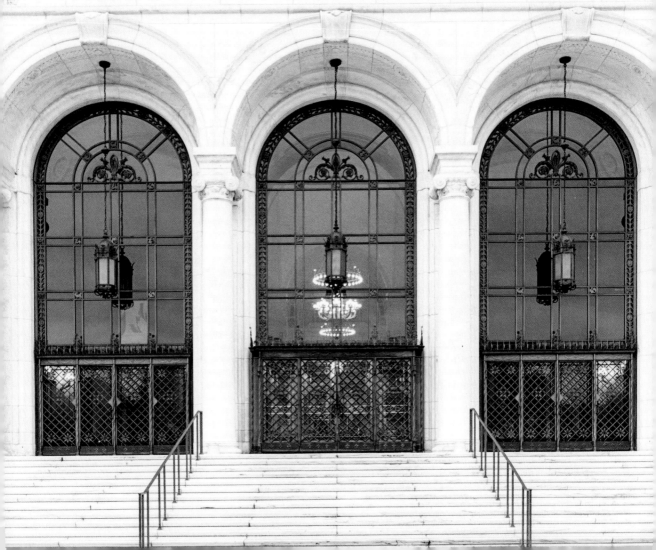

DEDICATED BY THE PEOPLE OF DETROIT

TO THE KNOWLEDGE AND ENJOYMENT OF ART

THE DETROIT INSTITUTE OF ARTS

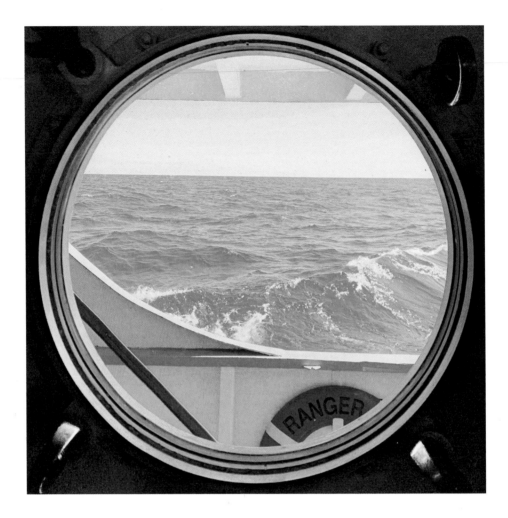

RANGER III FERRY

Keweenaw County, Michigan | c. 1958

Photo by Brad Baginsky

Isle Royale National Park is so isolated and challenging to reach that it receives fewer visitors each year than Yellowstone Park does in a single day.

The remote island can only be reached by boat or seaplane—though the National Park Service does offer a ferry.

Isle Royale is the most commanding island of a 200-islet archipelago in Lake Superior, which has the biggest surface area of any freshwater lake in the world. About a dozen families have leases on their cabins for life amid the island's vast wilderness, but the significant majority of the residents are moose.

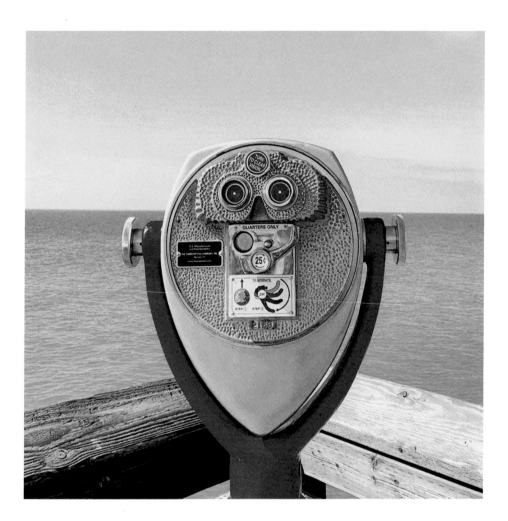

VIEWFINDER
Newport Beach, California | c. 1932

Photo by Savannah Sher

In the early 1900s, Newport Beach was a barren sandpit previously designated as "swamp and overflow" land—before it was identified as a potential summer destination. As the beach was cleaned up and developed, people took interest in the fresh plots of land and rows of beach cottages springing up.

This coast soon became home to the Balboa Pier and the Balboa Pavilion. The two structures were erected along the south terminal of the Pacific Electric Railway Red Car line, which ran from Long Beach to the Balboa Peninsula. In short order, beachgoers flocked to Newport Beach.

But what would a tourist-saturated scenic area with a devotion to old-school amusement *be*, really, without a lineup of artfully placed, coin-operated viewfinders? Several of these durable, weatherproof viewers garnish the piers of Balboa Peninsula and Newport Beach. For a quarter, those strolling by are given ample opportunity to enhance their vision of all the aquatic activity before them while also indulging in a swivel back in time.

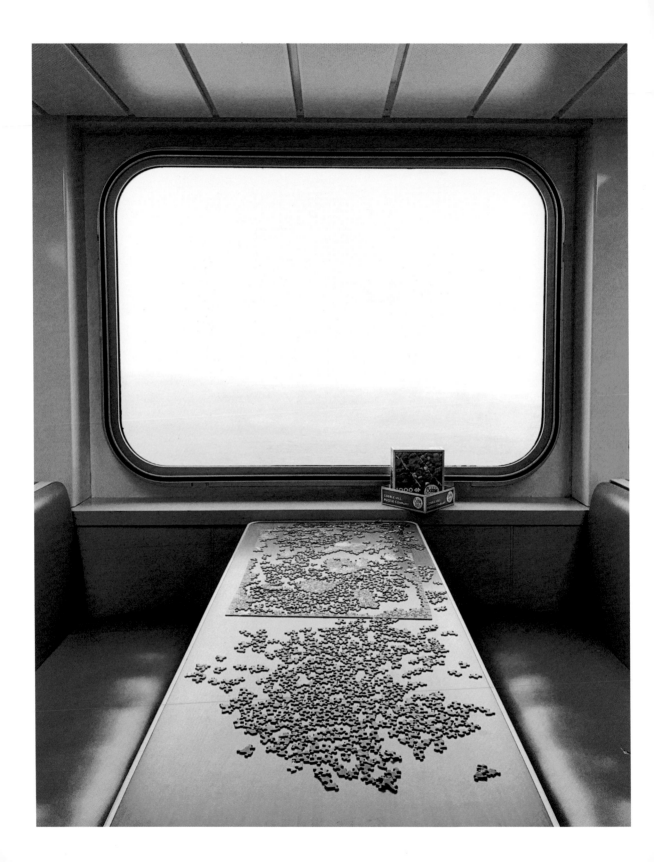

←

WASHINGTON STATE FERRIES
Puget Sound, Washington | c. 1951

Photo by Cole Whitworth

→

JOYCE THEATER
New York, New York | c. 1941

Photo by Jessica Hriniak

Washington State Ferries is the government agency that operates the largest ferry fleet in the United States. Its twenty-three vessels carry 25 million passengers throughout Puget Sound, from the northwest coast of Washington to the San Juan Islands and up to Canada's British Columbia via inland waterways.

The iconic ferries have become a source of Pacific Northwest pride. The summer months see a significant swell in business, as tourists treat the ferry as an attraction in itself. Visitors venture to the top viewing deck to take in the salty air, primed with binoculars, hoping to catch sight of a pod of whales.

But come winter, commuters are more likely to be found in the main cabin, brows furrowed, working on one of the ferries' massive jigsaw puzzles. This beloved practice captivates devoted regulars, who board the ferry and strike toward the large tables where the puzzles begin and end, in a constant cycle of impermanence.

The tradition began on the longer runs to the San Juans, which can take up to four hours. Staff pick up puzzles in thrift shops and put them out; now regular passengers donate them as well, leaving scribbled invitations and cheeky warnings on the boxes: "Public Puzzle: Abandon All Hope, Ye Who Begin."

With intricate puzzles containing as many as 1,000 pieces, the odds are long that a single rider will complete one alone. It's a communal effort, with some curious or bemused riders placing only a piece or two before moving along; others dedicate themselves to working with fellow travelers, seen or unseen, to complete the picture.

It's a nostalgic vision. Rather than passing a booth of solo riders checking emails or playing solitaire on their phones, one might see a group of four strangers hunched over a table, calling out sections, passing one another relevant pieces, the luckiest perhaps sharing a measure of excitement about finishing together. Once the ferry docks, the passengers disperse, perhaps only to be fit back together on their next journey.

The distinctive Art Moderne building at 175 Eighth Avenue on Manhattan's West Side has long served as a prime venue for leaps and launches. Since 1982, it has been home to the Joyce Theater—a premier venue for dance in New York City. Serving as the city's base for more than four hundred domestic and international traveling dance companies, the Joyce's program celebrates a spectrum of dance styles and traditions.

The Elgin Theater, which occupied the building before the Joyce took over, opened as a cinema in 1942. The Elgin was unremarkable, until the fateful hiring of Ben Barenholtz as manager. In 1970 the Polish immigrant invented the "midnight movie," showing Alejandro Jodorowsky's surrealist western *El Topo* into the wee hours to a sold-out house seven nights a week for six months (at which point John Lennon persuaded the Beatles' manager to buy the rights to the film).

The midnight movies continued, and Barenholtz refined his eclectic taste and ability to eye young talent. He began distributing films, turning the Elgin into a breeding ground for some of the great pioneers of independent American film culture. His work led to the release of the debuts of David Lynch, John Sayles, and the first two Coen Brothers movies.

While its name and artistic medium have changed over the years, the long-standing tradition of the Joyce continues to honor the patronage of New Yorkers, as well as their appreciation of art with a twist.

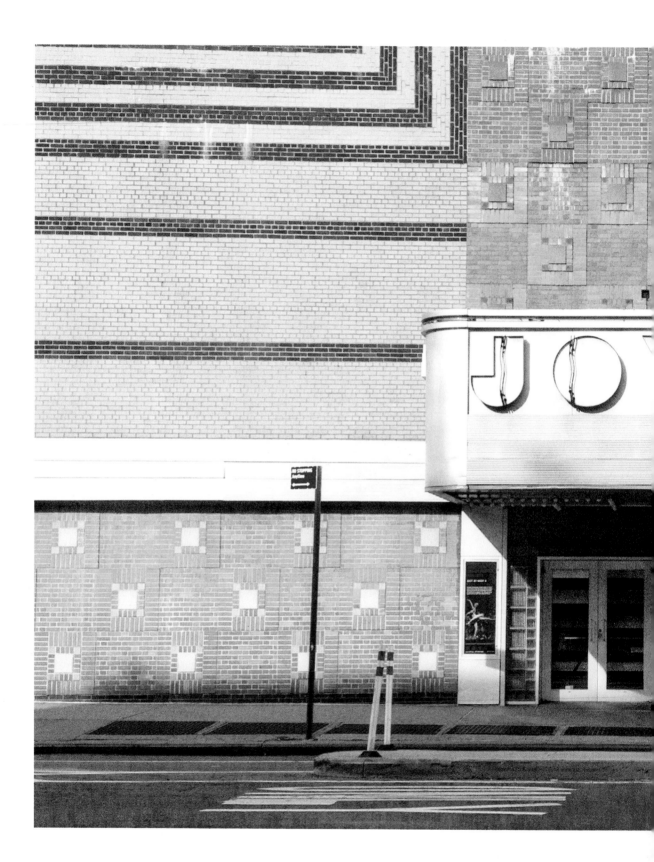

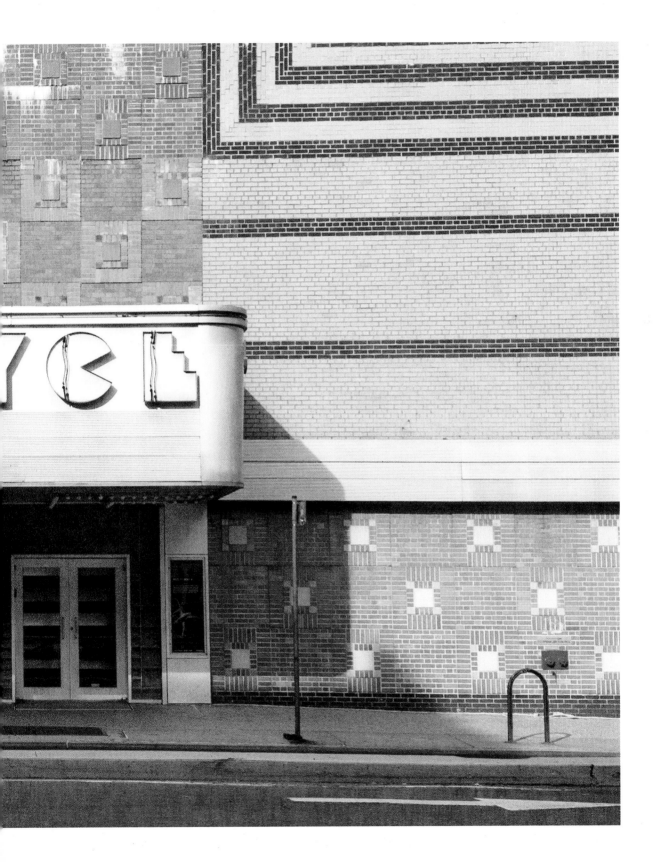

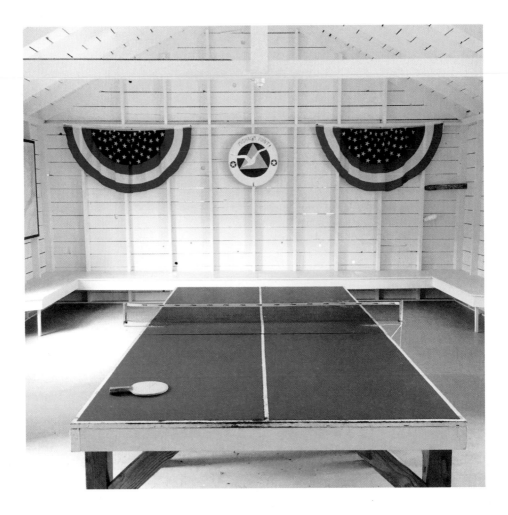

MISHAUM POINT YACHT CLUB

Dartmouth, Massachusetts | c. 1968

Photo by Shannon O'Halloran Keating

Mishaum Point is a private peninsula elbowing into the Atlantic on Buzzards Bay, Cape Cod. Once a salt-works site, Mishaum is more rural than neighboring areas of the Cape. It entices regular travelers who appreciate its tranquility a mere hour's drive from Boston. For summer visitors, this South Dartmouth destination hosts an active swimming pier, a boating dock, and this recreation area. All are encompassed within its signature Mishaum Point Yacht Club which, due to its seclusion, sandbars, and well-protected harbor, has yet to welcome any yachts.

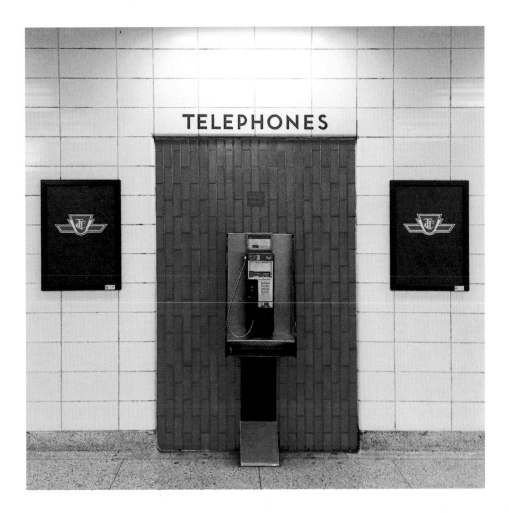

SUBWAY PAY PHONE
Toronto, Ontario | c. 1954

Photo by Cailen Speers

The Toronto subway has a typeface all its own: a graphically unique rectangular sans serif, exclusively upper case. It is primarily found in older subway stations in Toronto, which feature a washroom-tile aesthetic.

The original font, though revered, is anonymous—it has neither a known creator nor an official name. The Toronto Transit Commission (TTC) refers to this orphan as "Station Font." (The name has not yet taken root with avid transit or typography fans.)

In the late 1990s, as newer stations began adopting easily identifiable typefaces such as Helvetica, artist David Vereschagin became determined to recreate the TTC's birth font, "to rescue the Toronto subway typeface...to ensure its continued existence." He visited stations, took photographs, and made rubbings of the letters, and issued a new "Toronto Subway" typeface that served as an extremely close reproduction of the original. It's so close, in fact, that the TTC adopted and now uses it widely throughout their stations—and above any remaining public phones that exist.

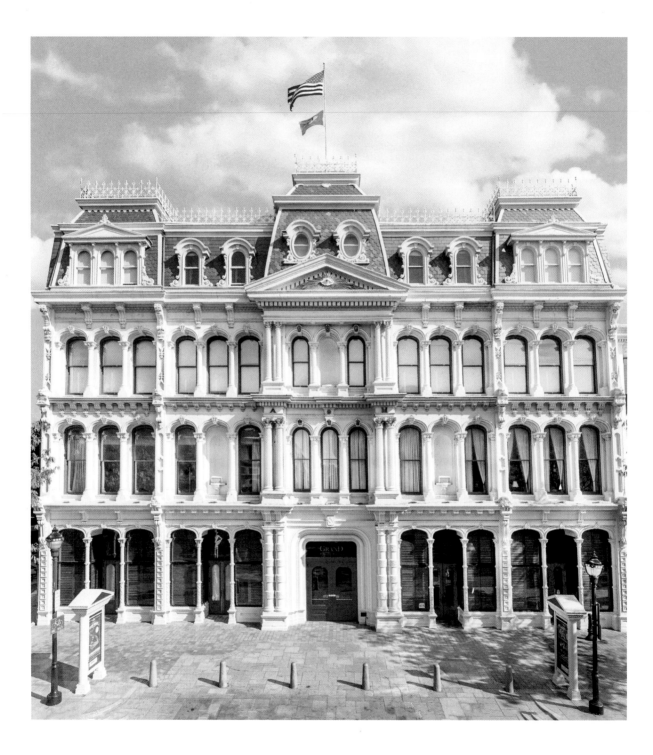

GRAND OPERA HOUSE

Wilmington, Delaware | c. 1871

Photo (left) by Evan Lober, photo (above) by Luke Koval

For almost 150 years, the Grand Opera House has stood as a landmark and a source of both nightlife and pride for the people of Wilmington, Delaware. It was originally a temple for the Grand Lodge of the Masons—hence the Masons' imagery that still adorn its exterior, and the Eye of Providence at its center. The entire facade is created from cast iron that was painted white, to imitate marble, while the architecture references the numbers 3, 5, and 7, all significant in Masonic symbolism. (For example, there are five sections to the facade, each with three arches and three keystones.) Though ownership has changed hands, the Masons still have offices in the building.

As a performing arts center, The Grand has hosted thousands of entertainers, from vaudeville shows to world-class symphonies. In the early twentieth century it became a movie theater, but as the decades wore on and competing venues started eclipsing it in sales, it was forced to close in 1967.

Prominent citizens of Wilmington wouldn't have it. "To destroy it would be a crime, to restore it would be a triumph," trumpeted one news anchor. Just before Christmas 1971, for its hundredth anniversary, the Grand Opera House reopened its doors. Excited citizens flooded in and plans for its renovation were unveiled. The Grand was rededicated two years later, in what prominent Delaware historian Carol Hoffecker described as "the most spectacularly successful preservation effort in Wilmington's history."

Many among the Grand's staff would argue that efforts to protect the venue were a collaboration between determined citizens and a few otherworldly inhabitants; its executive director even wrote an article describing the phenomena for *Out and About* of Greater Wilmington. According to the accounts of several people who have \rightarrow

→ worked the graveyard shift, late-night work is often accompanied by murmurs and the clinking of glasses, or the general sense of being in the presence of inexplicable, intangible company.

The head custodian has caught sight of ghostly phenomena such as buckets and mops changing rooms, shaky lights, and chairs repositioned, all without explanation. His most frightening encounter occurred when he was attempting to unscrew a burned-out ceiling bulb. After several tries, he insists that he watched as "the bulb unscrewed itself and floated...slowly...almost to the ground. Then, it dropped the last few inches and shattered." He continues to sense unexplained movements or mysterious sounds. "I have learned to announce myself to the building. I say who I am and what I am doing, and then they're fine," he says.

The master electrician corroborates, adding that these otherworldly lingerers have been perceived by people other than staff at The Grand. Roadies "have asked me who the woman in the balcony is," she says. "They see her just sitting there in period garb. I say good night to her every night as I leave, because if I don't, something usually goes wrong the next day. I think of her as the spirit of The Grand itself."

Finally, there are rumors of "Tom," seen slumped in a specific chair in a lobby outside the Masonic offices. The electrician has been told that he was a former Mason secretary who used to leave the office every night and sit right there, often taking a snooze. "He doesn't like people being in the lobby, but I acknowledge him now, and he's much nicer."

The custodian appreciates the loyalty and protection that these souls offer. "A lot of them care about The Grand," he says, "just like we do. They monitor the building, and if you have the wrong attitude, they'll let you know."

STONY ISLAND ARTS BANK
Chicago, Illinois | c. 1923
Photo by Rebuild Foundation

The Stony Island Trust and Savings Bank building opened its doors in Chicago in 1923. Designed in the Classical Revival style, the bank was owned and frequented by members of the community, becoming a symbol of the area's prosperity. That is, until the Great Depression struck. By 1931, the bank was forced to close, and the building fell into neglect.

In 2012, artist and developer Theaster Gates Jr. bought the building from the city for a dollar, with a plan to turn it into an arts center. The basement was waterlogged, there was a hole in the roof, plaster fell from the walls, and the windows shared a cracked spiderweb design. To finance a multimillion-dollar renovation, Gates came up with ingenious fundraising methods, such as carving salvaged marble into rectangular "bank bonds," which he sold at Art Basel.

Since its restoration and reopening in 2015, the former bank has become home to collections of local relevance, including over 15,000 books belonging to John H. Johnson, Chicago publisher of *Ebony* and *Jet* magazines; 60,000 glass lantern slides depicting art and architectural history from the University of Chicago; and the vinyl record collection of "Godfather of House Music" Frankie Knuckles, who lived and DJ'ed in the city throughout the late 1970s.

RITTENHOUSE SQUARE

Philadelphia, Pennsylvania | c. 1683

Photo (above left) by Pavel Vekshin,
photo (above right) by Mahdiyeh Khodaparastan

The founder of the city of Philadelphia, William Penn, designed five original public squares. Of the five, Rittenhouse Square has changed the least since then, retaining the openness and integrity Penn originally intended. In 1913 its design took on the character of the Luxembourg Gardens or any number of Parisian parks when the French architect Paul Philippe Cret added fountains, flowers, and other elements, softening Penn's Quaker sensibility.

Originally called Southwest Square, it was later named after David Rittenhouse, an exceptional man whose mind appreciated both vast mysteries and intricate detail: he served as the president of the American Philosophical Society and as the nation's first director of the United States Mint. And in his spare time, he was an astronomer and a clockmaker.

SALEM TOWNE HOUSE
Sturbridge, Massachusetts | c. 1796
Photo by Deb Cohen

Old Sturbridge Village is a re-creation of a typical early nineteenth-century rural New England town, complete with a 200-acre historic working farm. Originally intended to showcase the impressive antique collection of eyeglass manufacturer and closet tool collector Albert Wells, this immersive living museum has grown to include the neoclassical Salem Towne House—built in Charlton, Massachusetts, but transplanted here in 1952. In the early

1800s the house was inhabited by businessman and farmer Salem Towne Jr. (two of whose ancestors were accused of witchcraft and executed in Salem in 1692), his wife, Sally Towne, and their seven children.

The Village remains popular among student groups, who visit the blacksmith's workshop, make bread from scratch, and ride a horse and carriage to tour the stately grounds, alongside a guide in full colonial-era dress.

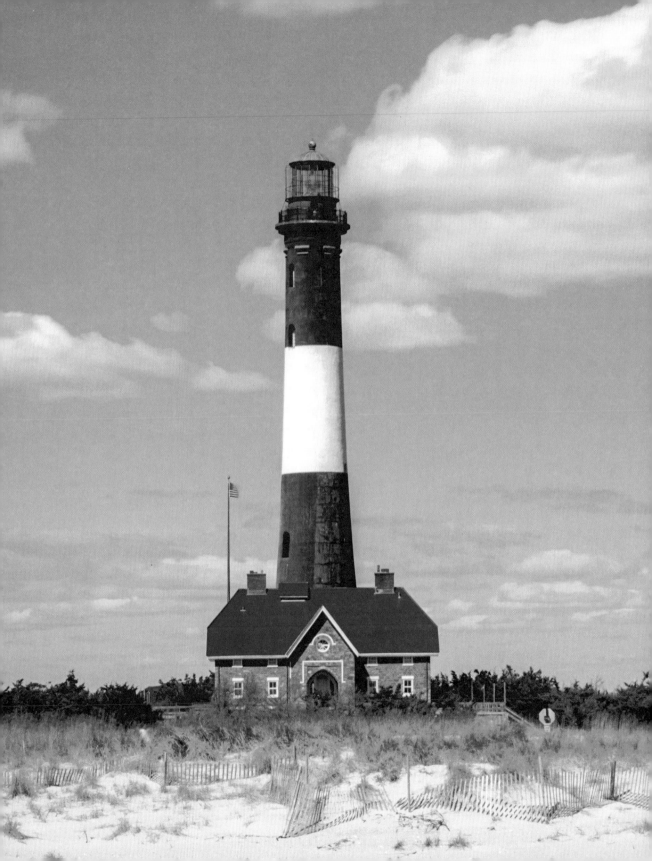

FIRE ISLAND LIGHTHOUSE

Fire Island, New York | c. 1858

Photo by Jimmy Hayden

The Fire Island Lighthouse was deemed "the most important light for transatlantic steamers bound for New York" by the 1894 Annual Report of the Lighthouse Board. For decades it served as seafarers' first evidence of land on the western end of New York after the long journey across the Atlantic. Except for one twelve-year closure, the 168-foot tower has been operating since 1858.

Constructed as a replacement light, the red-brick tower was originally painted "an agreeable cream yellow color," until it was repainted with its distinctive black and white bands—known as day-marks—just before the turn of the twentieth century.

To ensure it was more effective than its predecessor, a first order Fresnel lens (the largest and most powerful such lens), was in place from 1858 to 1933, emitting a white flash at one-minute intervals. The lens was kept illuminated by the tower's Funk hydraulic lamp with five wicks burning whale, lard, and mineral oil, as well as kerosene before electricity ultimately provided the lighthouse's illumination.

The US Coast Guard decommissioned the lighthouse in 1974. Seven years later, the decaying tower was declared unsafe, unworthy of repair, and was scheduled to be torn down. However, private citizens banded together to form the Fire Island Lighthouse Preservation Society. They raised more than $1.3 million for the restoration of the beloved landmark, and on Memorial Day of 1986, the Coast Guard held an extravagant relighting ceremony, heralding the coming summer and the signal's triumphant return.

In 1996 the society took over the lighthouse operations. The beacon—now lit by 1,000-watt bulbs that rotate counterclockwise, giving the appearance of a flash every 7.5 seconds—is visible twenty-four miles from shore. Volunteers maintain and continually improve their striped tower, ensuring that it remains an active aid to navigation, a central feature of the island's nautical heritage, and a testament to a community driven to reignite their brightest monument.

Big Cottonwood Canyon, Utah | c. 1942

Photo by Chelsea Krant

The road that leads from Big Cottonwood Canyon, Utah, to Little Cottonwood Canyon sees snow from September to June, making for some hazardous driving conditions. However, hop in a snowcat, and enjoy the ride through thick pine forests until eventually hitting a dead-end at an enormous underground vault shrouded in secrecy.

Tunneled two football fields deep into the canyon is a facility operated by the Church of Jesus Christ of Latter-day Saints: the Granite Mountain Records Vault. Alternative theories abound as to precisely what is stored here, but the church says that it houses information on the genealogical and family history of its members. The vault's library contains over 2.4 million rolls of microfilm, equal to about three billion pages of records. Perhaps even more curiously, the volume of rolls increases by as many as 40,000 rolls annually.

Why such information should be kept in a highly secure vault in the side of a mountain is anyone's guess. Perhaps it is best not to be too curious. Should you visit and need to get away quickly, know that you'll be cursing the snowcat as it tops out at a mere 25 miles per hour.

PIERHEAD LIGHT
Milwaukee, Wisconsin | c. 1872
Photo by Justin Hernandez

Milwaukee sits along a natural indentation on the western shore of Lake Michigan, where the Milwaukee, Menomonee, and Kinnickinnic Rivers merge. In 1848, a "bug light," or fire safety lamp, was placed on the pier at Milwaukee as a navigational marker.

After complaints about insufficient light, construction of this stout red lighthouse began in 1872. The tower was connected to the keeper's dwelling by an elevated walkway until the final weeks of 1905, when a windstorm whipped up Lake Michigan, struck the house with full force, and nearly carried the entire structure down the lashing river.

Nobody was hurt—as the keeper held fast to a lifesaving beam—but the community needed to come up with another system. While the resilient lighthouse remained, they had to build a tunnel to access it from the new abode that was built.

Today, Pierhead Light remains active, signaling the mouth of the river to traveling ships. This lone beacon has been automated and now operates by solar power.

GRAMERCY TYPEWRITER COMPANY

\longleftarrow

New York, New York | c. 1932

Photo by AccidentallyWesAnderson

POST OFFICE

\longrightarrow

Wrangell, Alaska | c. 1869

Photo by Robin Petravic & Catherine Bailey

Founded by Abraham Schweitzer in the darkest days of the Great Depression, the family-owned and -operated Gramercy Typewriter Company offers a safe space for Luddites averse to the computers dominating our hyperconnected, delete-happy era. You needn't worry about how much personal data is being extracted when you type on an old Smith Corona or a classic Royal De Luxe.

Abraham's son Paul followed him in the family business and has been working in the store six days a week since 1959. With sixty years of experience behind him, he has developed a great skill for matching the right machine with the right buyer—a fact confirmed by frequent customer Tom Hanks, an ardent typewriter collector and enthusiast. Gramercy Typewriter supplied twenty-five machines for the 2017 film *The Post*, in which Hanks starred. After filming wrapped, director Steven Spielberg gave the machines to the cast as gifts, each with a typewritten note.

Though they're indisputably keepers from a bygone time, the future looks bright for Gramercy Typewriter Company, thanks to a resurgence of interest as a new generation falls in love with the deep satisfaction and permanence of a typewriter's clicks, clacks, and dings.

Located on the northern tip of an island in the Alaska panhandle, Wrangell is home to 3,000 people who love visiting their well-decorated post office—a necessity in an area with no home delivery of the mail.

Although Alaska was a US territory at the time (not yet a full-fledged state), this current post office was constructed as part of President Roosevelt's New Deal public works projects. As these buildings were uniformly sober in design, several post offices built in the 1930s were decorated with images of the "American scene."

A nonprofit known as the Alaskan Art Project sought to soften the austerity of the building's architecture by commissioning a bohemian couple to bedeck its walls with their own vision of an American scene.

Artists Austin Mecklem ("Meck") and his wife, Marianne Greer Appel (later a puppeteer and Muppets designer), painted this vivid and impressive mural while living at an artists' colony in Woodstock, New York. *Old Town in Alaska* depicts the town's harbor and the horizon of the wild Alaskan coast. After completion, in the fall of 1943, the mural was sent on a 3,500-mile journey via railway and was installed two months later.

The people of Wrangell clearly appreciate the intricate painting and the experience of visiting the postmaster. The community was offered standard mail delivery service, but the proposal was overwhelmingly defeated, as the vast majority of Wrangell's citizens prefer the social ritual of going to the post office.

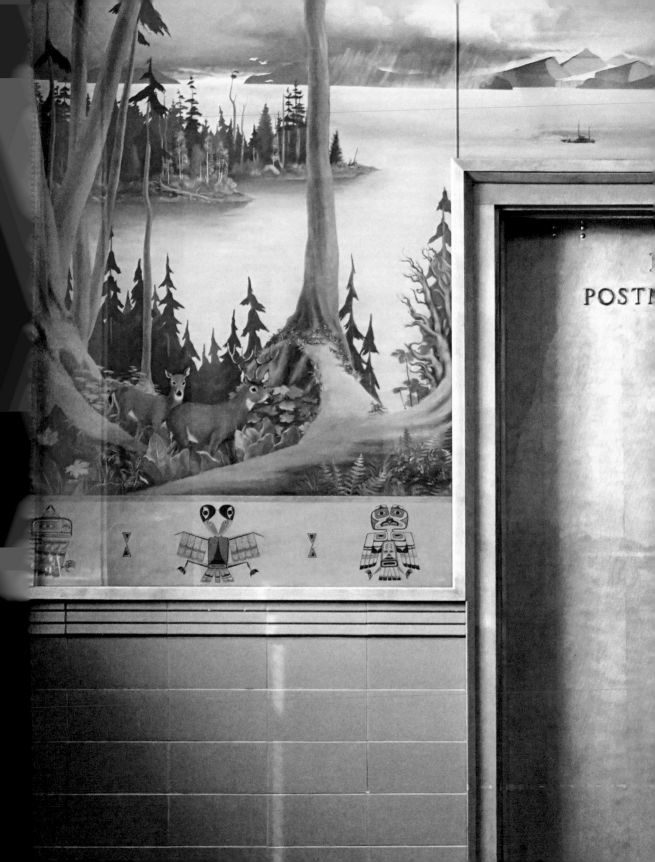

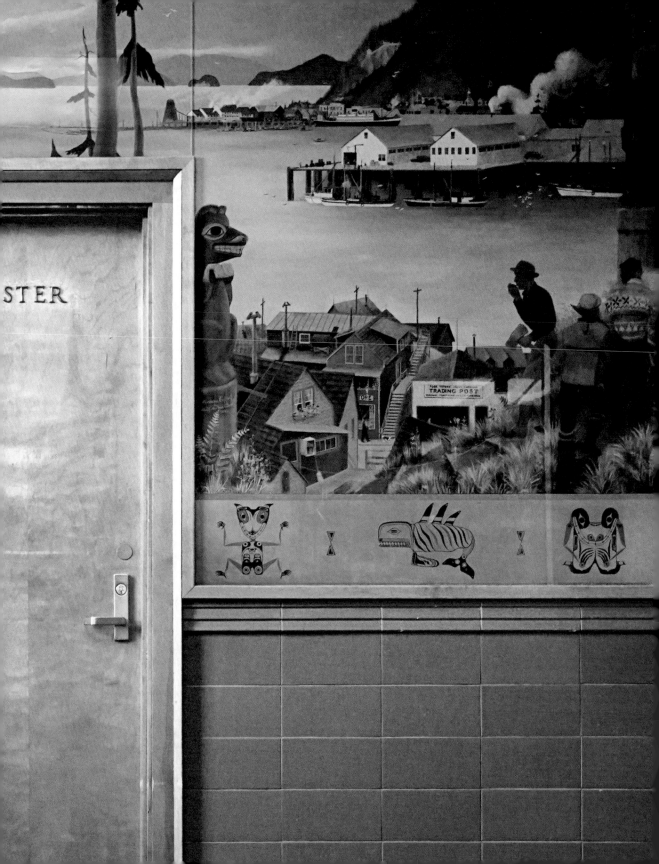

LATIN
AMERICA

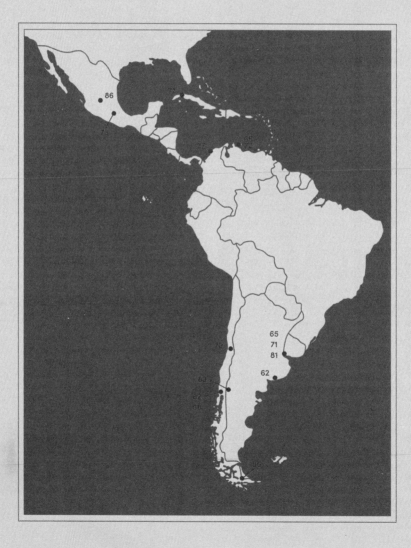

CLAROMECÓ LIGHTHOUSE

Buenos Aires, Argentina | c. 1922

Photo by Marco Catullo

The lighthouses of Argentina's lengthy coastline need to be exceptionally tall due to its dense sandbank and the threatening shoals offshore. Claromecó Lighthouse reaches into the sky at a height of 177 feet, making it the second tallest in all of South America. It was once possible to climb the 278 steps along its spiral staircase to reach the top, but safety precautions now preclude the public from doing so.

However, it is not merely the height that makes this striped warning tower unique. At its base are the skeletal remains of a whale that washed ashore in 1991. Out of respect for the majesty of the mammal, its skeleton was reassembled and placed at the foundation of the lighthouse.

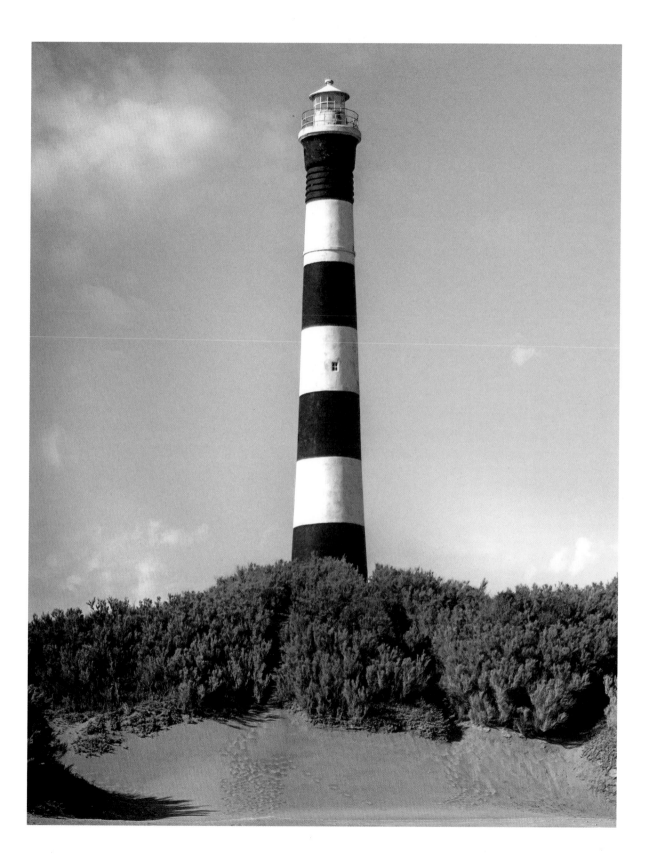

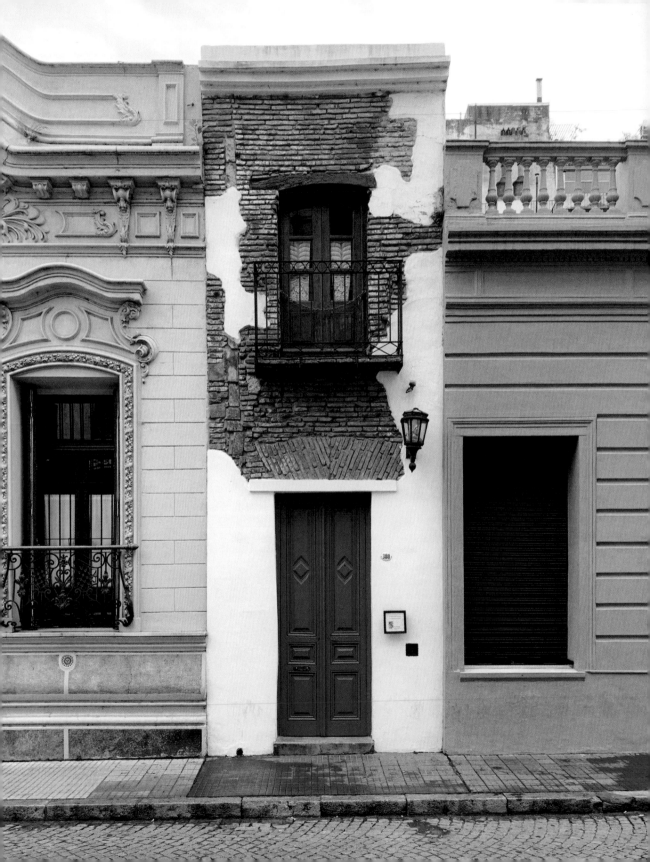

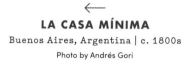

LA CASA MÍNIMA
Buenos Aires, Argentina | c. 1800s
Photo by Andrés Gori

SKYLINE
Willemstad, Curaçao | c. 1634
Photo by Jeffrey Czum

La Casa Mínima, at 380 Pasaje San Lorenzo, is the most narrow house in the Argentine capital. Measuring just over eight feet wide, its depth goes back forty feet, suggesting room to live, if snugly, despite its remarkably narrow entrance.

For decades, legend circulated that the house was given to a freed slave, but archaeologists dispelled that myth. Historical studies suggest that La Casa Mínima was once a single home measuring over five times its current width but was gradually divvied up. Poor planning left this magnificent runt of a home.

You can visit a small museum around the corner from the house, which offers four guided tours per week. Though worth the visit, it's safe to assume it will not be a prolonged one.

Curaçao is an island off the coast of Venezuela, with an estimated population just shy of 150,000. Although it is located in the southern Caribbean Sea, the island is actually a "constituent country" of the Kingdom of the Netherlands.

In the seventeenth century, the Dutch ruled the island and were very fond of colorful buildings—hence the vivid lineup that greets you at the harbor in Willemstad, the capital. It is meant to mirror the architecture of Amsterdam.

In addition to these brightly colored buildings, Curaçao is also home to an incredible blend of cultures and a complex, layered history. For nearly 350 years, the slave trade existed in Curaçao, until the Dutch abolished it in 1863. In addition, it had been under the rule of several nations through its past, and as a result, multiple languages are spoken. For some Curaçaoans, knowing four languages—Papiamentu, Dutch, Spanish, and English—is just a way of life.

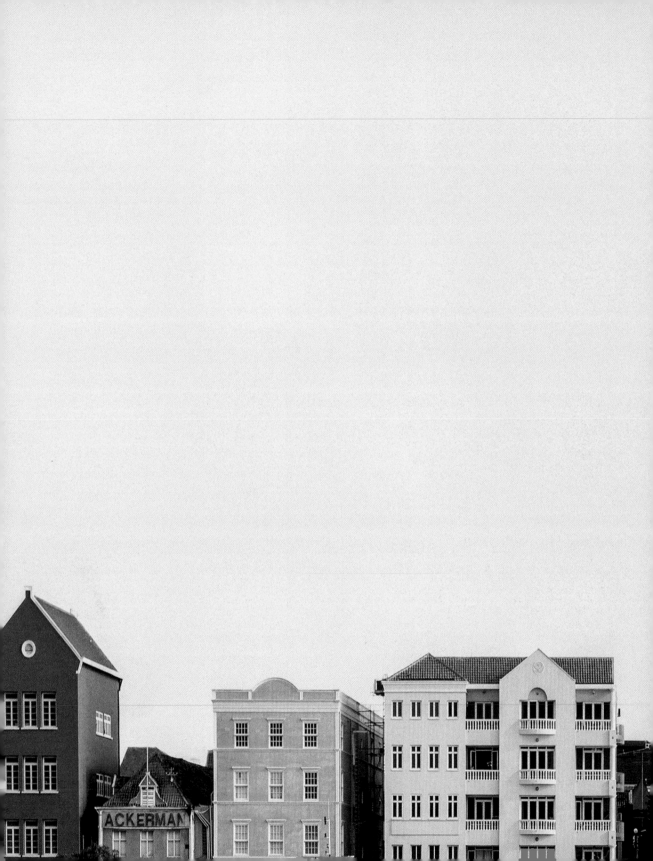

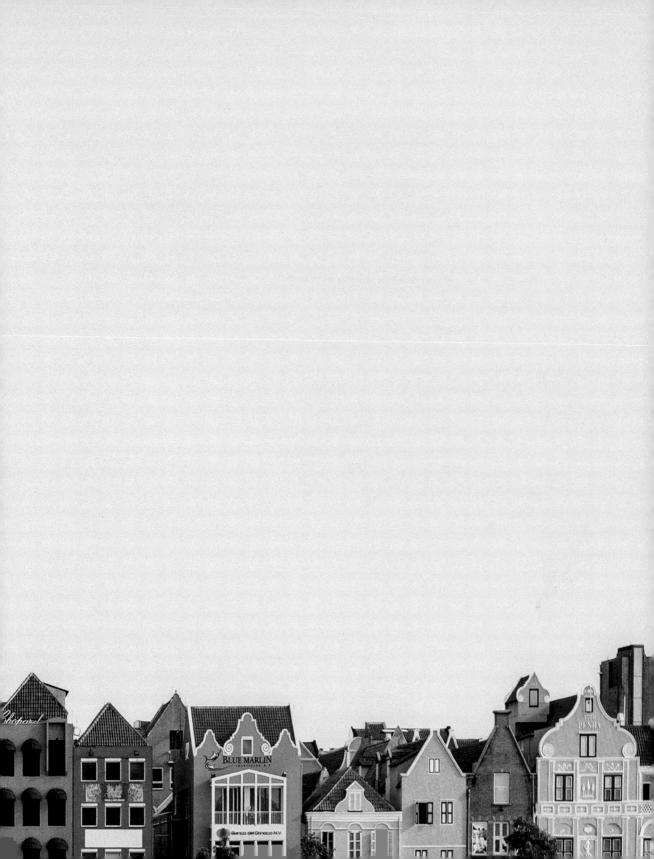

LAKE LLANQUIHUE PIER

Frutillar, Chile | c. 2008

Photo by Jaime Kunstmann

The best place to take in the shimmering waters of Chile's Lake Llanquihue and the snow-covered peak of Osorno Volcano is at the end of Muelle Frutillar, or Frutillar Pier. Tourists venture to this idyllic city for the stunning views, the boating, and the cool, dry mountain air. They also come to this sweet spot in Chile for German bratwurst and beer.

Some 12,500 miles from Deutschland, in a country whose official language is Spanish, Frutillar (pronounced "Frutijar") confusingly has German-language road signs, and its charming half-timbered houses more closely resemble a hamlet in the Alps than a village in the Andes. Since the 1800s, a thriving German population has grown around the Lake District in Llanquihue—the result of immigration policies that targeted, enticed, and welcomed them here.

In the mid-nineteenth century, it was believed that Germans would bring cultural sophistication to the region. A small group of Chilean locals also were hopeful that the Europeans would bring modern farming methods that would expedite the development of their lake district. But how to convince them to make such an epic journey?

German expatriate Bernardo Philippi was tasked by the government with attracting people from his homeland to resettle in southern Chile. Looking out over the lake, Philippi observed how similar the landscape was to that of the Alps (albeit with palm trees and volcanoes), and wrote home with picturesque descriptions of the distant land: "The water of this lake is as clear as that of Geneva in Switzerland...It has the snowy Alps: the Andes Mountains..." These letters, combined with promises of cheap land provided by the Chilean government, convinced more than 6,000 German immigrants to emigrate and settle around Lake Llanquihue.

It seemed that Chile's immigration policy aimed at populating its southern territories had been a success. However, the lake district had already been populated for centuries by the indigenous Mapuche people. Much of what was offered to the Europeans rightfully belonged to them, and inevitably, conflict ensued. In short order, the Mapuche declared war against the colonizers, but the uprising was extinguished.

Within a century, and as a silver lining to this all-too-familiar tale of land-snatching, a great number of German Jews fled to Chile before and during the Holocaust and successfully sought refuge, ultimately helping to cultivate greater prosperity in the region.

Frutillar continues to proudly promote its German heritage, with bakeries, breweries, schools, and churches. The distinctive Muelle Frutillar was built in 2008, in the style of the German docks that were built along the shores of Lake Llanquihue by its first European settlers. Should you find yourself standing on the pier, looking out at the stunning lake, or wandering through the town, marveling at the unusual Chilean German cultural mix, take comfort in your security. At all times, the city is watched over by all-knowing—and hopefully inactive—volcanoes.

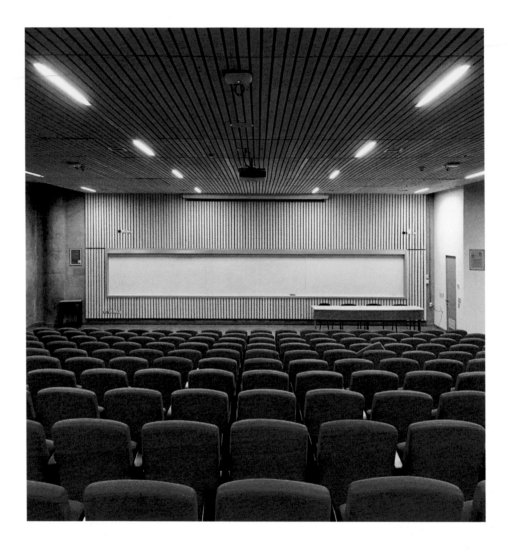

PONTIFICAL CATHOLIC UNIVERSITY OF CHILE

Santiago, Chile | c. 1888

Photo by Laura Sandoval

The Pontifical Catholic University of Chile (UC) is one of six Catholic universities in the Chilean higher education system. Among Chile's oldest universities, it was founded in 1888 by the archbishop of Santiago to offer training exclusively in law, math, and the physical sciences.

It has since blossomed and expanded across all disciplines, in large part due to the vision of Monsignor Carlos Casanueva, who in 1920 initiated coed admission. In his view, UC was to serve as a "beacon of truth," one which had the duty to enlighten. Truth, enlightenment, and fulfilling the nation's needs began by his opening the door to women.

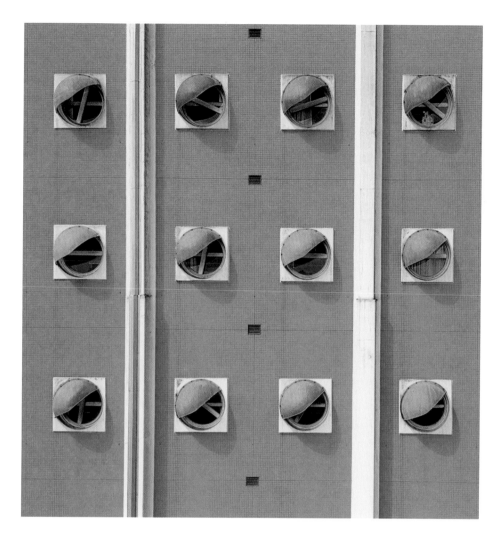

HOSPITAL NAVAL
Buenos Aires, Argentina | c. 1981
Photo by Matías De Caro

The facade of the Hospital Naval takes the building's name literally, with features suggesting an immense ship. Its most notable maritime feature is the inimitable window treatment, inspired by portholes, most of which face neighboring Centennial Park.

The building is also considered one of the city's prime examples of Brutalist architecture, a style that emerged in the wake of the 1950s modernist movement. The name derives from *béton brut* (raw concrete) and is characterized by massive, blocky framing and a rigid geometry.

Hospital Naval is a monumental, unyielding trapezoid, but its concrete is coated with a mosaic of light blue tiles, again evoking the ocean—and ideally providing a welcome, familiar sight for its seafaring patients.

LIGHTHOUSE

Klein Curaçao, Curaçao | c. 1850

Photo by Jeffrey Czum

After sailing two and a half hours southeast from the old Dutch outpost of Curaçao, you'll encounter this coral pink lighthouse on the uninhabited island of Klein Curaçao (Little Curaçao). Sail closer over the bright Caribbean waters, and an eerie scene will unfold before you. Multiple shipwrecks become apparent, and the desert that is Klein Curaçao comes into full view. The small island, just over half a square mile, reveals ruins of stone buildings as well as a sizable burial ground.

Klein Curaçao was once a verdant home to tropical birds, turtles, and monk seals. However, in the eighteenth century, the Dutch West India Company wreaked havoc on it by using it as a layover quarantine station for enslaved people who had taken ill during the unforgiving journey across the Atlantic. Those who did not survive were buried on the island.

Meanwhile, the English and Dutch mined the island for phosphate until it was completely depleted of the essential mineral. Monk seals were hunted, while herds of goats quickly decimated any remaining vegetation. When the Dutch finally abandoned their outpost, desertification ensued, and Klein Curaçao became the barren ghost isle it is today. The only structures remaining are a bleached blank cross marking the graveyard, and Klein Curaçao's faded pink lighthouse structure. After decades of disuse, it was reequipped with operational lights and still serves as a beautiful marker of the desolate island.

Efforts are being made to reforest Klein Curaçao. Monk seals and sea turtle populations are rising, and tourism is helping draw more attention to the land. The lighthouse is currently under renovation and the beacon will soon be freshly painted to welcome those who sail to Klein Curaçao seeking its tropical, albeit haunting, atmosphere.

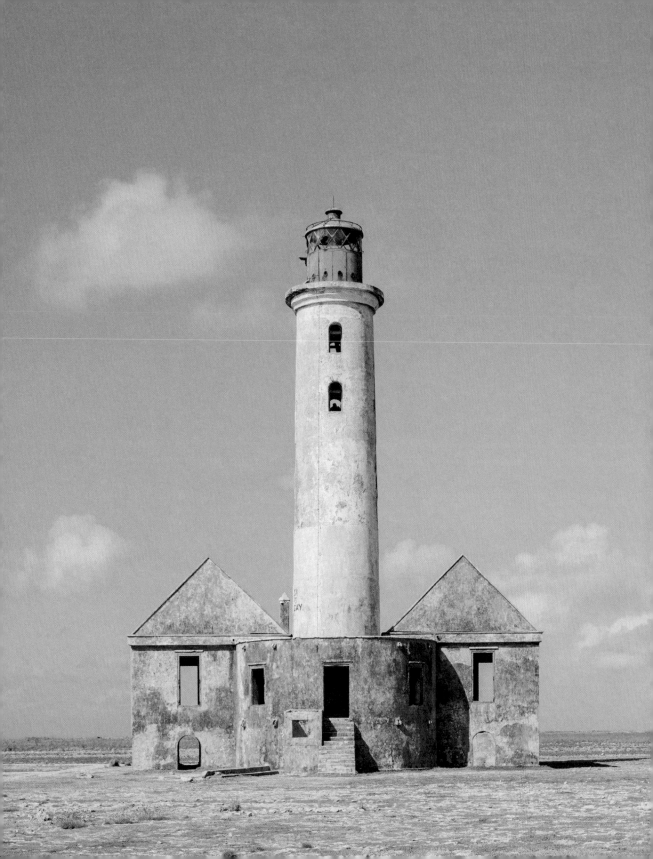

CUAUTLA CHURCH

Morelos, Mexico | c. 1950s

Photo by Conrado Vidal

Cuautla, or "where the eagles roam," is a city about sixty-five miles south of Mexico City, noted for its role in the Mexican Revolution (1910–20). Over a decade before the start of the revolution, newly orphaned and still in his teens, the revolutionary Emiliano Zapata took part in a protest among the peasants of his hometown against the owners of the hacienda (plantation) who had taken over their land. At the age of thirty-two, he was inspired by Francisco Madero's call to revolt against President Porfirio Díaz and the country's unbalanced system. Zapata quickly became the leader of the peasant uprising in the state of Morelos.

He arrived at Cuautla in March of 1911, surrounding the city with several thousand troops and launching the weeklong Battle of Cuautla. The battle forced a pivot in the Mexican Revolution, causing President Díaz to sign the Treaty of Ciudad Juárez. Shortly after, he resigned.

Three presidents and eight years later, leaving a legacy of resistance, Zapata was assassinated in Chinameca, his body ultimately returned to Cuautla for a hero's burial.

Where there has been war, there will be churches—where so many turn for explanations, for healing, and for community. Cuautla underscores this reality, with its twenty-two registered Catholic churches. Among them is the stunning Parroquia de la Medalla Milagrosa, a Roman Catholic sanctuary where masses are celebrated daily in the neighborhood of "Emiliano Zapata."

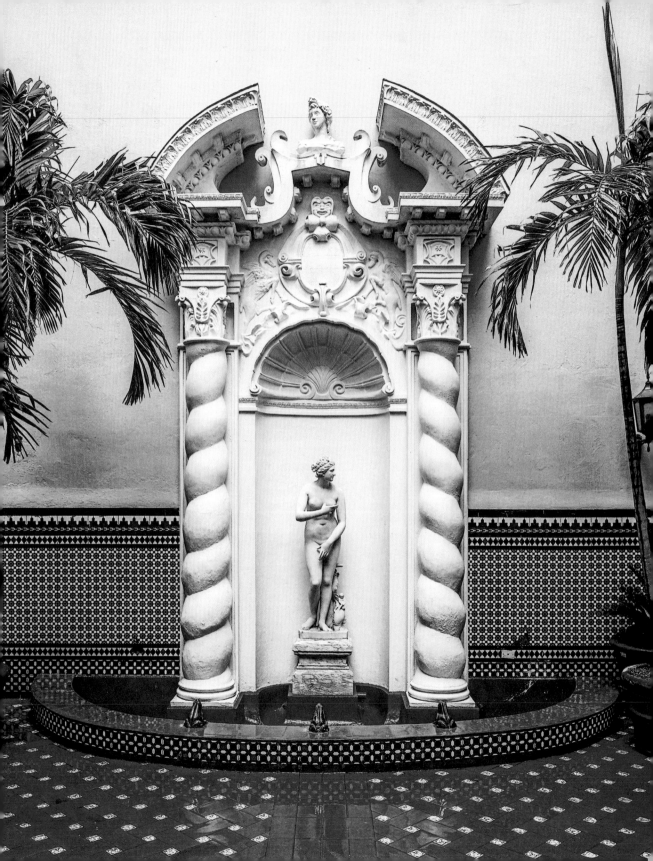

HOTEL SEVILLA

Havana, Cuba | c. 1908

Photo by Kenny Gunawan

UNIVERSIDAD DE LOS ANDES

Cartagena, Colombia | c. 2018

Photo by Nicholas Huggins

The historic Hotel Sevilla in Havana, Cuba, is a four-story Moorish Revival structure located at 55 Calle Trocadero. It opened on March 22, 1908, as Havana's top luxury hotel. Later, it would be purchased by New York hoteliers and renamed the Sevilla Biltmore.

The original architects drew inspiration from the Court of the Lions in the Alhambra Palace in Granada, Spain—whose entrance incorporates open-air marble columns and mosaic tiles. That style is reflected in the vibrant glazed tiles decorating the hotel's lobby.

In 1939, the hotel was owned and run by the Havana Mafia, its principal owner the Italian Uruguayan Amleto Battisti, mobster kingpin of La Bolita, the city's lottery racket, the racecourse, and the Casino Nacional. Over the next two decades, partial ownership of the casino was assumed by one of the most powerful mobsters in America, Santo Trafficante Jr., who was happy to offer Al Capone a complimentary stay at the hotel.

However, the Sevilla Biltmore's days of shady extravagance came to a halt in 1959 on New Year's Day, when Fidel Castro's rebel army descended on Havana, forcing then-president Fulgencio Batista to flee the country for the Dominican Republic. Mobs destroyed much of the city—including the hotel and its famed casino, forcing Amletto Battisti to flee, taking refuge in the Uruguayan embassy.

Today, the hotel remains a landmark of Old Havana's social and cultural scene. From the revived rooftop restaurant—its former grand ballroom—the city sparkles before you, as a rum cocktail sparks the illusion of sharing the rhythm of dancers who once graced the floor beneath you.

Opened in May 2018, the Caribbean Campus of La Universidad de los Andes is an adjunct to the university's seventy-year-old Bogotá campus and was inspired by Cartagena's Old City—founded by the Spanish in 1533.

The Moorish-style buildings in the Old City feature central courtyards shaded by banyan trees and pools with fountains to help naturally reduce temperatures in the surrounding residences. For the university campus, architect Brandon Haw created twin buildings overhung with concrete fins to help protect classrooms from the Caribbean sun and central pools of water to promote a natural cooling effect.

The campus also features an innovation not available to the Spanish colonialists of 1533: air-conditioning.

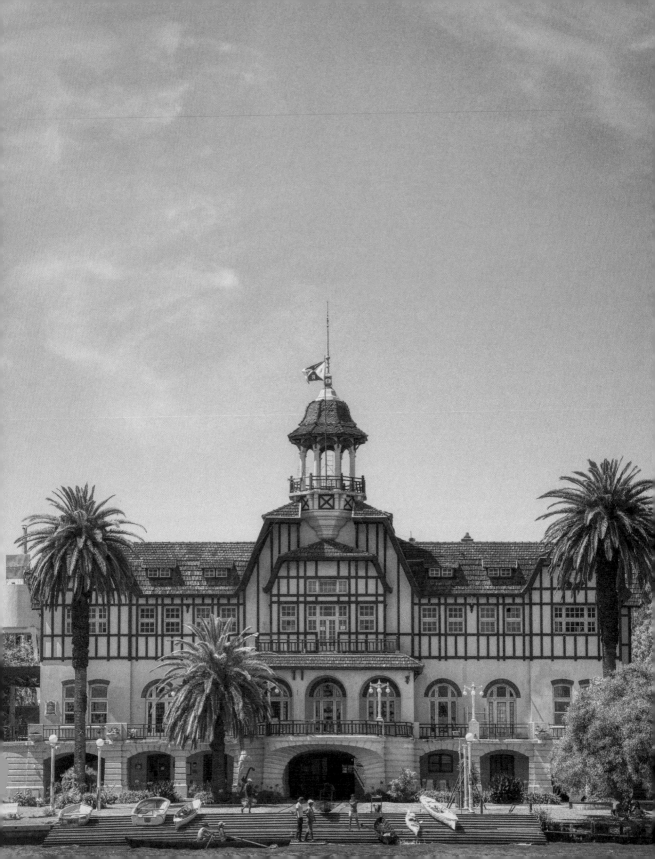

CLUB DE REGATAS LA MARINA

Tigre, Argentina | c. 1876

Photo by Alejandro Cornejo

The 1865 arrival of the railway connected Buenos Aires to the nearby town of Tigre, a gateway to the 3,000-mile Paraná river delta. Situated on the Rio Tigre, the town is an ideal place for water sports, especially rowing—which arrived with British settlers on the first horse-drawn trains to Tigre.

The Buenos Aires Rowing Club and the Club de Regatas La Marina were two of the first clubs dedicated to the sport. In December 1873, their inaugural regatta was attended by the president of Argentina, Domingo Sarmiento, who professed his excitement for this "new style of fun" that gave life to "the ancient aphorism 'Mens sana in copore sano' [a sound mind in a sound body]."

Sarmiento wasn't the only one excited. Supported by an international group of young enthusiasts, the sport continued to flourish, and in 1894, a young Frenchman named Enrique Goubat decided to take fuller advantage of the river. Goubat stoked interest among friends from Bella Vista (a district of Greater Buenos Aires), and within a year nearly thirty rowers met to sign the Minutes of the Bella Vista Race Club Foundation, marking the birth of the club. Goubat led their meeting with pride, wearing his well-pressed rower's uniform, including a signature cap.

He and his fellow founding members faced no shortage of obstacles as the club expanded: on August 15, 1911, by which time they could boast twenty-five boats and a grand piano for social gatherings, a fire destroyed their outpost. Only one boat was saved. Fires and floods continued to force the club to change headquarters until in 1927 when it found a permanent home in this neoclassical building designed by the Paris-born architect Eduardo Le Monnier.

Goubat devoted his life to the water. He built his boats, participated in countless races, and trained multiple rowers who went on to extraordinary success, both locally (winning more than 2,000 official regattas) and internationally (sending rowers to the Berlin Olympics in 1936 and Helsinki in 1952).

Today the club is an iconic athletic institution associated as much with its successful rugby and field hockey squads as its rowing program. But history and avid members recognize Goubat and his enthusiastic team as the true anchor and oars of this Tigre landmark.

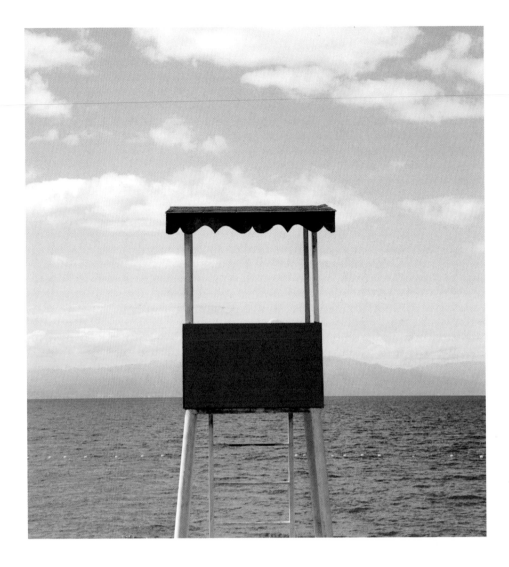

LIFEGUARD CHAIR ON LAKE LLANQUIHUE
Frutillar, Chile | c. 1856
Photo by Jaime Kunstmann

Frutillar, on the banks of Lake Llanquihue, the largest lake entirely within Chile, is home to a mere 15,000 residents yet holds the honor of being recognized, in 2017, as Chile's first UNESCO Creative City of Music. The lakeside town boasts a performing arts center so phenomenal that it has placed Frutillar on the world's cultural map and—evidently—inspired their lifeguards to abandon their posts and go catch a concerto.

MODESTA VICTORIA
Bariloche, Argentina | c. 1937
Photo by Cyntia Nobs

For more than eighty years, the *Modesta Victoria* has navigated the waters of Lago Nahuel Huapi, at the foothills of the Andes in Argentinian Patagonia. The ship has a capacity for 300 passengers and has carried princes and presidents: the Obama family even enjoyed a journey on it during their visit to Argentina in 2016.

Passengers often take note of its stylized air vent, formally known as a Dorade box. These not only add an extra bit of character to any vessel but also permit the steady flow of air through the cabins and engine rooms while simultaneously keeping out rain and sea spray.

Named for the first yacht that used them—*The Dorade*—today, these marine ventilation systems can be designed to your requirements. After selecting your box, you choose among "stylish cowl vents"—which look like something between a gramophone and a curious prairie dog.

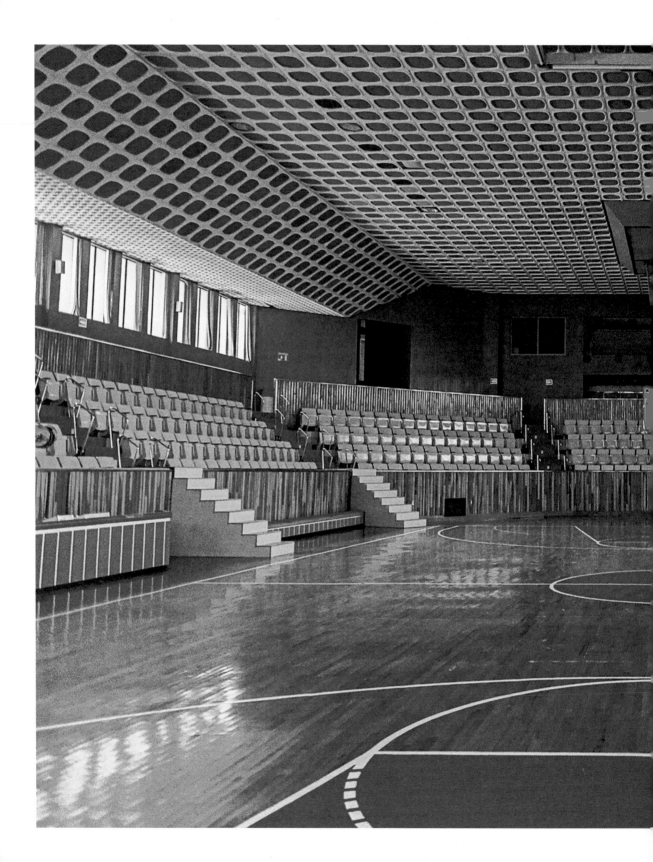

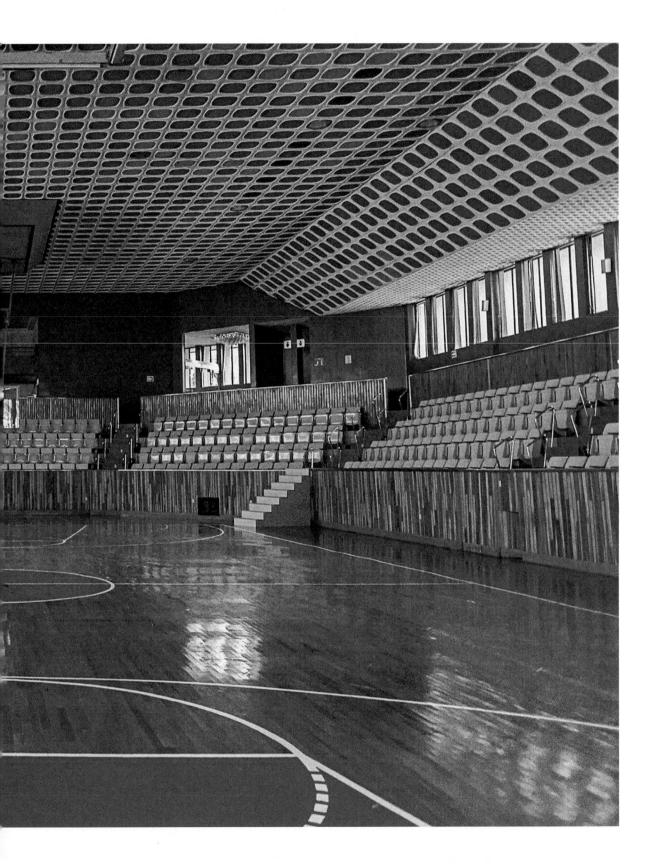

←

PARQUE J. M. ROMO GYMNASIUM

Aguascalientes, Mexico | c. 1980s

Photo by Jimmy De Alba

→

LES ÉCLAIREURS LIGHTHOUSE

Ushuaia, Argentina | c. 1920

Photo by Bianca Berti

Parque J. M. Romo was created by Jesús María "Chito" Romo (1918–1990), the founder of a thriving multinational manufacturer of everything from clothes hooks to supermarket check-out equipment. Born the fifth of ten children in Jalisco, Mexico, Chito began working after elementary school. At the age of twenty-one, he started the company, which began as a nickel-plating workshop, with just 3,000 pesos.

After decades of success, Chito's life was upended by the sudden death of his only son. Following this grave loss, Chito dedicated himself to the lives of his workers—offering them and their family members classes in cooking, weaving, embroidery, and cosmetology. He wanted to give them the opportunity to improve their household earnings by putting these skills to use.

He also built Parque J. M. Romo, or Romolandia, a seventeen-acre amusement park featuring games, rides, and sports facilities, including this stunning basketball court. Romo's 1,350 employees and their families were welcome to enjoy all facilities for free.

If you were determined to abandon all civilization, a good place to set sail from would be Ushuaia, Argentina, "The City at the End of the World." After pulling away from the southernmost city on earth, one of the last man-made structures you'd see would be Les Éclaireurs ("The Enlighteners") Lighthouse, sitting on a rocky inlet against the backdrop of the Martial mountain range. As the stripes of the still operational, remote-controlled, 100-year-old lighthouse fade into the distance, fur seals, cormorants, sea lions, and penguins would be the last creatures to bid you and other seafarers "adiós."

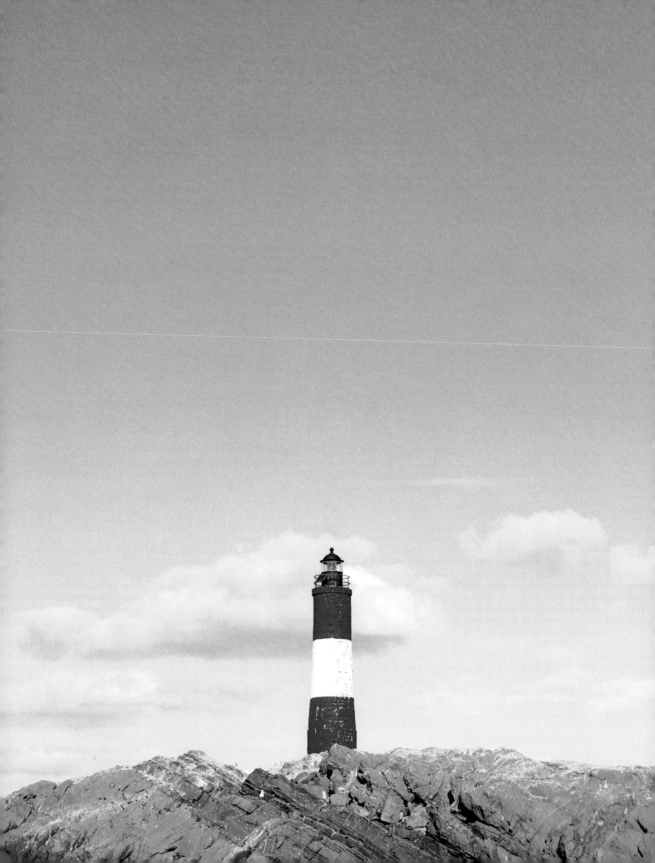

CENTRAL & WESTERN EUROPE

A hot-pink confection of Bohemian Neo-Renaissance style, the Hotel Opera stands in the less touristy Nové Město, or "New Town," quarter of storied Prague. It is a five-minute walk from historic Old Town—an apt reflection of Prague's nonlinear relationship to time. This romantic city is a unique meeting ground for old and new, historic and modern. Miraculously preserved buildings established in the fourteenth century are squeezed beside ultramodern constructions, like a Frank Gehry-designed glass building that resembles a dancing couple. And yet nothing feels out of place in this enchanted, haunted city—including the bright pink Hotel Opera...which is not particularly near the Opera.

Much closer is Wenceslas Square, the nerve center of some of the most significant shifts in modern European history. History emanates from this square, which locals and tourists still flock to for people watching, protests, and parties. Using the square and the Hotel Opera, one can trace some of the major pivot points of extreme change in this extraordinary capital city:

"He who is master of Bohemia is master of Europe," Bismarck said. Riding on this theory, the United States, France, Britain, and other allies helped create Czechoslovakia, carving it out of the losing side in World War I. In 1918, just months before the new democratic nation had its independence declared in Wenceslas Square, the Hotel Opera was purchased by Karel Češka, a man bolstered by optimistic ambitions of creating a lasting, family-run establishment.

During World War II, the Nazis invaded Czechoslovakia and remained there until the Russians drove them out of Prague in 1945. Soon after, without Karel's consent or compensation, the Hotel Opera was nationalized by the Communist regime and the building sat unused and ignored for decades of Prague's most dramatic transformations.

The Prague Spring reforms initiated by Alexander Dubček in 1968 proved to be an all-too-brief span of political liberalization. During this time, independent thought and expression were given room to blossom in politics, literature, and film, inspiring a burst of creativity from the likes of authors Václav Havel and Milan Kundera. This freedom was short-lived, lasting from January until August, when Soviet tanks rumbled onto Prague's cobblestone streets and through Wenceslas Square, as 250,000 Warsaw Pact troops ruthlessly invaded Czechoslovakia, putting a halt to its forward-thinking reforms and shutting down its span of artistic prosperity.

In 1989, twenty-one years after being invaded, hundreds of thousands of people held an escalating series of demonstrations in Wenceslas Square, leading to a nonviolent transfer of power known as the Velvet Revolution, engineered by dissidents but triggered by a student protest. Within a matter of weeks, the voices of the people of Prague successfully brought about the end of Communism and the Cold War in Czechoslovakia. Following such high levels of drama, this beautiful (albeit ultimately divided) nation had to redefine itself in the wake of decades of being held in a cage.

After the Iron Curtain collapsed, the Hotel Opera was returned to the Češka family. Decades of neglect had left it in such a state that it demanded years of extensive renovations, which were executed faithfully by Karel's descendants, fulfilling his dream of a family-run hotel, held over generations.

Today, it runs again, in all its pink glory. A day of seeing the sights and reckoning with the beauty and history boasted by this "city of a thousand spires" would exhaust even the most eager visitor. One could do far worse to close a day than by stopping by the bar at the Hotel Opera to sample a cold pint of world-famous Czech beer.

HUNGARIAN PARLIAMENT BUILDING
Budapest, Hungary | c. 1896
Photo by Eleonora Lattanzi

The Hungarian Parliament Building (or Országház, "House of the Country") is a global landmark, the most heavily visited tourist spot in Budapest, and the seat of Hungary's National Assembly.

In the late nineteenth century, Budapest was united when Buda, Óbuda, and Pest came together. In 1890 their legislative body, the Diet, established a Parliament Building to represent the city's enhanced dominion. A competition for its design was put forth, and was won by an unlikely contestant: Imre Steindl, a professor at the University of Technology and Economics. The creation of his ambitious entry required the work of nearly 100,000 builders, tens of millions of bricks, 90 pounds of gold, and hundreds of thousands of semiprecious stones.

Steindl didn't want to place chimneys atop his masterpiece, so the heating is generated by a boiler that circulates hot steam. In the summer, cooling would eventually come from massive blocks of ice placed in an underground labyrinth and replaced as needed—this stroke of ingenuity ensured "air-conditioning" for sixty years, until as late as 1994.

Hungarian Nándor Reischl is likely to have spent the most time in front of this stunning control board. He manned the electric, gas, and water systems, while living with his family in an apartment in the basement—which is also where his children were born. While that places an impressive locale on their birth certificate, Reischl couldn't have had much time to spend with them, as he managed 700 rooms, 10 courtyards, and 28 gates within this monumental Gothic structure.

GREAT MARKET HALL

Budapest, Hungary | c. 1897

Photo by Marcus Cederberg

When the three cities of Buda, Óbuda, and Pest were joined to create Budapest in 1873, the new city needed a grand modern enclosed food market. The Great Market Hall opened in 1897 and was declared to be among the most extraordinary and elegant in the whole of Europe. Since then—and despite having been rebuilt twice—the market shines like a beacon, thanks to its unmistakable roof of iridescent multicolored tiles made by the famed Zsolnay ceramics factory in Pécs, just a few hours to the south.

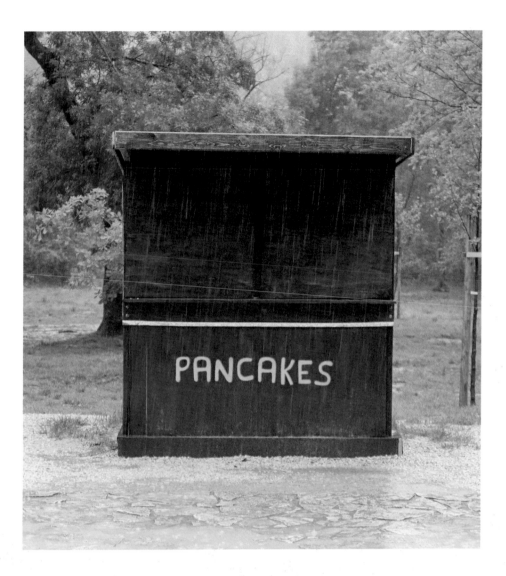

PANCAKES STAND

Krka National Park, Croatia | c. 1985

Photo by Cathy Tideswell

Croatia's Krka River slices over smooth limestone hills through a landscape punctuated by gorges, caves, lakes, and cascading waterfalls that possess an otherworldly beauty. Krka's national park features two monasteries, a Byzantine church, and an ancient Roman catacomb marked by first-century graffiti—and this pancake hut.

Nothing could better complement this marriage of natural wonder and sweeping history than Croatian pancakes. Seekers of a fluffy short stack be warned: these *palačinkes* are similar to thin French crêpes.

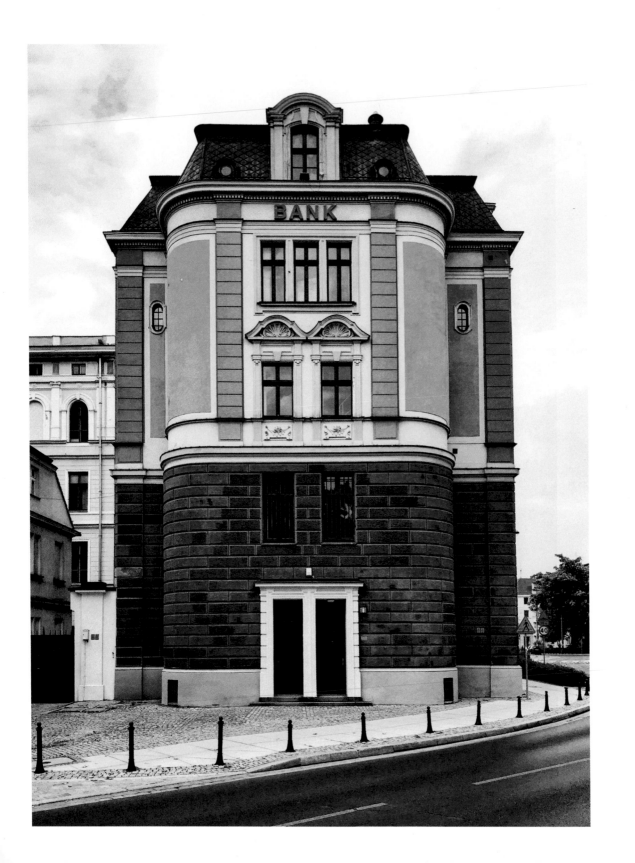

BGZ BNP PARIBAS BRANCH

Wrocław, Poland | c. 1827

Photo by Giulia Mulè

At the crossroads of central European history, Wrocław has—in the span of the last millennium—been a part of Bohemia, Poland, Austro-Hungary, Prussia, and Germany—and has now been returned to Poland.

For two hundred years leading up to World War II, the city was known as Breslau. But that changed when war struck, and it transitioned into the capital of Lower Silesia, eventually becoming both the last stronghold of the Nazis and the last sizable city to surrender to the Soviets.

In the late summer of 1945, the Allies adjusted the borders and returned the city to Poland. Breslau's German inhabitants were swept out, making room for an influx of Polish immigrants and refugees to flood "new," "old" Wrocław. Though 70 percent of the infrastructure had already been decimated by war, the early inhabitants of modern Wrocław were determined to clear away all remaining traces of German habitation. Buildings were destroyed, streets received different names, and any remnants of the past were left to deteriorate as the rubble was cleared out.

There were a few precious, colorful exceptions.

What is now the BGZ bank was originally built in 1827, then rebuilt at the close of the nineteenth century in this modernized style. Even the tough pioneers of Wrocław, who otherwise annihilated Breslau and transformed their new town, respected the legacy and aesthetic value of this stately, elegant pastry of a building. After the war, balconies had to be restored and ownership changed hands, but the core structure survived the tumultuous rebirth of Wrocław.

When the Iron Curtain fell in 1989, city leaders and the community became more willing to acknowledge Wrocław's diverse inheritance. As a reflection of that embrace, the bank has earned the designation "immovable monument," no matter what name the city goes by.

Though the building has borne witness to the brutality of the Nazis, Soviet oppression, Communist neglect, and the devastations of war, its survival throughout these harsh pivots of history is heartening, the city's very existence a testament to our shared capacity to appreciate beauty—a perception that has no country, no borders, no limits. By belonging to nobody, it belongs to us all.

MATTHIAS CHURCH
Budapest, Hungary | c. 1015
Photo by Timothy Desouza

Matthias Church, referred to locally as Matyas Tem-plom, has one of the most distinctive ecclesiastical histories in all of Europe. Located atop Castle Hill, on the Buda side of Budapest, it has been used as a coronation church (by Hungarian royalty) and as a mosque (by the Ottoman Turks—who destroyed most churches during the occupation but transformed this one into their own place of worship). It is now an active, flourishing Catholic church.

From a distance, the graceful architecture sug-gests a typical Gothic church with high turrets. As you grow nearer, your eye is drawn to the roof's 250,000 uniquely colored tiles, telegraphing an entirely different establishment than assumed. Zoom even closer, and the pattern of these Zsolnay pyrogranite tiles may remind you of the design of a 1970s kitchen backsplash or a lanyard from summer camp. Visu-ally, it's a unique invitation to a singularly eclectic church.

Matyas Templom's changing of hands aptly symbolizes Budapest's layered past: both city and church have been damaged by numerous invasions and attacks yet consistently restored, reimagined, and reinvigorated. The church's present facade, topped by this one-of-a-kind glazed quilt, blends multiple traditions into a graceful whole.

←

SLOVENIAN RAILWAYS
Pragersko, Slovenia | c. 1991

Photo by Nastja Kikec

→

GELLÉRT THERMAL BATHS
Budapest, Hungary | c. 1918

Photos by Anika Varma Pannu

The sleek modern trains of the national rail service of Slovenia represent one chapter in a sequence of dramatic changes that the country has undergone.

Its tracks were laid in the 1840s as part of the Austro-Hungarian Empire. After World War I, Slovenia was incorporated into a joint kingdom with its neighbors, leading the train system to be called the National Railways of the Kingdom of the Serbs, Croats, and Slovenes.

A decade later, Slovenian passengers found themselves on the renamed Yugoslav State Railways, in a new socialist state on the Soviet side of the Iron Curtain. This lasted until 1991, when the USSR dissolved. No longer bound to share its territory, Slovenia became a state unto itself. The Yugoslav State Railways divided itself into distinct Croatian, Serbian, and Slovenian Railways.

Today, if riders feel uncertain about which nation they're in, confirmation can be located on the name of the country printed on their train ticket.

The Gellért Baths of Budapest are among the largest natural springs in Eastern Europe. A center for relaxation and healing, the complex is a labyrinth of elaborately decorated art nouveau–inspired pools. Budapest was already long renowned for its generous medicinal baths when the doors to the Gellért opened in 1918.

Known as the City of Springs, Budapest sits on more than 100 thermal springs filled with naturally warm waters, enjoyed over the centuries by Roman invaders, medieval monks, Ottoman soldiers, and socialites today. The thermal baths at Gellért bubble up from the same subterranean springs discovered by the Romans in the second century, which led them to name the ancient city Aquincum, or "abundant in water."

The ornate interior of the Gellért Baths are composed of colorful mosaic tiles from the Zsolnay Porcelain Factory and watched over by a society of guardian-like figurines who host the bathers. As seen here, cherubs and putti can be found whispering to one another in the rafters. In the men's pools, one can measure the passage of time by the water-spitting lions, whose beards continue to grow over the years, due to the carbonate mineral deposits left by the rich flowing water.

PLETNA BOAT

Lake Bled, Slovenia | c. 1590

Photo (left) by Natalia Bolotskaya, photo (above) by Tanika Sorridimi

Lake Bled (or Blejsko jezero) is a picturesque Alpine lake located near the Slovenian capital, Ljubljana. It is a paradise once under consideration as one of the new "Seven Wonders of the World."

Slovenia's oldest medieval castle looks down upon the enchanted Bled Island, giving the setting a fairy-tale quality. The traditional way to reach the island is by hiring a wooden pletna boat.

Similar to Italian gondolas, pletnas have a flatter, wider bottom, a more pointed bow, and colorful protective awnings. To be a pletnar, or oarsman, is considered an esteemed vocation, and many modern oarsmen are descendants of the original families.

Most pletnas journeying to the island dock at the base of the baroque 17th century staircase, whose 99 steps lead to the church. Here, a local wedding day tradition calls for the groom to hoist his bride up the steps to the church, without her making a sound. Should they make it, they ring the bell, make a wish, and offer her a chance to holler.

FISHING BOAT SOP-8
Sopot Beach, Poland | c. 1901
Photo by Mariusz Majewski

Sopot is a seaside resort town in eastern Pomerania, on Poland's southern coast of the Baltic Sea. Now a resort town, the history of this fishing village goes back to the tenth century. Local fishing vessels can be found docked all around the icy Sopot Beach, their distinct colorful flags used to mark where nets have been dropped throughout their journey.

Seafaring and fishing still define the town, along with the pride of Sopot: its wooden pier. Initially built in 1827, it was once about 100 feet long but was taken apart each year before winter for fear of destruction by storm. Each spring, when put back in place, it grew, all the way up to its current length of 1,640 feet, making it the longest of its kind in Europe. The pier is a multi-purpose backbone for the town, serving as a jetty for fishing boats, a mooring place for tourist cruises, an event venue, and a last-ditch leaping point for reckless gamblers from the nearby casino.

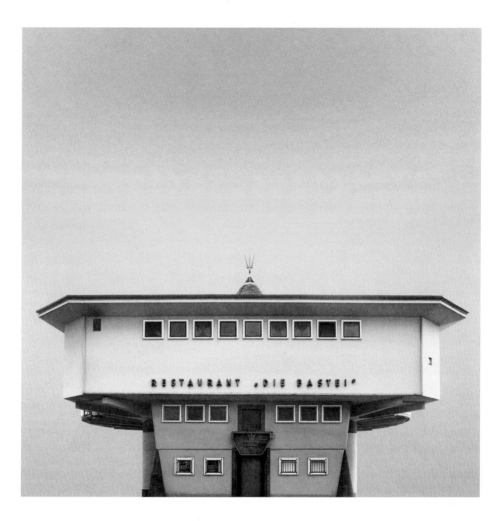

DIE BASTEI
Cologne, Germany | c. 1924
Photo by Geli Klein

Die Bastei, an art deco wonder, sits atop what were once medieval Prussian ramparts, overlooking the Rhine River in Cologne, Germany (Die Bastei is German for "the bastion"). Designed in 1924 by architect Wilhelm Riphahn, the back of this restaurant exposes curved windows hovering just over the Rhine, giving the impression of a floating platform.

At the time of construction, it was viewed as a controversial experiment—regarded as an eyesore by some, with others fretting that it would impair the view to the cathedral. As time went on, it was embraced by Cologne's most stylish patrons, who flocked to Die Bastei for its haute cuisine and panoramic views.

The building was destroyed in 1943 but restored in 1958—again by Riphahn, who took great pride in his work of art. It was during this renovation that he added a cherry on top: an illuminated trident for the roof.

SCHLOSS MORITZBURG

Saxony, Germany | c. 1542

Photo by Yura Ukhorskiy

In the middle of Saxony's Friedewald Forest, known for its lush woodlands, lakes, and abundance of wild game, stands Moritzburg Castle (Schloss Moritzburg). Originally established from 1542 to 1546 as a hunting lodge by Duke Moritz of Saxony, the grounds were later developed by a number of electors, most notably Augustus the Strong—elector of Saxony and king of Poland.

The extravagant property, situated on a completely symmetrical artificial island, boasts seven halls and over 200 rooms decorated by Saxon artists and craftsmen. Within the main property are a chapel, a game preserve, an adjoining "Little Pheasant Castle," and a mini-harbor, complete with its own dock and lighthouse. Paintings of hunting parties at Moritzburg over the centuries suggest evenings that included boat rides on the surrounding lake, after which the guests would watch parades of exotic animals, shoot those that were tethered or enclosed, play cards, and eat ice cream.

Today, Moritzburg functions as more of a baroque museum, filled with exquisite paintings, Meissen porcelain, leather-paneled walls, and a feather room—where one can find (but not photograph) Europe's most extensive collection of featherwork textiles and tapestries, woven with over 2 million vivid, exotic feathers.

All of these marvels and curiosities could be missed by taking a wrong turn, but even the least observant visitor would be unable to ignore the plentiful display of antlers throughout the property, signposting its original attraction as hunting grounds for royalty and aristocrats. Several hallways and rooms make those roots evident, but none so dramatically as the collection found in the *Speisesaal*, or dining room.

Formal meals in the *Speisesaal* would have been framed by seventy-one "trophies" of gargantuan red deer antlers, positioned with immaculate precision around the long dining table. Some of the antlers are nearly as old as the property itself, with many of them purchased from abroad or offered as gifts—or, one imagines, left behind by those who hadn't planned to return home with such substantial woodland souvenirs. Among them is a pair of red deer antlers weighing over 44 pounds and spanning roughly 6.5 feet—quite possibly the heaviest set in the world.

Visitors today don't journey to this stunning castle exclusively to get their lifetime's fill of colossal antlers. Moritzburg was among the locations for the 1972 Czechoslovak-German film *Tři oříšky pro Popelku* (*Three Nuts for Cinderella*), a bohemian variation on the classic fairy tale. Its central twist is that the handsome prince must actively pursue Cinderella, a Czech housemaid who is also a skilled sharpshooter, prone to wearing hunting outfits. It remains a hugely popular film in many central European countries, airing with highest frequency around the Christmas holiday (much like a Czech German equivalent of *A Christmas Story* or *It's a Wonderful Life*).

So, for those less inclined to seek out a majestic eyeful of antlers, there is a different variety of trophy on view: Cinderella's shoe, which remains perched and monitored on the central castle's staircase.

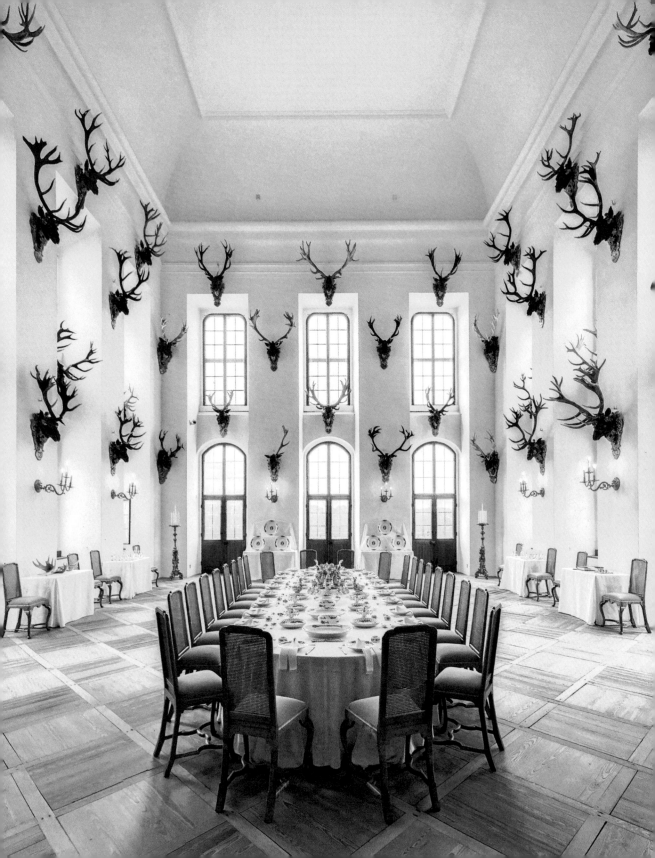

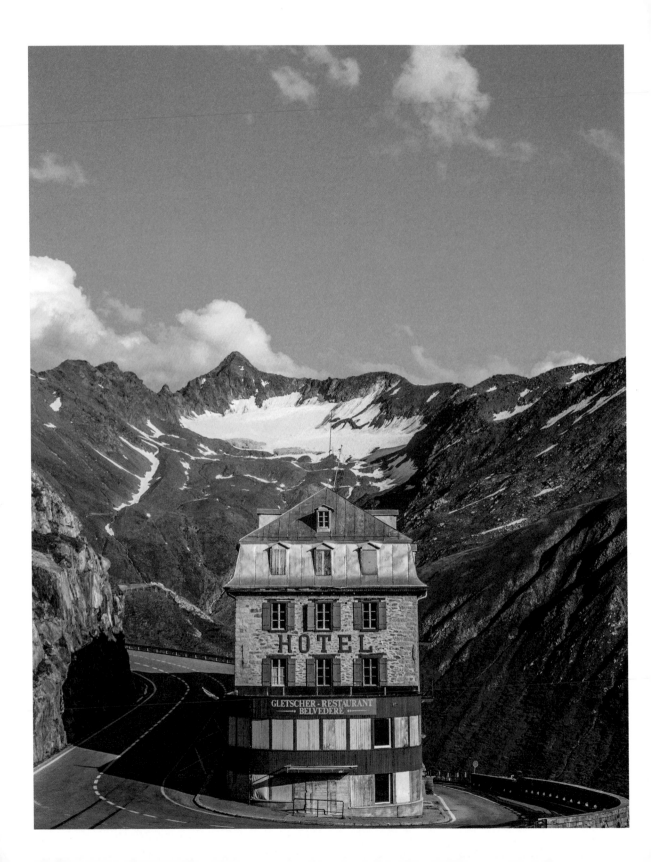

←

HOTEL BELVÉDÈRE
Furka Pass, Switzerland | c. 1882
Photo by Carlo Küttel

→

THE NIESENBAHN
Mülenen, Switzerland | c. 1910
Photo by Aydin Hassan

Built in 1882, the Hotel Belvédère is cradled by a hairpin turn in the Furka Pass, a road that winds in dramatic loops through Switzerland's Alps. In its heyday, guestrooms overlooked icy stretches of the Rhône Glacier and a grotto carved into the blue-tinged ice.

In 1965, the hotel was featured in a memorable scene in the James Bond film *Goldfinger*. Bond, played by Sean Connery, drives through the Furka Pass in his silver Aston Martin while trailing the villain Goldfinger and his henchman Oddjob in a yellow and black Rolls-Royce.

As climate change has melted the Rhône Glacier, tourism to the area has diminished. In 2016 the hotel closed its doors. Visitors today look out over a glacier literally covered up in fleece blankets—an attempt to reduce the ongoing melt.

The Niesen funicular shuttles travelers from the village of Mülenen, on the valley floor, to the summit of Mount Niesen (which translates as "sneeze"). The service staircase for the Niesenbahn is the world's longest, with 11,674 steps used exclusively by employees, except once a year when it opens for a public race called the Niesenlauf.

The line opened in 1910. Sixty-five passengers per car are privy to approximately thirty minutes of a mind-blowing panorama of the surrounding Alpine slopes and mountain lakes. That leaves enough time to sit back and marvel at those who engineered and built the Niesenbahn, which operates at a dizzying 68 percent incline. Take an extra moment to consider that it was installed without the assistance of cranes, which had yet to be invented. Instead, two hundred laborers worked for four years, using an ingenious wooden contraption to inch them along as they laid a track that measures nearly 11,500 feet, or almost eleven Eiffel Towers, long.

FRIEDRICH-LUDWIG-JAHN-SPORTPARK
Berlin, Germany | c. 1952
Photo by Clare Nicolson

Massive floodlights illuminate the Friedrich-Ludwig-Jahn-Sportpark, an arena built in 1912 in Berlin's Prenzlauer Berg district. The stadium—easily recognizable for its iconic pyramids of lights and (as of 1998) its 19,000 bold, multicolored seats—was first referred to as Berliner Sportpark, but was renamed after a German patriot and the father of modern gymnastics, Friedrich Ludwig Jahn.

Jahn believed that physical education was crucial to strengthening German health, character, and identity. In 1809, he settled in Berlin and created many of the gymnastics apparatus we know today: the balance beam, pommel horse, parallel bars,

rings, and horizontal bar. Shortly after, he would open Berlin's first open-air gym, or *Turnplatz*.

Today, the complex is home to Berliner FC Dynamo—a football team that celebrated nine of its ten consecutive championships here. Its lively surrounding area hosts the city's largest flea market, its dedicated karaoke amphitheater (the Bearpit), and an 800-meter remnant from the Berlin Wall—which once divided the capital, and is now used as a gallery for street artwork. So whether you're inside the arena or milling about outside, journeying to the Sportpark offers an apt reflection of the city's capacity to vault into a new era of color and flexibility.

ZWENTENDORF NUCLEAR POWER PLANT
Zwentendorf, Austria | c. 1978

Photo by Daniel Gebhart de Koekkoek

In the 1970s, it seemed the future of Austria's power would be generated by three massive new nuclear plants. In November of 1978, hundreds of workers prepared to begin at the inaugural and most impressive plant, in Zwentendorf. But it was not to be.

In a last-minute referendum, inspired by public outcry during construction, 50.47 percent of Austrians voted against nuclear power, instantly transforming the billion-dollar facility into a museum. It remains open to the public, for those who wish to take a peek at the inner workings of a 1970s power plant...without the nuclear reactor switched on. The power of public resistance remains its most profound exhibit.

CASINO MONT BLANC

Chamonix, France | c. 1848

Photo by Ramon Portelli

The windows remain closed at Casino Mont Blanc. However, opening the shutters would afford any bleary-eyed player a hypnotic view of the snow-capped mountain for which the establishment is named. Mont Blanc towers nearly 5,000 meters over the small village of Chamonix, daring visitors to brave its deadly peaks.

The French can take the credit, or perhaps the blame, for inventing roulette, pari-mutuel, baccarat, and even blackjack, which was originally called *vingt et un* (twenty-one). Mont Blanc's casino was originally a lavish hotel that hosted the likes of Napoleon III, but it is now more frequented by tourists looking to try their luck after skiing in the Alps.

Though easy to dismiss as a tourist trap, a casino serves as a fairly apt foundation for Mont Blanc, considering that the first people who successfully climbed it were taking quite a gamble themselves.

In 1760, before Alpine climbing became a sport, naturalist Horace Bénédict de Saussure announced a prize for whoever could reach the daunting summit of Mont Blanc. He had been the first to attempt the feat, only to cancel it a few days in, after his entourage of twenty—including servants ready to ensure a luxurious ascent for de Saussure—complicated the excursion.

Almost three decades later, amateur climbers Jacques Balmat and Michel Paccard set off on an expedition that turned the heads of Europe toward the Alps. The twenty-six-year-old Balmat was a peasant who wandered from village to village selling crystals to wealthy collectors, while Paccard—twenty-two years his senior—was a respected local physician. The unlikely duo yielded glory: they reached the summit in 1786. In doing so, they encouraged an Alpine movement that would bring countless mountaineers to the region for generations, all seeking to catch a view of the Alps from its highest peak.

Balmat would spend the rest of his life chasing the euphoria of that first big win, climbing dozens of other mountains in Europe. While attempting a reckless climbing gamble in the Sixt Valley in France, he disappeared. Paccard, on the other hand, was satisfied with the summits he'd reached and opted to fold on his climbing career. He married Balmat's sister, settled all debts, and became a justice of the peace.

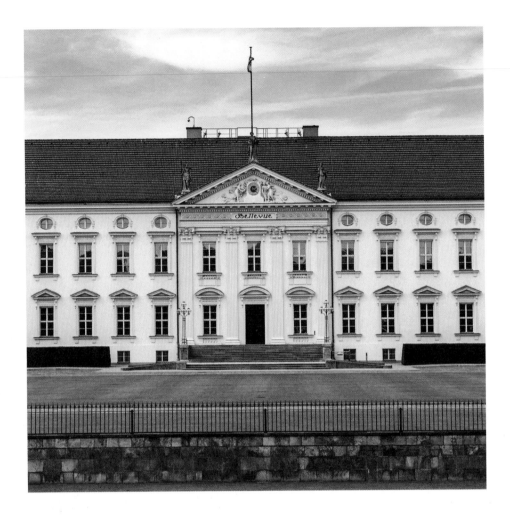

SCHLOSS BELLEVUE
Berlin, Germany | c. 1785

Photo by Federico Sartori

Originally built as a summer residence for Prussian royalty, the Bellevue Palace became a guesthouse for the Nazis in 1939. In the preceding decade it had lived many lives, as an art gallery, a school, and a museum of ethnography and German folk history.

After World War II, its park was transformed into vegetable gardens—but the gardeners didn't notice that statues of historical military figures had been buried there by citizens to prevent wartime destruction. The statues were not recovered until 1993. The following year, Bellevue became—and today remains—the president of Germany's primary residence.

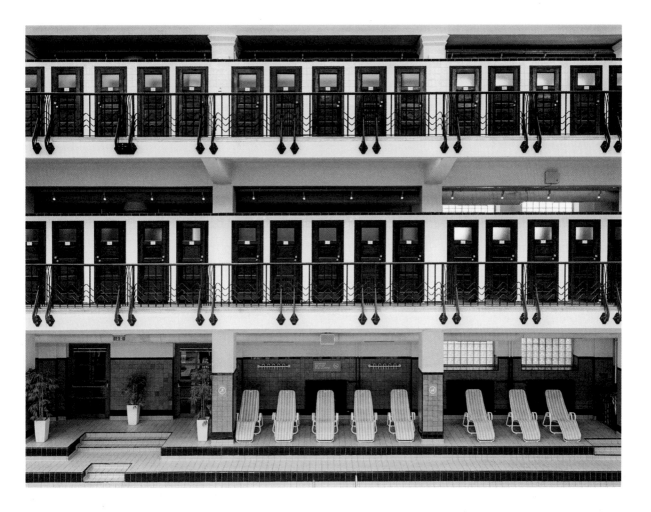

→

AMALIENBAD
Vienna, Austria | c. 1926
Photos by Paul Bauer

Amalienbad is named for Amalie Pölzer, the first woman elected to the municipal council of Vienna. Her party of Social Democrats advocated for public baths to be built to encourage personal hygiene and physical fitness at a time when few Viennese residents had their own bathrooms.

A dreary concrete exterior disguises this masterpiece of art deco and art nouveau design within. The two-story gallery showcases the pool, framed by symmetrical wooden cabins and precise Secession tiles.

After incurring damage in World War II, the baths have been impeccably restored, with one missing architectural marvel: a glass roof, which protected the Amalienbad's original structure and could be slid open in a matter of minutes. Backstroke swimmers today can still enjoy a view of the sky, but it is no longer a convertible ceiling.

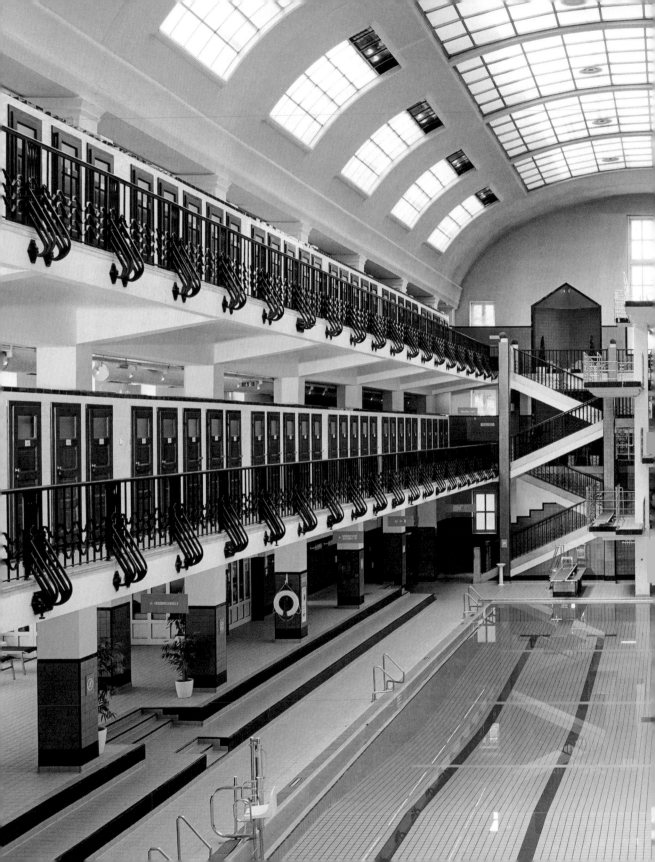

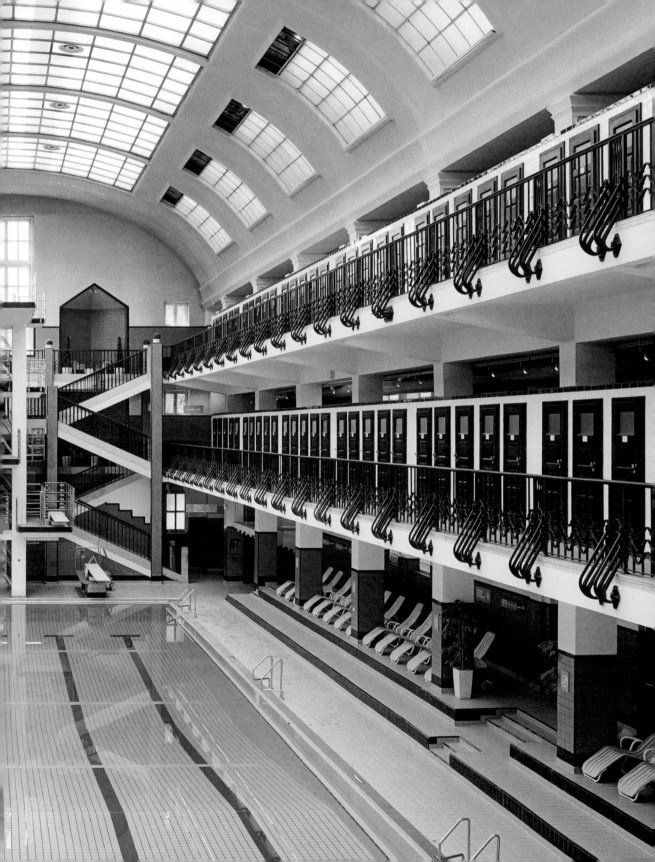

←

NIBELUNGENBRÜCKE
Worms, Germany | c. 1900

Photo by Anda Lavrenti

→

CABLE CAR
Cologne, Germany | c. 1957

Photo by Oliver Stolzenberg

Nibelungenbrücke, or Nibelungen Bridge, stretches over the Rhine River to connect the city of Worms (pronounced *Vahms*—rhymes with "moms") to Lampertheim and Bürstadt, in southwestern Germany. An imposing yet elegant tower known as Nibelungenturm crowns the bridge.

With the addition of the fairy-tale turrets, both bridge and tower were inspired by *The Song of the Nibelungs*, a thirteenth-century epic poem set in Worms. It tells a tragic saga of love, betrayal, and lost riches: the Nibelungs' treasure was sunk in the Rhine at Worms, precisely where the Nibelungenbrücke stands.

The bridge has been reconstructed multiple times, for reasons ranging from a full-scale bombing by the Wehrmacht in 1945, to improvements to accommodate heavy traffic. But even if traffic moves slowly, passengers can fantasize about the scores of treasure sunken deep into the waters beneath them.

The Cologne Cable Car company (Kölner Seilbahn or Rheinseilbahn) carries bright-red four-seat gondolas on a fifteen-minute, half-mile journey above the Rhine River.

The aerial tram was originally constructed in 1957 for a biannual horticultural festival. Its passengers can see the entire city, with unobscured views of Germany's most visited landmark: the majestic Cologne Cathedral, with its unmistakable twin spires.

In 2017, more than seventy passengers were left suspended in their gondolas for hours after one cabin crashed into a support pillar. No one was injured, but a dramatic rescue ensued as German fire crews lowered passengers to safety using winches.

Martina and Hans-Peter Rieger were the first to be rescued—and had been celebrating their forty-first wedding anniversary. They told reporters that they would never forget their day out in Cologne.

BATHING MACHINE
Borkum, Germany | c. 1735
Photo by Uwa Scholz

Borkum Island is the largest of the seven East Frisian Islands in Germany's Lower Saxony region. A destination known for its beaches, saunas, and rejuvenating coastal activities, it is also home to this unique style of historic beach cart.

In bygone days they were used as mobile changing rooms for a woman to get into her swimming costume. They could also be wheeled to the shoreline so that she could enter the water without exposing her body to the beachside. These "bathing machines" would go all the way into the water, and came equipped with little flags to signal a desire to return to shore.

These days, on Borkum, be mindful of the beach you choose. One of the major beaches—FKK Strand (for *Freikörperkultur,* or "free body culture")—is strictly nudist. Dogs and children are welcome. Textiles are not.

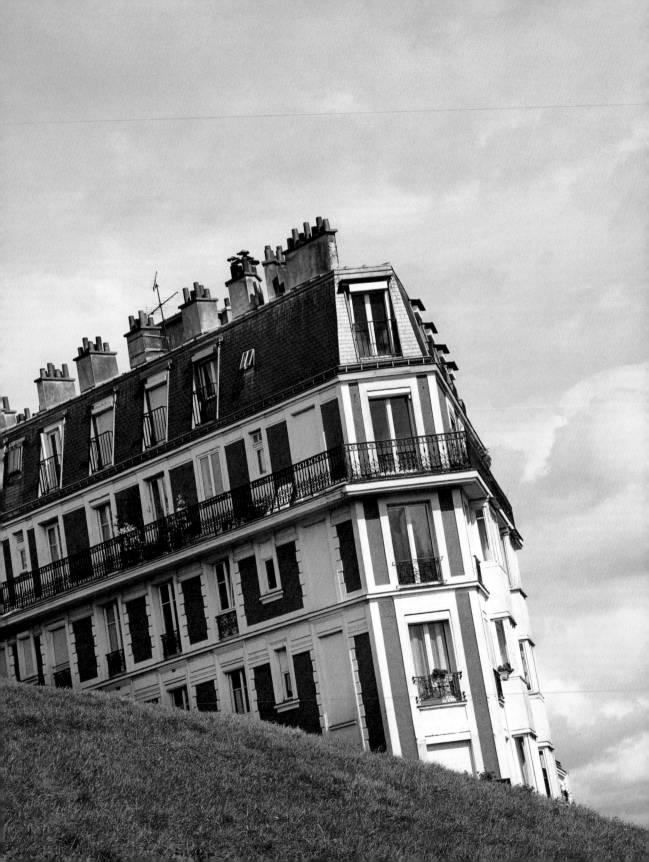

SINKING HOUSE

Paris, France | c. 1900

Photo by Claudia Devillaz

NEW PALACE

Potsdam, Germany | c. 1763

Photo by Esme Buxton

The sinking house is ...not actually sinking. Instead, this optical illusion highlights the peculiar topography of Butte Montmartre—the highest natural point in Paris. The bonus for ascending the narrow alleyways and steep slopes that snake up around the uniquely positioned house is a visit to the strikingly gorgeous Sacré-Coeur basilica, perched at its peak and set against the breathtaking background of the city of light.

Frederick the Great built the Neues Palais (New Palace) ostensibly as his main residence, but ended up utilizing it more so as his showroom and a place where he could receive and impress visiting dignitaries. This palatial retreat has two hundred rooms, decorated in extravagant rococo style, and was built to celebrate Prussia's triumph at the end of the Seven Years' War via an excess of marble, stone, and gilt.

The most eccentric, marvelous room is the Grottensaal (Grotto Hall), where, thanks to extensive restoration, more than 24,000 seashells, fossils, and gemstones continue to sparkle. The king acquired the minerals to highlight his newly acquired riches, and each Prussian ruler who followed did his part to ensure that the hall stayed agleam. Emperors William I and William II alone brought in more than 20,000 precious stones, shells, and ammonites.

Those less enthralled by encrusted walls need only turn their attention to the ground on which they're standing: the Grotto Hall's marble floor depicts an array of exotic marine animals and plants. Even the floors use various stones to form patterns that reveal treasures. Watching over the whole scene are Venus and Amor, the Three Graces, and a host of angels, painted on the ceiling in 1806.

Beyond the Grotto Hall and a sizable interior amphitheater, the New Palace's design, while majestic, is fairly conventional...with a few exceptions that are a nod to King Frederick's ego: protruding from the center of the building, painted black, is a shallow dome on a tall, windowless drum, topped by three nude female figures holding up a crown. The dome serves no functional purpose whatsoever, it only exists because the King deemed it necessary for his royal palace to feature such a trophy—one which is said to depict the enemies he defeated in the war, and which both he and the masses could admire.

HOTEL MOLITOR

Paris, France | c. 1929

Photo by Piergab

When Piscine Molitor, on the outskirts of Paris, opened its doors in 1929, its avant-garde atmosphere attracted the city's artists, celebrities, and high society. Molitor was an art deco lover's dream, designed to resemble a luxury ocean liner. For sixty years, patrons sunbathed by day (or ice-skated during winter months), then savored theater performances, fashion shows, and fine dining deep into the night.

However, by the 1980s, the luster had faded, and Piscine Molitor was closed in 1989. This wouldn't stop the hotel from remaining a destination for Paris's young art crowd. The crumbling concrete and abandoned pool became the scene for new kinds of social gatherings of graffiti artists, skateboarders, and DJs, who transformed Molitor into an underground venue for exhibitions and raves.

In 2007, plans were made to return Piscine Molitor to its original grandeur and reconstruct the luxury hotel. The design from 1929 was meticulously followed, with such precision that the original architect's daughter burst into tears upon seeing it so faithfully restored.

Although some Parisians bemoan the latest reversion from DIY artist mecca to wealthy tourist destination, the hotel attempts to bring in new elements (including this couch, which was hauled in for an impressive photo shoot). They also honor the role it had in shaping Parisian underground culture: some of the graffiti art from its abandoned period is prominently displayed on its lobby walls, alongside new works by the young artists who had found beauty in its neglect, a sanctuary in that which had been abandoned.

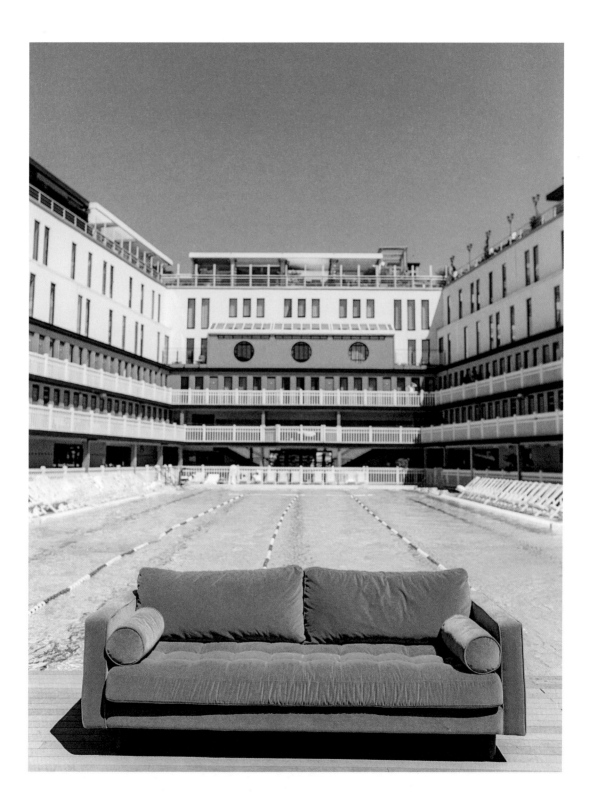

YENIDZE

Dresden, Germany | c. 1909

Photo by Matthias Dengler

Standing conspicuously among the traditional baroque buildings of the Friedrichstadt district in Dresden, Germany, the glazed dome and minarets of the Yenidze Building add an unexpected Middle Eastern flair to the city's skyline.

In 1907, cigarette manufacturer Hugo Zietz's plans to build a factory in the middle of Dresden were denied by the city, on the grounds that the standard aesthetic of a factory—bland, generic, obstructive—would threaten the architectural integrity of the historic center. So, with determination and ingenuity, Zietz began imagining a novel design that could satisfy city regulations while also providing clever advertising for his Turkish cigarettes.

Architect Martin Hammitzsch (who would later marry Adolf Hitler's half sister) was hired to design the factory in the style of the mosques of the Ottoman Empire, where the tobacco was grown. But there was a minor problem: Hammitzsch had never seen a mosque in his life. After studying photographs and drawings of tombs and mosques in Cairo and Andalusia, he created blueprints that blended art nouveau and Moorish elements. At the time, such influences were deemed so controversial that Hammitzsch was ejected from the distinguished chamber of architecture.

There was nothing left for him to do but to add icing to the offense, by including a garish final touch: a neon sign—the first in Germany—was mounted onto the building. On it were emblazoned the words *Salem Aleikum*, meaning "Peace be with you." Conveniently, the Arabic greeting was also the name of the cigarette brand produced within. The highly ornamented factory that came to be referred to as the "tobacco mosque" opened its doors in 1909.

The Oriental Tobacco and Cigarette Factory Yenidze soon became the largest cigarette manufacturing facility in Germany. While taking breaks from hand-rolling butts, the 1,500 workers at the factory were free to stroll through the immaculate light-flooded, well-ventilated halls. On the upper floor, there was an employee rest area equipped with a canteen and luxurious canvas chairs. The staff could even relax on the roof terrace and enjoy a full view of Dresden through the building's glass dome.

During World War II, Allied bombing devastated Dresden, leaving few structures untouched. The Yenidze was no exception. A third of it was destroyed; its neon sign of peace collapsed in a pile of rubble. After the war, the East German government made attempts to repair the damage, but the Yenidze was not fully restored until the reunification of Germany in 1990.

It is now a modern office building with a trendy restaurant on the top floor and a new sign that reads "Yenidze" where "Salem Aleikum" once blinked in neon. Attempts have been made to embrace its original inspiration, such as using the venue for performances of Middle Eastern music and belly dancing. Perhaps befitting the candy-land facade and exotic minarets (well-disguised chimneys), fairy-tale readings for children are held there every weekend. No smoking is permitted on the premises.

KARLSRUHE HAUPTBAHNHOF

Karlsruhe, Germany | c. 1913

Photo by Matt Ziegler

→

ALBERTINA MUSEUM

Vienna, Austria | c. 1776

Photo by Valentina Caballero

In the heart of Vienna, the Albertina Museum—which today houses some of the world's most impressive and diverse artwork collections—was once a residential palace for the Habsburg monarchy.

In the eighteenth century, Duke Albert of Saxen-Teschen used the palace as his home. He established the initial collection of art with Count Durazzo, the Italian ambassador to the court in Vienna—who donated nearly 1,000 pieces. Both the collection and the building itself were expanded by Albert's successors until 1919, when ownership passed to the newly founded Republic of Austria, which opened the collection to the public.

The pillared entrance hall, lined with Roman busts, ushers visitors in to behold the Albertina's treasures. Masterpieces by Da Vinci, Raphael, Michelangelo, Rembrandt, Monet, and Picasso have all visited the museum, as have exhibitions of modern work by Robert Frank and Keith Haring.

No matter who you are, or what art you may be there to enjoy, take comfort. They rolled out the red carpet just for you.

HOTEL SACHER

Vienna, Austria | c. 1876

Photo by Paul Bauer

The Hotel Sacher stands among the world's great luxury hotels and is celebrated as a veritable Viennese institution. Since its opening in 1876, the hotel has been distinguished for offering both cosmopolitan prestige and the country's finest patisserie. Years before the hotel opened, Franz Sacher invented and perfected the recipe for the divine chocolate tart known as the Sacher torte. Deemed incomparable by many a gourmet, it is still handmade today, using a secret recipe.

But it was Franz's son Eduard who opened the hotel. Soon after, he married a butcher's daughter, Anna Maria Fuchs, who swiftly took charge and helped elevate the Hotel Sacher Wien into a hub for the creme de la creme of Vienna's social scene. Eduard died in 1892, leaving his formidable thirty-three-year-old wife in charge. With devotion and flair, she developed a reputation for managing the hotel with classy discretion (never revealing what went on in her hotel's *chambres séparées*, private dining rooms in which wealthy male patrons were serviced in any number of ways).

In addition to being credited with the Hotel's ongoing success, Madame Sacher is remembered for her omnipresent cigar and sizable crew of French bulldogs. She was addicted to both with a steadfastness that would put Churchill to shame.

The end of the monarchy in 1919 spelled a loss of business for the hotel, and the Madame became increasingly withdrawn. In 1930, she died in her room at the hotel.

Her grandeur lived on over the course of the twentieth century through the Sacher's reputation, as it welcomed guests including Indira Gandhi, Queen Elizabeth II, and JFK. And though the institution lost its true ambassador, the Sacher torte has maintained its status as a coveted delicacy: around 360,000 handcrafted cakes are still sent around the globe every year.

Perhaps in honor of Madame Sacher's adoration for her canine companions, the hotel provides five-star accommodation for dogs. Call ahead and let them know if you are bringing your four-legged companion; if so, your room will be equipped with doggy blankets, towels, feeding bowls, and a comfortable basket with linens of various sizes—in addition to a special "Do Not Disturb" sign for your pup.

Dog food can be purchased from the front desk, but for those with more nuanced palettes, the hotel chefs will happily prepare a custom course. "They should simply order up a tenderloin or a veal schnitzel from room service," the hotel manager advised Reuters in 2015. For further helpful tips, one can request the "Sacher Pets—Animal Etiquette."

With such esteem for canine visitors, it's no wonder that one would be featured in the restaurant's opulent Rote Bar (next spread). The dining room is festooned in red crushed velvet, with gilded details and crystal chandeliers. A distinguished St. Bernard owns the focus, while surrounding portraits honor some humans of note, such as Emperor Franz Joseph.

The hotel's main dining room, however, is still named for Madame Anna Sacher. When visiting, be sure to pay respect to her oil portrait, which reveals her impressive stature and preferred companions—flanked by bulldogs, she wears an expression that does little to disguise her desire to cease posing and get back to her cigars.

HET SCHEEPVAARTMUSEUM

Amsterdam, Netherlands | c. 1656

Photo by Anne Danao

The title of "Maritime museum" typically conjures images of ship models and aged photographs; rooms filled with sundry objects—medals of valor, a galley spoon, preserved nets and fishing wire, perhaps a salvaged mast or an impressive display of knots. But for all the value that one may justifiably find in the memorabilia of man and the sea, you'll get far more than that at Het Scheepvaartmuseum— Here you're made privy to a crucial narrative of modern history: how the humble port of Amsterdam shaped Dutch society and global exchange.

Dating from 1656, the building is a wonder of the waters, planted on a man-made island that was created by sinking 1,800 piles of wood into the silty sea floor below. Aboveground, more than 400,000 objects are on display, including ship models, navigation instruments, and maps. They're organized in a way that guides one through the profound influence of the Netherlands' nautical stronghold over our world, and the economic and social changes that resulted.

Known as the country's Golden Age, the seventeenth century was the era of Dutch rule over international sea trade. Amsterdam was the richest city in the world. The Dutch East India Company traded vigorously with Europe, Africa, North America, Brazil, India, and Japan. Untold amounts of sugar, tea, spices, coffee, potatoes, and much more went through Amsterdam's port.

The frenetic activity at this influential port opened up a span of unprecedented prosperity. A new merchant class appeared, having accumulated more personal wealth than had ever been known outside royal circles. The aristocracy, instead of seeking to marry their daughters off to noble families, suddenly favored the sons of merchants. Radical social changes soon followed.

Freedom of expression proliferated, including a revolutionary liberated press. A wave of new artists, including the likes of Rembrandt, broke with tradition and started painting portraits of everyday people. This span of time saw a rise in religious tolerance, scientific discoveries, medical breakthroughs, and an expansion of the rights of women in the Netherlands. All of this and more is chronicled within this national museum.

Even those uninterested in the consequential history of Dutch trade can revel in the museum's ambience. During the 2010s, work was completed on the building, and glass roofing was installed over the vast space of the inner courtyard. By nightfall hundreds of tiny LED lights, placed between shields of glass, give the impression of the cosmos that one might see out on the ocean, far from the glare of urban life.

And if you're *still* unimpressed with these wonders (plus half a century of Dutch history and its powerful influence on our world today), merely wander out back, where the museum meets the water. The museum's submarine can often be found there, having come up for air and open for exploration.

UNITED KINGDOM & NORTHERN EUROPE

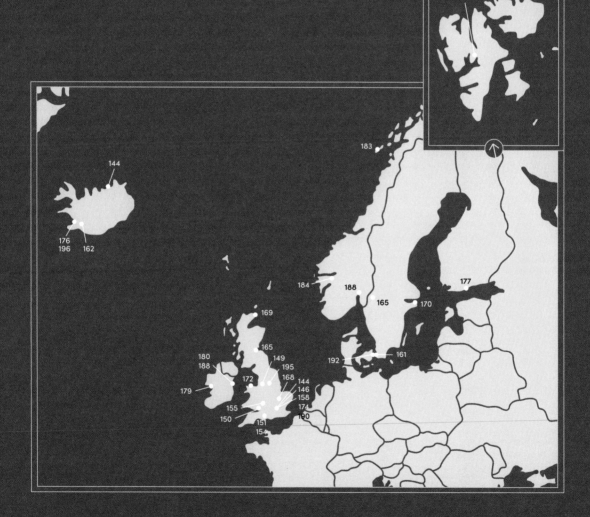

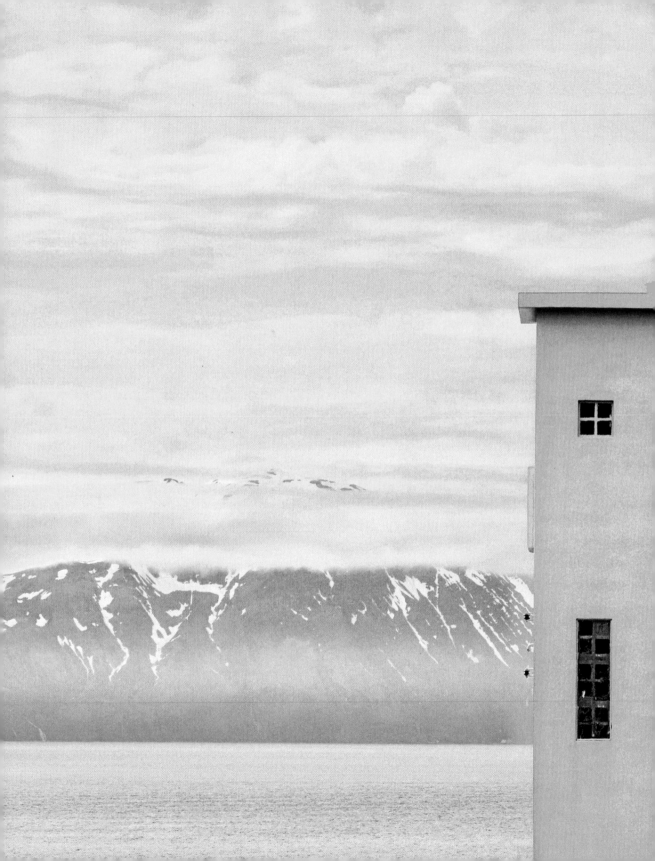

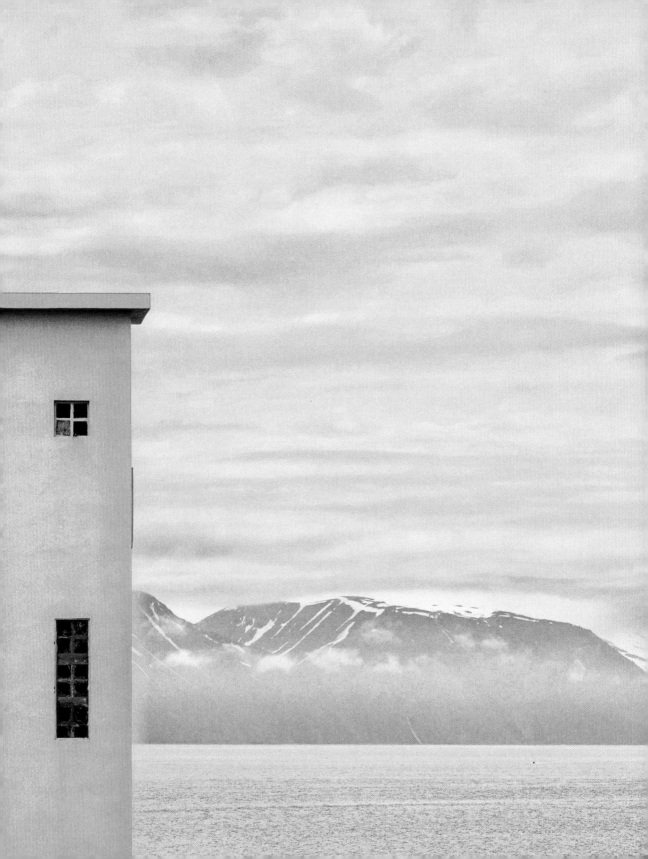

← **HÚSAVÍK LIGHTHOUSE**
Húsavík, Iceland | c. 1956
Photo by Matthijs Van Mierlo

→ **WOOLWICH TOWN HALL**
London, England | c. 1906
Photo by Steven Maddison

Sixty-six degrees north of the equator, off the northeastern coast of Iceland near the Arctic Circle, the brightly painted Húsavík Lighthouse spends the winter in near-perpetual darkness. On December 21, the sun is out for a total of two hours and forty-five minutes.

Since 1956, this lighthouse has guided fishing boats safely through Skjálfandaflói Bay to the small town of Húsavík. However, it's not the only illumination to be seen in Iceland's winter skies. The phenomenal light displays of the aurora borealis, visible from the fishing port of Húsavík, have sparked the imagination of northern dwellers for centuries and continue to astound skywatchers today.

Many people climb to the top of Húsavík Lighthouse to view the aquatic wildlife in Skjálfandaflói Bay. Minke and humpback whales, orcas, and even blue whales have been spotted from the top of the lighthouse. And when the northern lights decide to make their way across the night sky, the top of the lighthouse makes for the perfect place to view them in all their real and ethereal splendor.

Woolwich Town Hall, a listed Edwardian building, is the seat of the Royal Borough of Greenwich's local government, as well as the hall where votes are counted and major life events are registered. Located at 35 Wellington Street in southeast London, it is a Grade II* listed building on the National Heritage List.

Within is the ornate Victoria Hall, a gorgeous example of the Edwardian style.

A convenient route to reach the hall is via the nearby Woolwich foot tunnel, which has provided decades of dependable passage under the Thames River. Toward the end of the twentieth century, however, murmurs began to circulate about the tunnel's temporal instability. Workers claimed they had spent several hours refurbishing the foot tunnel, but in fact would exit a mere few minutes after having entered.

Time slips and related anomalies, though infrequent, continue to this day. Do visit this magnificent baroque building, but if going by tunnel...perhaps bring an analog watch.

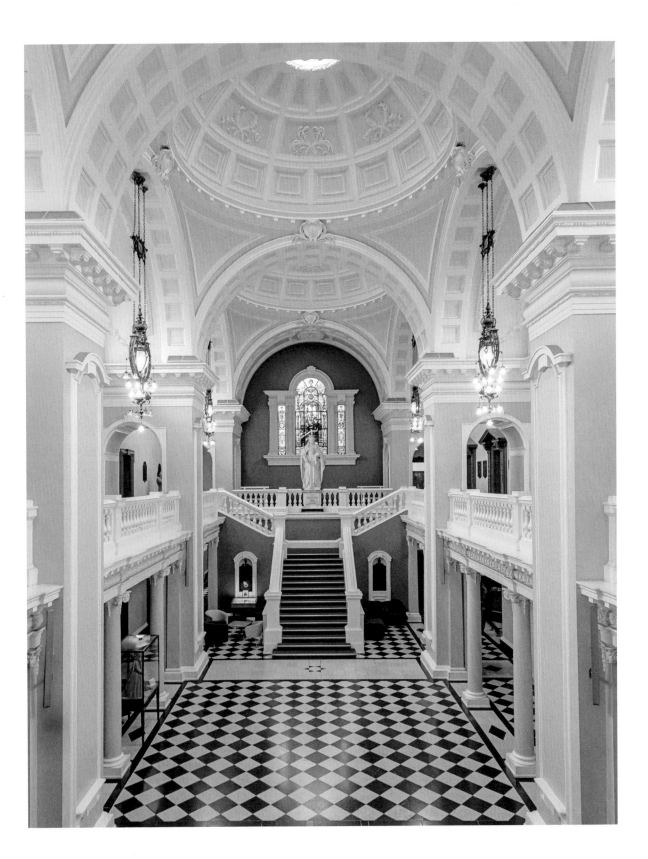

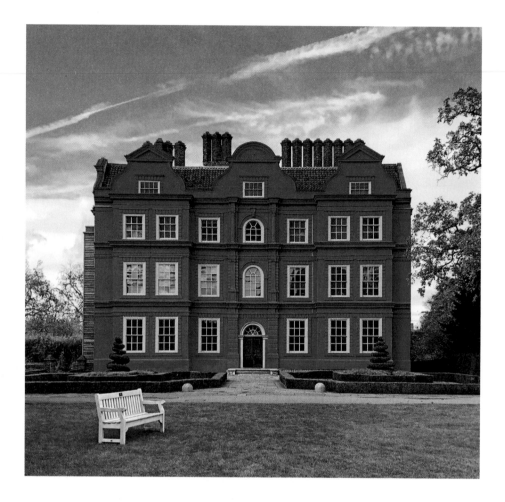

KEW PALACE & QUEEN CHARLOTTE'S COTTAGE

London, England | c. 1631 & 1772

Photo (above) by Andrew Afram, photo (right) by Silvia Molteni

KEW PALACE is the smallest of all the British royal palaces, located in the natural expanse of Kew Gardens, just upriver from London on the banks of the Thames. Originally a mansion for wealthy London silk merchants, in the 1720s George II and Queen Caroline arrived with their children and took leases on the palace, as well as several other small properties in its vicinity.

Georgian royalty occupied Kew and its neighboring Richmond Lodge for generations, using it as a retreat from public life. It was a place where they could be private and domestic, and could exist together, unencumbered by the expectations of ceremony, stifling traditions, and strictly maintained homes. As such, Kew's relative intimacy reflects a wholly human portrait of the British monarchy during the eighteenth and early nineteenth centuries.

In some way, the very atmosphere of the palace itself tells the powerful story of George III (1738–1820), who used Kew as a refuge when he went "mad"—a claim that has been repeatedly disputed and supported, ever since the monarch's death.

George loved his garden, much of which was designed by renowned landscape architect Capability Brown, who was responsible for over 170 of the finest gardens in Britain (his real name was Lancelot, but he received his nickname because he told clients that their property had "capability" for improvement). The gardens were cultivated more wildly than was customary, and were viewed as an idyllic pleasure ground. But the wildlife on display went beyond mere fauna.

Among the properties surrounding the main home is **QUEEN CHARLOTTE'S COTTAGE**, which is open to the public. Downstairs, the queen displayed her extensive collection of prints from the artist William Hogarth—art that provides, in sequence, a sort of moral display or fable—on the walls of the print room. Upstairs was the tea or picnic room, decorated with bamboo and floral paintings done by the queen's third daughter, Princess Elizabeth.

Toward the back of the cottage was a menagerie, home to a range of exotic animals over the years. Queen Caroline (1646–1723), wife of George II, acquired civet cats and tigers, whereas George III and Queen Charlotte contented themselves with tamer pets like cattle and colorful pheasants. Near the turn of the eighteenth century, the first kangaroos to arrive in England were kept and bred successfully there, and once bounced freely behind the monarch's cottage.

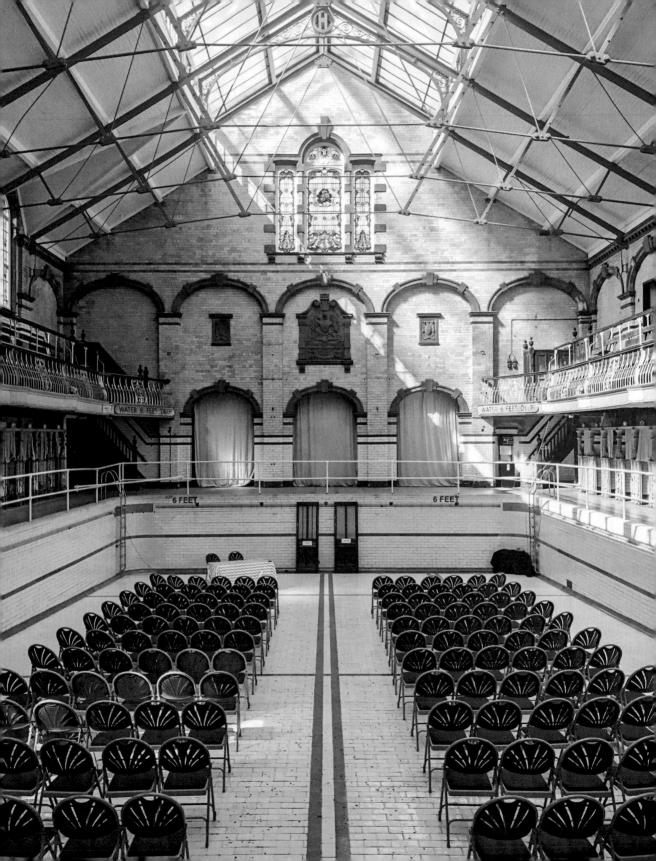

VICTORIA BATHS

Manchester, England | c. 1906

Photo by Ben Carpenter

The Victoria Baths opened in 1906, intended to serve as "a water palace," according to the lord mayor of Manchester upon its opening. No extravagance was spared, with the baths costing almost twice as much as any other facility of its kind.

A multicolored brickwork and terra-cotta exterior gives way to floor-to-ceiling glazed tiles, mosaic floors, and stained-glass windows more befitting a grand cathedral than a bathing complex built for inner Manchester.

Throughout the twentieth century, several professional swimmers trained in the generous central pool, including Olympic swimmer John Besford who notably emerged victorious during the European 100-meter backstroke. Germany's own Ernst Kuppers was expected to win, but Besford took the title, thus infuriating the führer, as Hitler himself had commissioned a one-of-a-kind bronze eagle trophy for the country's favorite.

For eighty-six years the delightful baths provided both essential and leisure conveniences: baths and a laundry could be found beside three large swimming pools, a Turkish bath, and, in time, a sauna and the first public jacuzzi in the country. Come winter, the gala pool was often floored over and used as a venue for dances, particularly in the postwar years.

By the 1990s, the lavish baths had fallen into disrepair and were shuttered. The building was slated for destruction, but public outcry saved it from bulldozers. Despite frequent fundraising attempts, however, the building continued to deteriorate as the cost of renovations skyrocketed.

Salvation arrived by way of a television contest. In 2003, BBC Two's reality show *Restoration* entered the baths in a competition for a hefty restoration grant. Nearly 300,000 viewers voted for the building, securing an award of £3.4 million from the Heritage Lottery Fund.

While the show did much to rejuvenate the baths, the BBC underestimated the price of a full restoration...which has since grown to £20 million. Nonetheless, in 2006, the gala pool was filled for the first time in thirteen years, to celebrate its centenary. The building is once again open for weddings, private functions, concerts, and swimmers training for a surprise victory.

ADVENTUROUS ACTIVITY COMPANY

Bristol, England | c. 2004

Photo by Adam Buckles

Though you wouldn't know it by its entrance, Bristol's Adventurous Activity Company offers a diner-sized menu of outdoor challenges, from kayaking and ropes courses to Stag & Hen events and Urban Adventure Challenges—but they're prepared for more bespoke requests as well: once, they provided the equipment and support to help a vicar rappel from his church tower into the middle of his congregation.

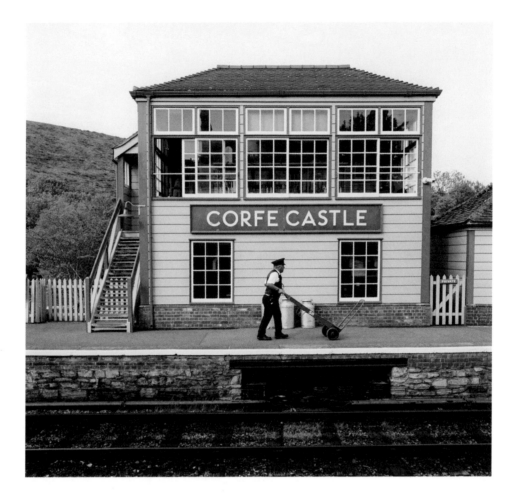

CORFE CASTLE RAILWAY STATION
Dorset, England | c. 1885

Photo by Simon & Jennifer Darr

The village of Corfe Castle lies at the center of a peninsula in England's Dorset County. In the nineteenth century, the area became known for its ball clay—a rare and versatile material used to make everything from tableware to pharmaceuticals to toilet bowls and tanks.

The clay and Purbeck marble, quarried nearby, attracted the interest of railway companies, and the Swanage Railway opened in 1885. A small station was built in Corfe Castle. However, in 1972, after the collapse of the clay and marble industries, British Rail closed the line and ripped up the tracks.

The village banded together to launch a campaign to save and reopen the track—if for nothing else than as a heritage railway. Over the course of decades, volunteers worked to rebuild every meter of the 5.5-mile stretch to Swanage.

The station itself was painstakingly recreated in the style of the 1950s, with original wooden floors, coal fires, and a free railway museum describing the station's story of persistence and triumph. After a trial service in June 2017, the heritage line was reconnected to the rail station in Wareham, and steam trains run to Corfe Castle every day from April to October.

Nearly six hundred volunteers keep the railway going, with hopes that one day it will be connected with regular service to the whole UK network.

KINGSTON LACY
Wimborne Minster, England | c. 1663

Photo by Guy MacLean

Built in 1663, the Kingston Lacy estate was owned by the family of William John Bankes for three hundred years. Bankes was an aristocrat who lived large and had exquisite taste, afforded by inherited wealth. Often referred to as an "explorer," he lived life with such an eye for adventure that he was once referred to by Lord Byron—the notoriously naughty leading figure of the Romantic movement—as "the father of all mischiefs." He journeyed through Europe, Asia, and the Middle East, notably curating one of the world's most extraordinary private collections of ancient Egyptian artifacts and antiquities.

By the time Kingston Hall fell into his hands, the family fortune was vast and his tastes had grown even more refined. He hated the redbrick house his ancestors had left him, so in 1835 he began reconstructing it as a gray stone palazzo-style mansion, thereafter known as Kingston Lacy. The Italianate country house became a monument to Bankes's voyages and obsessions.

In 1841, William was driven out of the country after being caught in what was then deemed a homosexual scandal, a crime punishable by death in his day. He left his art behind, along with detailed notes and drawings, which remained for some time in a cabinet at Kingston Lacy, unpublished and forgotten.

From exile, through his sister, Lady Falmouth, he continued to provide instructions on the decor, while sending back precious items—thus making Kingston Lacy among the most enchanting houses in England, with one of the most poignant legacies.

For traditional art lovers, the paintings hung on the many walls are its triumph. But Kingston Lacy's outstanding collections are not all to be found inside the house. Much of Bankes's large collection of Egyptian antiquities remains—somewhat contentiously—on display outside. The most significant piece is the Philae obelisk, an engraved stone structure dating from 150 BCE. Originally it stood at the entrance to the Temple of Isis on the sacred island of Philae until Bankes acquired it sometime between 1815 and 1819. Its journey from Egypt to Dorset was a six-year undertaking by famed adventurer Giovanni Belzoni. Before it had even left Egypt, the obelisk sank into a riverbed of the Nile. Eventually, the Duke of Wellington got involved, arranging for its subsequent delivery to Dorset in a gun carriage.

The obelisk made a massive contribution to the nineteenth-century race to decipher hieroglyphs. As an Egyptologist, Bankes's interest in the stone tower was hardly idle: he was quick to note inscriptions on it in both ancient Egyptian hieroglyphs and ancient Greek. His understanding of the latter led him to identify the names Ptolemy and Cleopatra—a discovery that, once verified, made the obelisk instrumental in Jean-Francois Champollion's breakthrough in deciphering the inscriptions on temple cartouches and eventually the Rosetta stone.

Bankes died in Venice, having never officially returned to the UK, but family legend suggests that in 1854, in rapidly declining health, he made a final secret visit to his one true love, Kingston Lacy. Following Bankes's death, the house passed through several generations. In 1981, a descendant of Sir Ralph Bankes (1631–1677), bearing his same name, bequeathed the house, collections, and twelve working farms (along with Corfe Castle) to the National Trust—the most generous bequest it had ever received.

GLOUCESTER SERVICES
Gloucester, England | c. 1972

Photo by Louise Walsh

The M5 motorway links England's Midlands to southwest England. Journeying along it can feel awfully monotonous, until you reach Gloucester Services near Whaddon, Gloucester. Unlike the standard chains one often sees on a long car journey, these service areas sell artisanal food and feel a bit different than your average stop.

In 1972, John and Barbara Dunning's Cumbrian farm was cut through by the M5 motorway. Unlike others, the Dunnings didn't view the loud motorway as the end of their farm, but rather the beginning of a new chapter. Their farm shop sold locally produced food, a butcher offered meat from their farms, and a kitchen served homemade dishes to a thirty-seat café. Their intention was to provide a strong sense of the surrounding community where you'd least expect it. Back then it was visionary. Today, the family is part of a local food revolution.

In May 2014, they opened Gloucester Services on the M5. They offer a "quick kitchen," ATM, toilets, and showers twenty-four hours a day. During working hours, they open up their kitchen, local store, butcher counter, and fishmonger. A postbox is on the scene for additional convenience.

As a final touch, the green roof was designed to help blend the new station in as part of the landscape. Grass and other foliage was planted on the roof, in the hopes of attracting bees and butterflies, to complete the welcoming scene offered just off the highway.

PYRAMIDEN
Svalbard and Jan Mayen (Norway) | c. 1910

Photo (above) by Anastasia Yakunina, photo (right) by Aase Marthe Horrigmo

Pyramiden is a former Russian coal-mining village, now a ghost town. Located on the Norwegian archipelago of Svalbard, the settlement was founded by Sweden. However, with mining rights possessed by the United States, Japan, the United Kingdom, and Russia, the frigid hands of many countries have an interest in this derelict mine above the Arctic Circle.

In 1927 the remote settlement was sold to the Soviet Union, which carried out coal-mining operations for seventy years while also creating the portrait of an idealized Soviet village.

In 1998, the village's population of around 300 people was told to leave behind everything but what they most needed. The operation was shuttered, and within a matter of months, the only occupants were seals, birds, and the occasional polar bear.

Today, this ghost village showcases Soviet industrial life, literally frozen in time. Not exactly Pompeii, the remnants include a frozen statue of Vladimir Lenin; a house made entirely of clear and green glass vodka bottles, exhibiting the creativity that boredom can reap; and the world's northernmost basketball court.

Efforts have been made to lure tourists, but Pyramiden is accessible only by sea or snowmobile. All the same, those who do visit can survey the remnants of a bygone culture under the watch of a guide who is prepared to shoot approaching wildlife. The most intrepid tourists are even welcome (in the summer) to stay overnight in this place most people are happy enough to leave in the past. However, due to the extreme climate conditions that protect it, Pyramiden will likely resist decay for longer than any modern human settlement on our planet.

BUCKINGHAM PALACE

London, England | c. 1703

Photo by Oksana Skora

Buckingham Palace is the official London residence and headquarters of the reigning monarch of the United Kingdom. Initially built as a private residence, it was purchased by George III for Queen Charlotte in 1761, to create a comfortable home for their fifteen children. However, the first royal to adopt Buckingham Palace as their official home was Queen Victoria, who moved there in 1837.

Today, the palace contains more than 830,000 square feet of floor space. This astronomical building is not all ballrooms and banquet halls: beyond the expected luxuries, there's also a post office, a movie theater, a police station, a surgical operating room, and an ATM reserved for the royal family.

To service all of these amenities, more than 800 staff members live in the palace, including a flagman, a fendersmith, and a woman who breaks in the queen's shoes (yes, the queen's budget prevents her from getting blisters...candidates must wear a size 5 and use ankle-length beige socks). And of course, no montage of London sights would be complete without an image of the changing of the guard, which occurs daily from 11:00 to noon. Occasionally, however, the tradition is canceled due to weather conditions—so make sure to pay attention to posted signage.

But there is one team that can never take a day off: the "horological conservators," or clockmakers. Royal engagements wouldn't be quite as grand if they weren't run on such a precise schedule—and the palace contains more than 500 clocks and watches (plus over 350 in Windsor Castle). They're wound every week, meaning the task is a full-time job in every way.

Being a horological conservator is not a simple task—especially during daylight saving time, when, after months of planning around the palace schedule, the clock-winders start work in the early hours on Saturday and work tirelessly, making certain that the correct time is set by midnight on Sunday evening.

The Senior Horological Conservator explained to a magazine why this adjustment can take as long as fifty hours: "The Royal Collection contains many fascinating and extraordinary timepieces with highly complex mechanisms, so great care has to be taken with each one." Indeed, the palace timepieces reflect centuries of tastes from various monarchs and their children—there are varieties ranging from musical clocks, to astronomical clocks, to organ clocks, to turret clocks (the latter being widely regarded as the most daunting to change). Monarchs have recognized the value of timekeeping well before they could rely on a team of horologists: the alarm on the tiny watch that Queen Elizabeth I wore as a ring purportedly made no sound, but rather notified her of royal duties by scratching her finger.

In 2019, however, the queen is able to outsource these reminders. In fact, the Royal Collections Trust put out a job posting for a skilled horologist to mind the queen's timepieces in each of her residences. Applicants needed to have top marks from the British Horological Institute, where fewer than 100 people annually achieve the required grade. The job description was daunting, explicit, and arguably a touch aggressive:

You will be confident and experienced at working with hand and machine tools, with particular ability to strip and clean mechanisms, make new parts, solder, turn, cut screws, wheels and pinions, make hands, silver dials, pattern making, brazing and some forging.

The description continues, appealing to the more profound responsibility of the job:

Preserving a collection that's on display and appreciated by thousands every year will inspire you to achieve the highest standards in all you do...Above all, your passion for conserving horological items will be evident from your meticulous approach and high standards. This is your opportunity to take your skills to the next level and deliver the exceptional.

MALMÖ LATIN SCHOOL

Malmö, Sweden | c. 1406

Photo by Marcus Wallinder

"Malmö Latinskola," or Malmö Latin School, was founded in 1406, when Pope Innocentius VII issued a "letter of privilege" to the citizens of the town. Fast forward a few hundred years and it is today a thriving upper secondary school with roughly 1,000 students. As suggested by the six name changes that have taken place since its opening, Malmö Latinskola is a flexible institution, noted for its endurance, advanced learning, and frequent renovation to its building's structure and design.

That innovation is an apt reflection of Malmö itself. As Sweden's third-largest city, this growing cosmopolitan area is distinguished by its happy marriage of longstanding tradition and cutting-edge experimental art and development. The city has undergone a renaissance, as exemplified by bold architecture and changes to everything from the minuscule to the monumental.

Crouch down to marvel at two mouse-sized, mouse-targeted establishments: Noix de Vie (Nuts of Life) and the adjacent restaurant Il Topolino (Mickey Mouse, in Italian). Each storefront measures about 1 foot by 2 feet. The former has piles of carefully displayed nuts in its window. The latter displays a typical red-and-white awning and matching checkered tablecloths with a tiny menu on the wall listing a selection of cheese and crackers. These curious masterpieces are the work of the artist (or collective) Anonymouse MMX, who crafted both with materials like matches, buttons, caps, lids, and stamps—all of which mice would be able to use to build such fine enterprises.

But the most dramatic marvel of modern engineering, which has altered the physical and cultural landscape of this unique Swedish city, is the Øresund Bridge—a nearly 5-mile road and rail bridge that is the longest in Europe and as of July 2000, connects Sweden to the Danish capital of Copenhagen. Looking out the window from Malmö Latin, the sweeping suspension bridge appears to lose interest in the distance, gradually bending beneath the water. And indeed it does. As construction and traffic would have interfered with the high levels of activity at Copenhagen's International airport, the nearly ten-mile span was divided into three sections: a bridge, a man-made island (Peberholm), and a tunnel dug beneath the strait on the Danish end.

Connecting Sweden to the rest of Europe in this way has resulted in an increasingly diverse, dynamic, and youthful city, where over 150 languages can be heard along its quickly developing streets.

Malmö Latinskola has kept pace, completing a new auditorium in 2014, where students can enjoy lunch while watching a rock concert, a consequential international broadcast, or collectively listen to an engaging podcast. The school pays for each student to have a laptop and encourages specialization and an interest in experimental disciplines. And, perhaps not to be outdone by the masterwork that is the Øresund Bridge, in 1999 the formerly white school decided to distinguish itself with a fresh coat of paint: its current unmistakable bright mustard hue.

ÚLFLJÓTSVATN CHURCH

Úlfljótsvatn, Iceland | c. 1914

Photo by Rares Peicu

Roughly forty miles east of Reykjavik, Iceland, sits Úlfljótsvatn Church. This small place of worship and the pristine lake below it are named after Úlfljótur, the man who invented a new political structure for his homeland in the tenth century.

Iceland has long been known for its majestic, albeit intimidating, natural elements. Fire and ice meet frequently, with volcanoes erupting from glacial peaks. Upon this unforgiving terrain, the lives of the Vikings who first settled these lands were defined by fierce struggles for power with warring tribes. It was into this chaotic time that Úlfljótur, whose name means "Ugly Wolf," was born.

Rather than embrace the violent traditions of his ancestors, Úlfljótur traveled to Norway to study law.

When he returned to Iceland in 930 CE, he called for the first parliamentary meetings in the world. The place he chose for the occasion was Thingvellir, a dozen miles north of Lake Úlfljótsvatn, where the North American and the Eurasian tectonic plates come together.

At the point at which the continents meet, the leaders of Iceland gathered to discuss law and justice in a civilized manner. The congregation was known as Althing, or "assembly" (and is also the origin of the English word "thing"). Since the first Althing, the continents have shifted twenty-eight feet away from each other, but the political assembly still functions today as the oldest surviving parliament in the world.

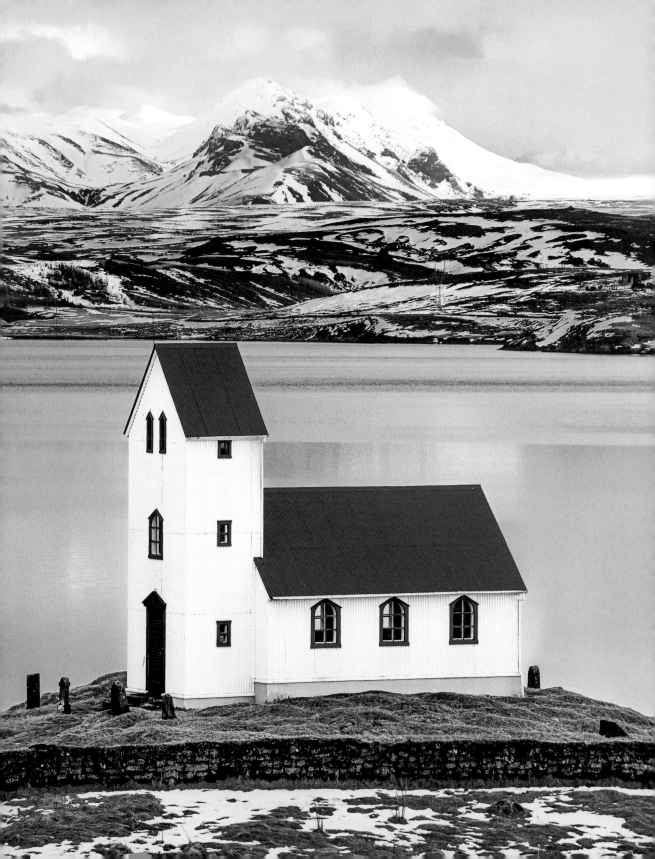

←

GRANDSTAND
Glava, Sweden | c. 2013
Photo by Claudia Jacquemin

→

WARRENDER BATHS CLUB
Edinburgh, Scotland | c. 1887
Photo by Soo Burnell

Glava is a municipality in the community of Arvika, Sweden. In 2010 Glava ceased to be regarded as a town, because the number of residents fell below the minimum to hold status as an urban area in Sweden, which is two hundred people. The locals got to work and regained the privilege back in 2015...only to lose it again three years later.

The neighboring community of Hillringsberg (stretching for all of two streets) uses the Glava football pitch for the Hillringsbergs IF, who play in the lowest division in the system. By the appearance of their grandstand, the team struggled with maintaining the requisite rowdy fan base to boost their morale.

Either that, or this photograph was taken on the same day as the entirety of Glava made a pilgrimage to Sweden's nearest census bureau, fighting to reclaim recognition as a proud legitimate town once again.

In 1886 in Edinburgh, Scotland, a group of swimming enthusiasts decided to start a swimming club. Queen Victoria was still on the throne, and not only did Great Britain rule the waves, but its people were famous for swimming in them. Only a decade prior, the legendary Captain Matthew Webb of Shropshire had smeared himself in porpoise oil and breaststroked across the English Channel, becoming the first person to do so and sparking a mania for swimming up and down the country. Ten years later, the swimmers of Edinburgh approached their local baronet, Sir George Warrender, with a grand idea: a private swim palace.

A local fifteen-year-old (the youngest member of the British team) named Ellen King trained at Warrender and competed in the 1924 Summer Olympics in Paris. Despite her success, the men of the club refused to allow King and her fellow female team members a celebratory gala. The following year, a group of women (including King) left in protest, forming their own Zenith Ladies Swim Club. It was Warrender Baths Club's loss: King later won two silver medals at the 1928 Olympics in Amsterdam.

Fast-forward to 2005: just three years after King was inducted into the Scottish Sports Hall of Fame, the pool where she began her illustrious career underwent a dazzling renovation. Warrender Baths has now been renamed Warrender Swim Centre, its pool lanes open to all genders equally.

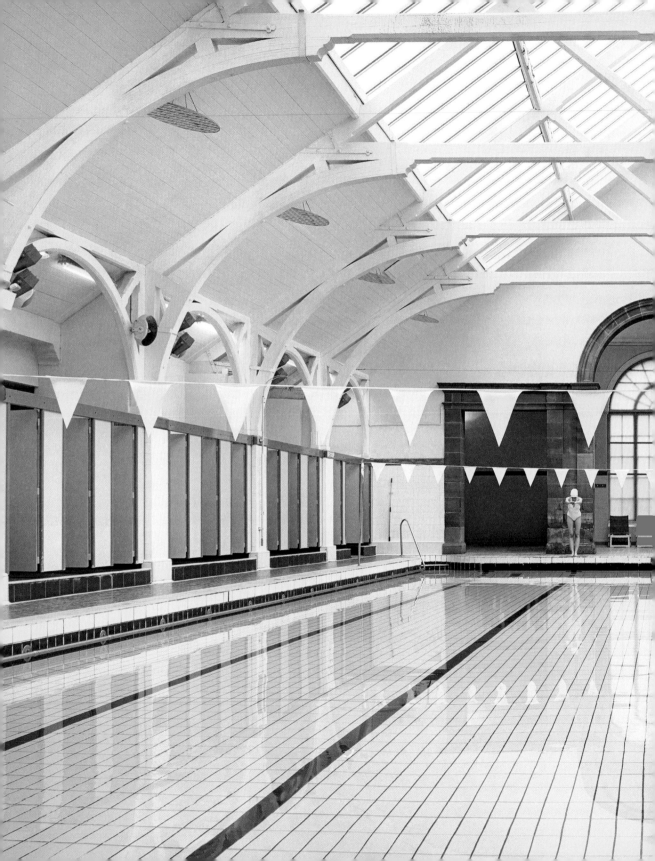

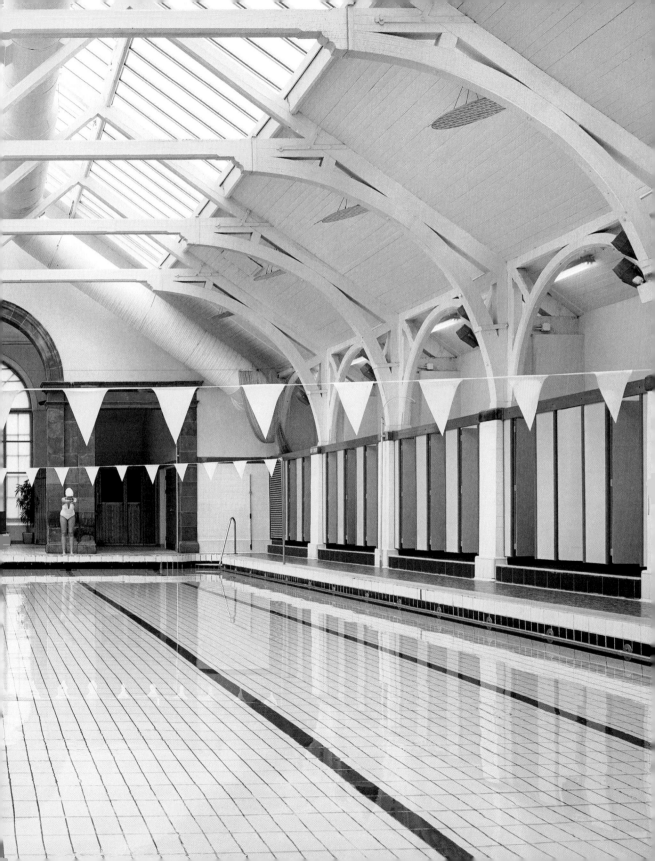

BRITISH ANTARCTIC SURVEY

Cambridge, England | c. 1962

Photo by Louise Walsh

What began as a secret mission during World War II would become the UK's national Antarctic research group. Operation Tabarin—named for a Parisian nightclub—was launched in 1943 with a dual scientific role. The original expedition was led by a marine zoologist, with the goal of denying safe anchorage to enemy raiding vessels while also gathering meteorological data in the South Atlantic.

By 1962, research was ongoing, with more than nineteen stations operating in the Antarctic, and reporting their findings back to Cambridge. It was then that the British Antarctic Survey gained its namesake.

The overall operation proved fruitful in the early 1980s, when scientists found a hole in the ozone layer. Their discovery was met with worldwide concern and brought validation and resources to the survey's work. In addition to culling data, Cambridge has been the headquarters for research team training. Discoverers prepare for the polar environment and test their proficiency with deceptively complex equipment, as seen here.

BAS's continued activity helps confirm that there are far more than penguins and desolation to discover at our globe's icy bottom.

THRUMSTER STATION

Thrumster, Scotland | c. 1903

Photo by Samuel du Plessis

Thrumster Station was a short-lived light-rail stop between Wick and Lybster in Scotland's county of Caithness—known enigmatically as the "Land Beyond the Highlands." Opened at the dawn of the twentieth century, the stop was terminated in the spring of 1944, along with all of the other stations along the same line. The building, however, remains in good shape thanks to a restoration bankrolled by the National Lottery.

GRÖNA LUND

Stockholm, Sweden | c. 1883

Photo by Marta Rękas

On Djurgården Island off central Stockholm lies Gröna Lund ("Green Grove"), a "magical world where the impossible becomes possible. Old gets young, little gets big, up gets down and down gets up," according to official descriptions. German carpenter Jacob Schultheiss rented the area to build "carousels and other amusements" in 1883, making Gröna Lund—more widely referred to as Grönan—Sweden's oldest amusement park.

Grönan hosts thirty attractions—including a tunnel of love, a funhouse, and roller coasters. Among the rides is the hand-painted Kättingflygaren: mechanized swings designed to give you a feeling of flying over the bordering lake.

The park holds regular dances, shows, and concerts at three entertainment venues. Music legends Tina Turner, Elton John, and Jimi Hendrix have graced its stages—with the capacity record set by Bob Marley, who packed in 32,000 people in 1980. Marley's record is unbeatable, since new regulations preclude audiences of that size.

Right across the street is a parking lot that was the site of a competing amusement venue. The rival parks battled it out from 1924 to 1957, when matters of the heart took both of the owner-families for a ride. The children of the competing owners fell in love and got married, leaving the businesses with little better choice than to merge. Schultheiss's descendants ran the park until 2001.

Grönan has soaring ambitions for the future. There are plans to begin building a promenade along the water by 2024, and the once-rival-now-family's parking lot is slated to be an active zoo.

LLANDUDNO CABLE CAR
Llandudno, Wales | c. 1969
Photo by Alexander Wormald

Since the summer of 1969, the longest passenger cable car system in Britain has run from Happy Valley to the summit of the Great Orme, a limestone outcropping in Llandudno, Wales.

Climbing to nearly 80 feet and traveling a mile in either direction, these vibrant, multicolored gondolas offer ten minutes of striking views from the Irish Sea to the Isle of Man—unless the weather is windy or rainy...in Wales (Adventurers are advised to check the forecast before venturing out.)

VICKERS VISCOUNT
London, England | c. 1948

Photo by Paul Fuentes

MARSHALL STREET BATHS
London, England | c. 1850

Photos by Soo Burnell

The Vickers Viscount is a turboprop airliner designed by Sir George Edwards (who oversaw the development of the Concorde) and first flown in 1948 by Vickers-Armstrongs, a British engineering conglomerate.

This particular stunner was taking off from London's Gatwick Airport—notable for building itself up from humble beginnings as a 1920s aerodrome. Gatwik was a manor house in the village of Charlwood, which today serves as the airport's North Terminal taxiing area. The manor's name, first recorded in 1241, combines the Old English "gāt" ("goat") and "wīc" ("farm").

So the next time you feel you're being shepherded through an endless queue at check-in, pause to enjoy history's curious tendency to repeat itself... and keep in mind that you may be standing on what was once a thriving goat farm.

"Whereas it is desirable for the Health, Comfort, and Welfare of the Inhabitants of Towns and populous districts to encourage the Establishment therein of public Baths and Washhouses and open Bathing Places..."

So began the 1846 Baths and Washhouses Act passed by the British Parliament to encourage local authorities to build public bathing areas. The Act came as a response to the growing number of citizens who were in severe need of bathing facilities and a place to launder their clothes. Public funds were used to finance these baths, not so much to offer a luxurious spa experience as for purposes of basic health and hygiene.

The Vestry of St. James took advantage of the Act and began to construct the Marshall Street Baths in 1850. The original proposal requested sixty-four pools and baths, and two large plunge baths (which women were allowed to use once a week, on Wednesdays from 2:00 to 6:00 p.m.). There was an extra charge for hot water.

The land cost £3,500, including a house for the superintendent, and in 1931 the Westminster Public Baths were opened to the public. Great attention was devoted to the main swimming pool, which was lined with white Sicilian marble, and further embellished by Swedish green marble used at either end. In a small niche in the shallow end was a bronze fountain depicting a merchild with two dolphins, designed by Walter Gilbert, a sculptor who also created a coat of arms for the gates of Buckingham Palace.

The baths were closed in 1997 for refurbishment that took over a dozen years. The 2010 reopening returned the baths to their former glory. The stunning pool retained its original design, with marble lining and its barrel-vaulted roof, offering swimmers a tunnel into the past.

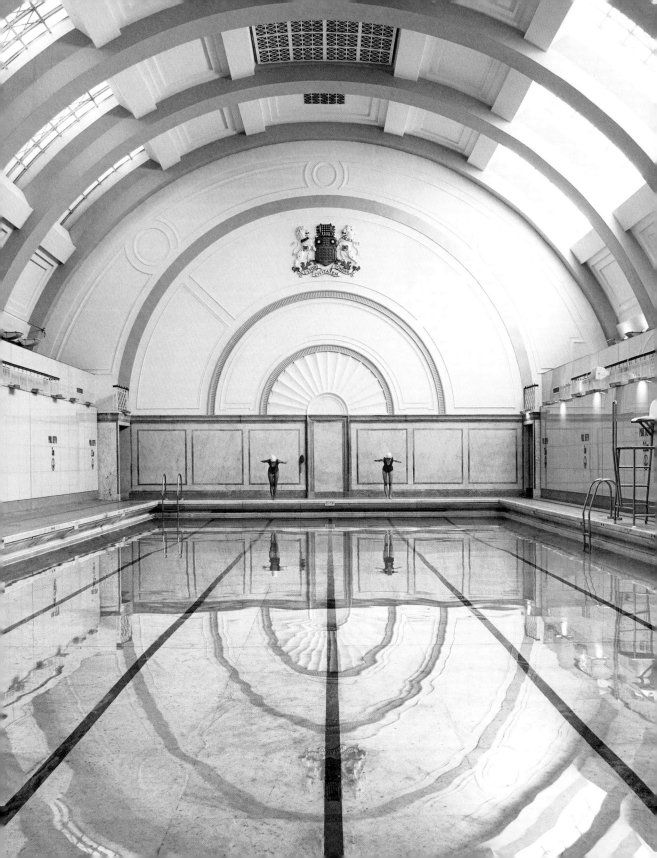

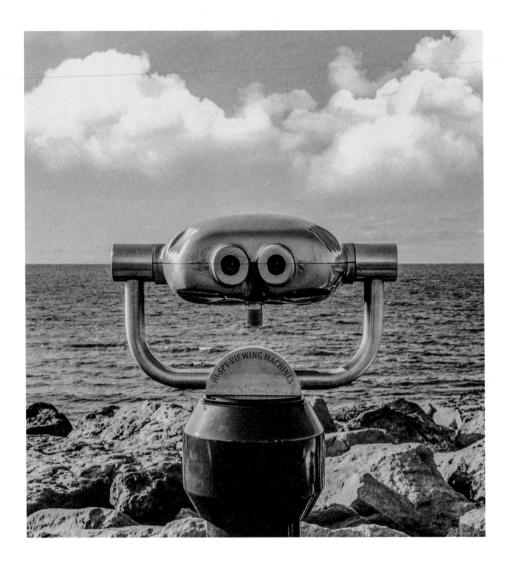

VIEWFINDER
Reykjavík, Iceland | c. 1991

Photo by Oksana Smolianinova

Though this Hi-Spy Viewing Machine looks like R2-D2's cousin who rolled off the Star Wars set and made his way to the rocky edge of Reykjavík, this family of observation scopes wasn't manufactured until 1991.

Its brethren can be found looking out over other scenic spaces, through two eyes or one. Admired for their robust durability, their heavy-duty structure enables them to sustain intense usage, over time and throughout the extreme seasons endured in places such as Iceland.

SEURASAARI OPEN-AIR MUSEUM
Helsinki, Finland | c. 1909
Photo by Lucrezia Rossi

Established in 1909 on a Seurasaari island off the coast of Helsinki, this museum—known as "rural Finland in miniature"—displays Finnish life through a wonderland of cultural treasures. Hidden in the middle of the forest, the museum's more than eighty buildings honor Finnish culture over the last three centuries.

Seurasaari was created as a tangible symbol of Finnish national pride, at a time when the country was a semiautonomous part of the Russian Empire. The 1905 Russian Revolution served as a distraction, giving the Finns room to create a radical legislative body that made tremendous strides toward a more open society—making Finland the first European nation to grant full political rights to women, and to elect them to their parliament. The Seurasaari Museum was opened around the same time, as a

cultural effort to preserve cherished traditions that seemed under threat from renewed efforts of Russia's aim to destroy "Finnish separatism."

The portrait of a simpler past shares the same island with far more liberated advances, including being the site of one of only three nudist beaches in all of Finland. The Seurasaari beach is segregated for men and women, and visitors must pay to enjoy their freedom from the oppression of clothing.

The island's popularity peaks on midsummer's eve, during the solstice festival. Following a tradition of uncertain origin, a newlywed couple participates in a ritual lighting of a bonfire—or *juhannuskokk*—and are ferried around on a boat. Thousands of people, clothed or otherwise, take in the bonfires from Seurasaari and boats anchored nearby.

UNITED KINGDOM
& NORTHERN EUROPE

SALTHILL PROMENADE
Galway, Ireland | c. 1860
Photo by Lucy Parkinson

The Irish name for Salthill is Bóthar na Trá, or "the road by the sea." Stretching out beside Galway Bay with the hills of Clare waving in the distance, Galway City buzzing behind you, and the Aran Islands off to the side, Salthill Promenade captures the full allure of West Ireland. Even when dense clouds of rain or fog obscure one's view, you can still feel the charm when you're standing on the 150-year-old seaside "Prom." Should you wander down this historic stretch, local tradition dictates that you kick the wall across from the Blackrock diving boards (seen here) before turning around and strolling back to town for a pint.

If, over that pint, you happen to spend enough time discussing the area with any reasonably sauced local, you'll hear about the savage storm of 1839, which destroyed much of the Salthill area. Boats were lost, crops were destroyed, most of the traditional thatched cottages were demolished, and lives were upended. As lore has it, there was a boat going from Galway to Sligo, to transport poteen—an often homemade distilled Irish drink, akin to moonshine. When the storm hit, the boat was obliterated, and all the men drowned. Their bodies were found on the sand in Salthill, and each man had an unshattered bottle of protected poteen in his pocket.

This tragic storm was closely followed by the Great Famine, which further destroyed the area, resulting in the sale of local estates whose landlords had gone bankrupt. In the wake of such loss, the large and influential Eglinton Hotel was built in 1860. Shortly afterward, tram tracks were laid down from Eyre Square out to the Eglinton, making transport from the city center to Salthill accessible. Several new amenities were developed, facilities were put in place for swimmers, and the prom was built.

Galwegians and visitors alike take advantage of Salthill Prom, whether enjoying the frigid swimming area (which still includes a ladies-only side), playing at arcades, listening to gigs, or simply walking along the coast and breathing in the sights, as hundreds of people do every day, regardless of weather or season.

There are parts of Salthill prom and its immediate surroundings that portray less of a postcard view than other areas. The prom has seen dramatic changes in a relatively short amount of time—just ask that local. Seafront ballrooms were replaced by nightclubs, leading inevitably to brawls, especially during the more tumultuous years in Ireland's history. In the late 1980s, Galway rose to become a big tourist attraction. As hotels, hostels, and trendy gastropubs sprang up within the city, the main drag of Salthill—once peppered with a string of B&Bs and small, family-run establishments—was eclipsed by two large hotels overlooking the prom. Overpriced cafés, a gourmet tart company, and a microbrewery replaced decades-old fish 'n' chip shops.

The promenade remains a blend of beautiful views and flashy, tourist-luring venues. As is the case in similar seaside areas, such as Coney Island or Fisherman's Wharf, it's rare to find such a remarkable commercial strip between land and water without there being some elements of flagrant neon. Nevertheless, tourists and Galway locals alike continue to get a kick out of "walking the prom."

NATIONAL LIBRARY OF IRELAND

Dublin, Ireland | c. 1877

Photo by David Maguire

The island of Ireland is about one tenth the size of Texas. To put that into perspective, you could fit almost 100 Irelands into Australia. Its population—the Republic and Northern Ireland combined—is around 6.7 million people, which would place it at #53 on the list of the world's largest *cities*, not *countries*. And yet, this tiny isle has produced some of humanity's finest published authors, poets, and playwrights. James Joyce. Oscar Wilde. Samuel Beckett. Jonathan Swift. George Bernard Shaw. William Butler Yeats. Eavan Boland. Bram Stoker. Seamus Heaney. Frank McCourt. Anne Enright. Iris Murdoch. Colm Tóibín. To name but a few. With such a profound literary heritage, it's fitting that one of Dublin's most impressive and often-frequented buildings is its remarkable National Library.

Much like the prodigious works and notable characters whose art is preserved upon its hallowed shelves, there is nothing average about this library. For starters, this library does not lend out its treasures. Instead, you may peruse most of its collections within one of its many reading rooms.

Home to a stunning array of rare books and historical records, alongside many of the notebooks in which the country's finest works were drafted, the library boasts 10 million artifacts available to view (on-site or in its growing digital archive). Many of those records are sought after by the thousands of people who visit each year to trace their family history.

Chances are good that you'll find the obscure article or image you're seeking. After all, the library's records, gathered for over 140 years, constitute the most comprehensive collection of Irish documentary material in the world, with every page preserved in order to represent the country's history, its heritage, its memory, its story.

But it would be impossible to tell any story in true Irish form without adding a pinch of the absurd, a wink that the audience may or may not fully comprehend. The history of Ireland's "memory keeper"— as the National Library is called—delivers. With such a robust story to tell and with so many records to keep, severe shortage of space became an issue for the NLI during its earliest days. Further properties in the vicinity were acquired, including numbers 2 and 3 Kildare Street (previously part of the Kildare Street Club—a private social club dating back to the 18th century). The architect of the library and the Kildare buildings, Thomas Newenham Deane, was known for adding sculptures of "whimsical beasts" to his structures, most notably the billiard-playing monkeys on the Kildare Club building. One monkey is leaning over the table taking a shot; another is chalking his cue; still another is watching idly. Who *actually* sculpted these sophisticated, competitive primates? It may be difficult to get a straight answer, as this remains a longstanding controversy among Dubliners.

Regardless, the next time you visit the wonders of the National Library of Ireland, after exploring the legendary whimsy in the pages of Joyce or Wilde, or the beasts created by Jonathan Swift or Bram Stoker, step outside and seek out another form of immortal genius: the monkey billiard game that will never end.

RORBU CABIN

Lofoten, Norway | c. 1120

Photos by Maria Vanonen

Well above the Arctic Circle, the Lofoten Islands of Norway spend the winter covered in snow and cloaked in darkness. From early December to early January, the sun does not rise...at all. Perhaps it is due to these dark and dreary conditions that the islands' wooden huts, known as *rurbuer* (*rorbu* in the singular form) are so brightly painted.

The predecessors of these small cabins were commissioned by King Øystein in 1120 as housing for seasonal fishermen, who would descend upon Lofoten during the winter months, when cod arrives in droves to spawn in the arctic waters. The cabins were originally built on poles, partly out in the sea. Many of these tiny homes have been refurbished to modern standards and are now rented to those seeking utter darkness or rustic Scandinavian charm.

FLÅM RAILWAY
Flåm, Norway | c. 1924
Photo (above) by Vrinda Gupta, photo (right) by Patti Gutierrez

In 1924, hundreds of workers used hands, picks, shovels, and acute determination to dig and carve out ample space within and throughout a series of soaring mountains. The resulting eighteen tunnels made possible the hour-long, twisting journey between western Norway's Flåm and Myrdal stations.

These comfy train cars provide such awe-inspiring views—stunning fjords, sheer gorges, magnificent waterfalls—that the ride itself has become a tourist destination. The breathtaking sights so delight passengers that many neglect to disembark, opting instead to spend all day riding back and forth, gawking at the scenery.

CROSS-COUNTRY SKIERS
ON SOGNSVANN LAKE
Oslo, Norway | c. 1700s

Photo by Chris Dovletoglou

7 THOMAS COURT
Dublin, Ireland | 1940s

Photo by Joabe Ferreira

The Norwegian relationship to skiing runs deep: the first rock carving of a skier was created 4,500 years ago in Rødøy, Norway. Centuries later, Norwegians invented cross-country skiing as a means to *gå på ski* ("walk on skis") across heavy snow. They were also the first to transform it from a mode of transport to a recreational activity, or *langrenn* ("long competition").

Oslo alone is host to 2,600 miles of cross-country ski trails twisting through its forests. In the winter, locals can clamber onto the Metro with their skis and soon find themselves breathing in the crisp air at snowy Sognsvann Lake alongside fellow day-trippers trading an urban landscape for pristine nature. Some clad in layers of gear, others wear nothing but shorts and ski goggles as they push and wind their way through the conifer-lined trails.

Skiers often take a break at one of several public cabins dotted along the trails, where they're offered hot drinks, *vafler* (heart-shaped waffles topped with local jams), and *brunost*, a caramelized goat cheese that refuels the body before venturing back out to *gå på ski* along the restorative, snow-laden trails.

Located southwest of Dublin's city center, the Liberties is among the oldest working-class neighborhoods in the country's capital. It also happens to be home to the original Guinness brewery, founded in 1759.

The Guinness family built tenement housing on Thomas Court for their workers, and their enterprise dominated the Liberties throughout the late eighteenth and nineteenth centuries as they developed what was then the world's largest brewery. Distilleries for the whiskey makers Powers and Jameson were also located nearby, creating a cityscape of chimney stacks, mills, and malt houses.

On June 18, 1875, disaster struck when a whiskey and malt depot went up in flames, sending burning whiskey flowing down the cobblestone streets like lava.

Dublin Fire Brigade chief James Robert Ingram knew that dousing the flames with water—as a number of frightened yet benevolent locals rushed to do—would make matters far worse. Rather, he ordered his men to unload horse manure onto the streets, which successfully stopped the flow of the fiery liquid, allowing the brigade to extinguish the burning buildings.

After all was said and done, the Liberties reformed. No one was set aflame, nor did anybody perish from smoke in their lungs. However, newspapers from the time confirm that during the calamity, masses of people rushed to take off their hats, boots, or any nearby vessel to grab a drink from the streams of flaming whiskey and at least four people died from the effects of consuming the burning hot liquid.

In a city known for its statues and tributaries, there is nothing to commemorate this tragedy, nor to honor the fact that the Liberties was saved by piles of horseshit. But the evening's events lend credence to the saying "God invented whiskey to keep the Irish from ruling the world."

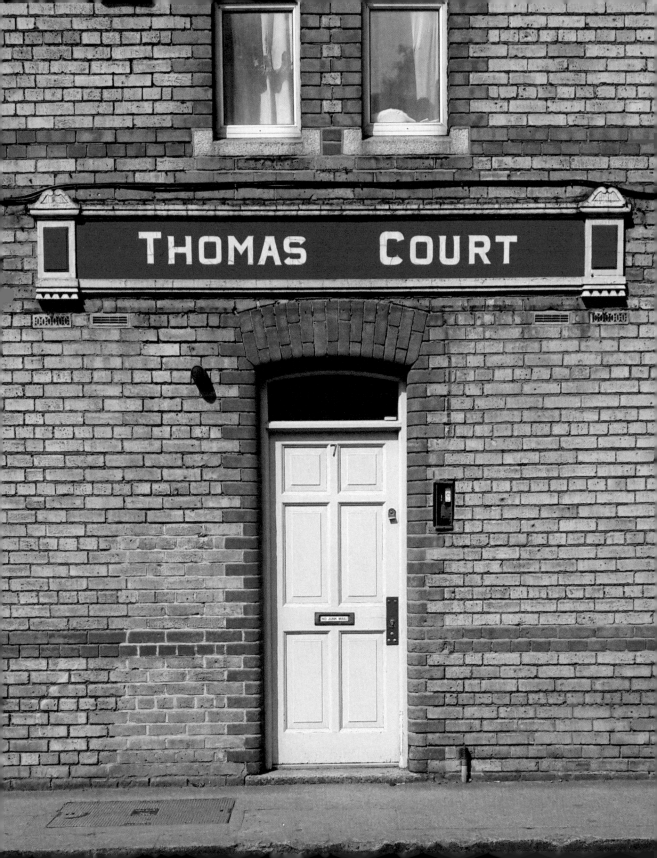

LAUNDERETTES
London, England | c. 1949
Photos by Joshua Blackburn

On May 9, 1949, the first launderette in the UK opened at 184 Queensway, London. The launderette industry grew steadily over the next three decades—until home washing machines became more affordable.

Frigidaire dominated the self-service "launderette boom," providing the company the opportunity to promote their products while promising an effortless second income for investors. Unstaffed premises could be open 24/7, and anyone could buy in on the franchise. But machines required ongoing maintenance, and the city's less fortunate population began to use the premises as makeshift shelters.

Though launderettes still provided a much-needed service, more than a thousand of them closed in London over a thirty-year span, leaving around 350 active locations.

Though home ownership of washing machines would rise to 97 percent, an unlikely savior has arrived, in the form of a duvet. Those who have looked into the subject share the prediction that the future of the British launderette is secure, due to a renewed passion for comforters—which simply don't fit in domestic machines.

So, as long as the rain keeps falling in England, the rumble and tumble of the remaining London launderettes should be safely preserved.

AMALIENBORG

Copenhagen, Denmark | c. 1754

Photo by Lara Miles

The storied palace of Amalienborg in Copenhagen is the winter residence of Queen Margrethe II, protected night and day by the Royal Life Guard. At first blush, their uniform appears similar to that of the foot guards of the British army, with one key difference: each of their exceptionally heavy hats is made from the fur of an entire bear.

Every day at noon, these top-heavy guards march from Rosenborg Castle past the centerpiece of Amalienborg: a statue of Denmark's King Frederick V—a man known for fits of drunken rage, shameless womanizing, shirking his royal duties, and the brutal treatment of his mentally ill son, whose bouts of hallucination and mania would later establish him as Denmark's mad king, Christian VII.

In 1748, Frederick V ordered the reconstruction of Amalienborg, which had burned down more than a century earlier. The restored complex became the centerpiece of Frederiksstaden—a district the king designed, with himself at the center and the royal aristocracy's four identical mansions facing him.

He had his likeness immortalized in bronze; he was depicted sitting in a commanding pose upon a horse. The statue was as expensive as it was heavy—weighing in at 22 tons, it was commissioned at a cost

of four times the budget for the surrounding mansions. When it arrived by ship, it required the might of 200 sailors to haul the statue from the Copenhagen harbor to the center of this square.

In a fitting twist, the king never had the opportunity to see this embodiment of his self-regard: complications from a drunken accident ended his life before he caught a first glimpse.

Now centuries later, at a daily parade and concert involving over fifty musicians, Frederick is saluted as the royal protective unit moves from Rosenborg Castle to Amalienborg for the changing of the guard (and the relief that comes from removing a huge fur hat from one's head, no matter the season).

Unlike guards elsewhere (like those at Buckingham Palace), members of the Royal Life Guard are free to physically push tourists away should they come within two feet—a perk that is often enjoyed as a spectacle. And if ever they are forced to fire a warning shot in the air, they point their guns toward Sweden—a remnant of a long rivalry between neighboring countries...and King Frederick V would no doubt approve that his equestrian self-tribute is never marred by a single bullet hole.

←

REYKJAVÍK OLD HARBOUR
Reykjavík, Iceland | c. 1913
Photo by Keira Lyons

→

FIGARO
South Yorkshire, England | c. 1989
Photo by Hayley Doyle

While Iceland is home to the descendants of Viking settlers and their Celtic wives, it is also home to marine animals and birdlife including minke whales and the beloved puffin. For those desiring a close-up view, boat tours depart daily from Reykjavík's Old Harbour.

The harbor once allowed for the comings and goings of thousands of fishermen, but as tourism rose over the last two decades—joining aluminum smelting and fishing as Iceland's largest industries—whale-watching ships have joined the fishing vessels. Old bait and net sheds have become trendy cafés that cater to the influx of visitors intent on experiencing the natural splendors of this tiny country, just south of the Arctic Circle.

Minkes are the most commonly spotted whales on these excursions. Until recently, hunting these whales was common, but this practice was halted in 2018. The minke is identified by its narrow snout and distinct "*Star Wars* call," which sounds remarkably like the pulsing hum emitted by lightsabers.

But don't let the Jedi qualities of the minkes distract you from the brightly colored beaks of the native puffins. From April to August, more than half of the world's Atlantic puffins settle on the tiny islands off the shore of Iceland. The rest of the year, they are solitary, spending winter out at sea, bobbing alone in the waves, taking stock. They come ashore to breed and to raise their young, happily pairing up with other introverted puffins for the season.

Should they find their partner, adult puffins mate for life. They share parental responsibilities, and even take turns incubating the egg.

The Nissan Figaro is a happy little two-door convertible designed as a tribute to vintage microcars. Originally marketed solely in Japan with the slogan "Back to the Future," the minicar's retro design was always meant to shuttle drivers to another age—a dimension of sweet simplicity.

The car debuted at the 1989 Tokyo Motor show. As a result of the initial enthusiasm, Nissan launched sales in Japan in 1991, offering the car in colors to suit the seasons: Lapis Grey (Winter), Emerald Green (Spring), Pale Aqua (Summer), and Topaz Mist (Autumn). Immediate demand so outstripped the company's limited run of 20,000 vehicles that prospective buyers had to enter a lottery to drive one of the cars home.

The Figaro's inimitable design is credited to fashion designer Naoki Sakai, who had never designed a car and who didn't even have a driver's license... which may explain why its style surpasses its safety. In fact, the Figaro was so far from U.S. standards that it was banned there after the car's debut.

Its size does lend to great maneuverability: it's even been said that "if you can't parallel park the Figaro, you should be walking."

SOUTHERN
& EASTERN
EUROPE

NATIONAL ART MUSEUM OF UKRAINE

Kyiv, Ukraine | c. 1898

Photos by Dasha Lukyanova

The National Art Museum of Ukraine has long been an arena for the country's fight to express its own identity. In 1898, it was established as a small center for local art and antiques. Kyiv had been under Soviet rule for centuries, resulting in heavy restrictions imposed on cultural expression—at one point, the Russians even banned the use of the Ukrainian language, spoken by the majority of the population. To further discourage pride in or proliferation of local culture, the museum was reintroduced in 1904 as the Kyiv Industrial Arts and Science Museum of Emperor Nicholas II.

After World War II, the museum renamed itself the National Art Museum of Ukraine. Leagues of Ukrainian artists had fled the country, so to properly represent native artists, the museum sought out pieces from refugees residing in Western Europe and beyond. Stalin's regime determined such works to be subversive and forced the rogue art to be dispersed or hidden.

In 1991, Ukraine celebrated its independence. In a flourish of renewed pride, the museum expanded its collection and began to attract international attention, as audiences grew fascinated with art from behind the Iron Curtain. The museum continues to honor its identity through a vast range of Ukrainian art with collections that are decidedly more exciting than this receptionist's demeanor would suggest.

102.4 FM

Mirny, Mirninsky District, Russia | c. 1955

Photos by Felix Lowe

The 40,000 people who choose to live in Mirny, a city located about 280 miles from the Arctic Circle, have a number of reasons to listen to the radio. Winter lasts for ten months out of the year, which means enduring an average temperature of −40°F. Turning off the radio and leaving the house for work can essentially mean you're going to do one thing: find diamonds.

Desperate to recover from the devastation of World War II, in the 1950s the Soviet Union scoured remote Siberia for precious metals. When tests from the desolate outpost of Mirny came back positive for traces of the volcanic rock kimberlite, suggesting diamond deposits, Stalin ordered a mine to be dug there immediately.

Breaking through the surface of Mirny's soil was no small feat due to its inhospitable temperature and dense permafrost. During construction, the extreme cold shattered the steel machinery and caused oil to freeze. Finally, under pressure from the Kremlin, workers used jet engines to thaw the permafrost and then blasted through it with dynamite.

The resulting chasm is 1,700 feet deep and more than a half-mile wide: the second biggest hole made by man.

The gamble was deemed worthwhile: the mine produced 10 million carats of diamonds per year in its first two decades, 20 percent of which were gem quality. One particularly notable find was a 342.57-carat yellow diamond given the inelegant name, "The 26th Congress of the Communist Party of the Soviet Union."

Beginning with a few log shanties created for the original miners, Mirny grew rapidly. Today, the town has everything one needs to survive more or less constant winter. They have a daily newspaper, a library, two theaters, five cinemas, and their very own radio station, 102.4 FM.

The name of the station can be translated as radio from either the "realm of diamonds" or the "edge of the world." Both names suit a frequency that broadcasts beside one of the largest diamond mines and most gargantuan holes on earth...and is based in Siberia.

KYIV METRO
Kyiv, Ukraine | c. 1960
Photo by Alina Rudya

MARITIME STATION
Constanța, Romania | c. 1931
Photo by Waqar Ahmad

The Kyiv Metro is the backbone of Ukrainian public transport. First proposed in 1884, it was seventy-five years before its first five rapid-transit stations opened.

Since then, the network has expanded to 52 stations, including a stop at Arsenalna station, 350 feet below street level—the deepest train station in the world. Reaching its platform requires a five-minute multiple-escalator descent. Other Metro stops are cast in marble, with chandelier fixtures and ornate details.

Passing through these stations are brightly colored trains painted blue and yellow, like the Ukrainian flag. There are a few marvelous exceptions: as part of a project from ArtUnitedUs, one of the five-wagon trains of Kyiv has been transformed into a kaleidoscopic wonder. Some have described this singular car as a "psychedelic vision" pulsing through the capital, turning an otherwise gray and dreary commute into a multicolored joyride.

Constanța is the oldest continuously inhabited port city in Romania, having served as a gateway from the Danube River to the Black Sea since its founding by the ancient Greeks. Located at the nexus of trade routes linking landlocked European countries to Central Asia and the Far East is the 1931 Maritime Station. With its clean, modernist design, it was built in part to receive passengers from the Orient Express and usher them onto the ferry to Constantinople, now Istanbul. Waving passengers off from the top of the station are two dolphins frolicking around a shield in the guise of a clock.

HOTEL MOSKVA

Belgrade, Serbia | c. 1908

Photo by Marius Svaleng Andresen

In 1908, King Peter I of Serbia presided over the opening ceremony for the new Hotel Moskva in Belgrade. Citizens had been gathering daily to witness its construction, from the digging of the foundation to the laying of the last emerald tiles on the roof.

After World War I, Hotel Moskva's kafana, or café, became a center of the Serbian literary scene. In war-torn Belgrade, where electricity was scarce, novelists came to the hotel because, as writer Miloš Crnjanski explained, "It was the only place with light." Crnjanski formed a collective of artists and creators, "Grupa Umetnika," who were determined to bring new art and culture to their beloved city. Escaping the devastation of Belgrade, the group spent evenings in Hotel Moskva's finely decorated kafana, engaging in passionate discussions and enjoying the luxury of artificial light.

Such intellectuals dominated the scene at the hotel in the interwar years, but by the summer of 1941, Nazi Germany had invaded not only Belgrade but Hotel Moskva as well. The establishment became a Gestapo headquarters. However, the post-World War II period saw writers and artists cautiously but happily returning to the hotel for coffee and reinvigorating discourse. Nobel laureate Ivo Andrić had a permanent table of his own, where he might have nodded to poet Vasko Popa, another regular.

Hotel Moskva continues to attract elite guests, including famous actors, politicians, and other luminaries. Everyone from Albert Einstein to Indira Gandhi to Alfred Hitchcock (who all have suites that were subsequently named after them) has graced its halls, though nobody ever stayed in room 13, because the hotel doesn't have one.

BLUE MOSQUE

Yerevan, Armenia | c. 1764

Photo by Giancarlo Caramadre Amodio

The Blue Mosque is among the oldest structures in central Yerevan and the last one standing of the eight mosques that once graced the city. Constructed in the 1760s, it was secularized under Soviet rule. They used the mosque to host an Anti-Religious Museum and then the Museum of Antifascism. Later, it became a science museum, with a planetarium located in the main prayer hall. Following Armenia's independence, it once more became a house of worship for Armenia's small Muslim population (roughly less than a tenth of 1 percent of the nation).

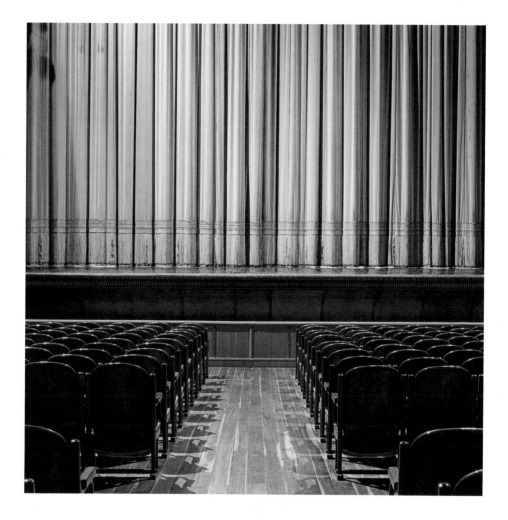

TEATRO ALESSANDRO BONCI

Cesena, Italy | c. 1846

Photo by Maicol Marchetti

The cosmopolitan Italian town of Cesena has several theaters, but none more epic than Teatro Alessandro Bonci—its drama and opera house, named for the famed tenor and Cesena native. Alessandro was an apprentice shoemaker before studying music and gaining international prominence. His voice vibrated through the world's best theaters, among them Milan's La Scala, New York's Metropolitan Opera, and London's Royal Opera House.

Inside, the five-level auditorium, the original stage and signature painted curtain have been specially preserved—along with its original sound machine. The source of auditory effects such as thunder has been kept alive, along with the legacy of the cobbler trainee whose voice once resonated throughout Cesena's classic venue.

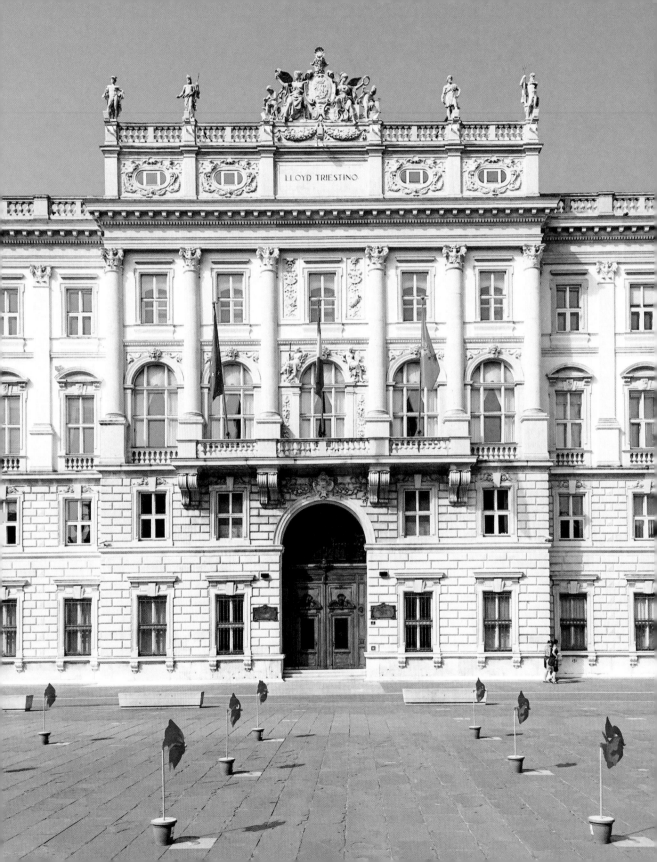

LLOYD TRIESTINO PALACE
←

Trieste, Italy | c. 1836

Photo by Lorenzo Marchi

ASCENSOR DA BICA
→

Lisbon, Portugal | c. 1892

Photo by Jack Spicer Adams

In the eighteenth century, Empress Maria Theresa of Austria sought to develop the port of Trieste, the northern Italian city that was then under her rule. She orchestrated its transformation into a prime gateway between European and Eastern markets.

Her foresight, plus an influx of craftsmen as the city went through its own renaissance, explains the most striking building in the Piazza Unità. The Lloyd Triestino Palace overlooks the sea and still serves as a hub for one of the oldest active shipping companies. Lloyd Triestino, known originally as Österreichischer Lloyd ("Austrian Lloyd") and now operating in partnership with Taiwanese shipping giant Evergreen Marine, was among the first companies to use steamships. It offered both passenger and cargo routes to the Middle East and Far East, reaching India, China, and Japan.

After the Great War, Trieste became a part of Italy, and the company continued to thrive, only to be crippled in World War II. Once eighty-five ships strong, its fleet was reduced to just five.

Its swan song came in 1963, when the gorgeous sister ships *Galileo Galilei* and *Guglielmo Marconi* wowed the public as the biggest passenger ships ever built for Lloyd Triestino—but they were also the last. In the 1970s, competition from airlines forced the Lloyd to close down its passenger services, withdrawing its glamorous liners and replacing them with container vessels. It is now a much smaller enterprise than it once was, but this grand building testifies to Trieste's momentous seafaring tradition.

Built in 1892, the charming Ascensor da Bica is one of Lisbon's three funicular railway cars. A funicular railway car differs from a standard tram through its reliance on its twin. Two passenger vehicles are pulled on a slope by a single cable looped around a pulley wheel at the top. The pair move in perfect synchronicity: one vehicle ascends as its descending partner counterbalances it.

This unique mode of codependent public conveyance, which bears similarities to a kind of outdoor elevator, was initially powered by a water system—a car at the top of the hill was loaded up with water until it was heavy enough for gravity to assist in its descent, thus pulling its counterbalanced twin up to the top of the hill. In 1896 the system became steam-powered, and in 1924 it was electrified.

Ascensor (or Elevador) da Bica climbs 800 feet up one of the city's steepest hills. A delightful, leisurely ride and a hop off at the top leads you to Miradouro de Santa Luzia, a terrace from which to marvel at the distinct rooftops of Europe's westernmost capital city.

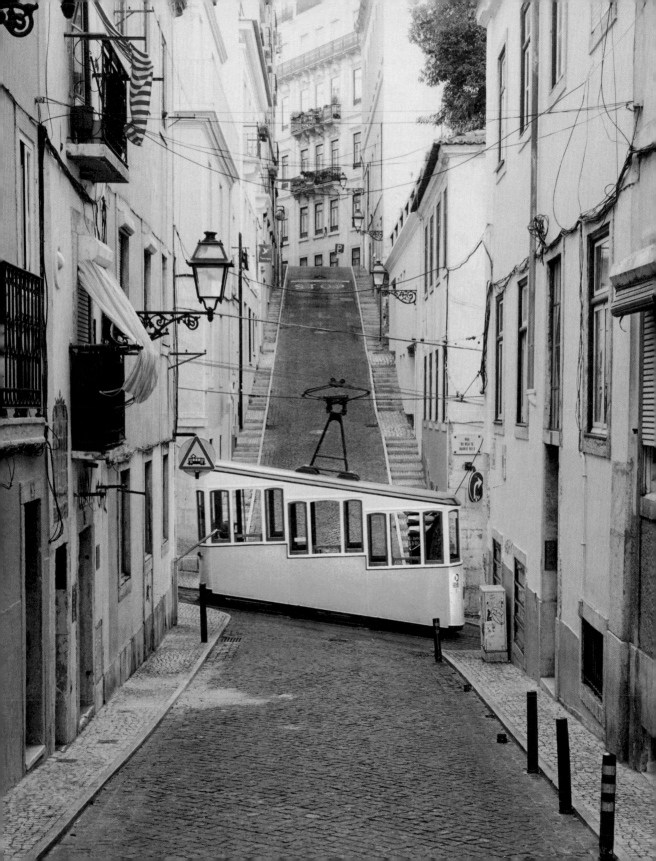

TYPICAL HOME

Burano, Italy | c. Sixth Century

Photo by Claire Walker

Burano, Italy, is an island in the Venetian lagoon, often listed among the ten most colorful locales in the world. Here, Technicolor homes painted using the full rainbow are made all the more vibrant for their reflection off the green waters of the canals that snake through the town. There's also the inevitable sight of Italian women embroidering original Burano lace—the island's primary craft—while gossiping in the central square of Piazza Galuppi.

The multicolored houses originated as a sort of communal lighthouse for returning fishermen, so they could find their homes through the fog. Today, a strict color scheme remains in force: if residents choose to paint their home, they send a request to the government, which responds with the specific colors permitted for that lot.

PALAZZO DUCEZIO

Noto, Italy | c. 1830

Photo by Deborah Lo Castro

Palazzo Ducezio is the core of Noto, in southeast Sicily, and serves as town hall. Named for the city's founder, the baroque palace has a magnificent convex exterior—but is best known for its evocative *Sala degli specchi* ("Hall of Mirrors"), an oval room embellished with Louis XV decor and gargantuan mirrors. Gold-framed reflections may please the vainer visitors but shouldn't detract from the side panels, which elaborate on the city's splendor via a sort of collage of preserved items from Noto's past.

PLAZA DE TOROS DE LA MAESTRANZA
Seville, Spain | c. 1749

Photos by Emil Edilersky

Regarded as a celebration of tradition by some, a shameful glorification of violence by others, the bullfight continues to evoke extreme passion in the people of Spain. One of the world's oldest and most significant bullrings, La Maestranza is a mecca for *toreros* skilled enough to fight within its bounds, staring down triumph or death.

Twentieth-century architect Rafael Moneo contemplated the provoked bulls and their valiant opponents from a comfortable distance, and remarked: "The Maestranza reminds us that there is always a place for the brave, and that our destiny is unwritten."

←

FOTOAUTOMATICA
Florence, Italy | c. 1969
Photo by Claire Walker

→

THE ECONOMICAL SHOE STORE
Valletta, Malta | c. 1880
Photo by Michael Hsieh

On the corner of via dell'Agnolo and via Giuseppe Verdi, in the midst of Florence's nightlife and within earshot of Piazza Santa Croce, sits a kiosk of pure nostalgia.

Professional set designer Matteo Sani—driven by fond memories and a sound knowledge of how they were once captured—restored an original 1969 photobooth, or Fotoautomatica, to its authentic form and installed it on this lively street corner. It drew such curiosity and affection that he restored four others and placed them throughout Florence, home to so many of the world's unique artistic treasures.

Night revelers shout with delight, tourists heading to see Michelangelo's *David* pause in confusion, and Vespas squeal to a halt at the sight of this wooden booth—a time machine of sorts. One of its most alluring qualities is the fact that Sani restored it to its original function, rather than updating it to animate one's image or adjust the filter used.

Two euros and a bit of patience get you the traditional strip of four black-and-white photographs. For younger generations, these serve as vintage curiosities. But for those who visited the originals, the Fotoautomaticas offer the sensory memory of cramming inside a booth, closing the curtain, and waiting with suspense and expectation. Taking your cue from a blinking light, you'd smile, make a funny face or two, then maybe—if you were lucky—exchange a kiss, a *bacio* captured in time.

Valletta is the capital and the commercial heart of the islands of Malta. Described as an open-air museum, Valletta boasts a wealth of intriguing sites to explore—be they cathedrals, gardens, or relics from the Knights of St. John. However, this fortress city is also one of the world's most concentrated historic areas. It is a town of delightful nooks, charming shops, and niche destinations that reward you for exploring on foot and climbing hundreds of steps to take in the full breadth of its splendor and surroundings—including The Economical Shoe Store.

After a mere day or two spent traversing Valletta's twisting alleys and narrow side streets, you'll be relieved to find the storefront, not merely for its charming facade but also to get a fresh pair of soles to carry you onward in your adventure.

EL RASTRO FLEA MARKET

Madrid, Spain | c. 1740

Photo by Leah Pattem

HOTEL RIPOSO AL BOSCO
BOWLING ALLEY

South Tyrol, Italy | c. 1950s

Photos by Sarah Isle

The stunning mountain ranges that make up the Dolomites stretch across South Tyrol—a province in the north of Italy—where more than 60 percent of the population speaks German. Nestled among them is Hotel Riposo al Bosco. Alternately translated as "resting in the forest" and "recreation in the forest," either option can be fulfilled at this family-operated hotel set in the small town of San Vigilio di Marebbe.

For those feeling indecisive about hitting the slopes or taking in the views, this convenient bowling alley and bar were built in the basement in 1978, collectively satisfying the desire for simultaneous rest *and* recreation—the defining feature of the game.

FUNICULAR TBILISI
Tbilisi, Georgia | c. 1905

Photo by Julia Molton

At 10:00 a.m. on March 27, 1905, fanfare at the foot of Mount Mtatsminda celebrated the opening of the new funicular in Tbilisi, Georgia. Curious onlookers gathered around and marveled at the novel mode of transportation, created to take citizens 710 meters from Tbilisi's old district to a new district planned for the mountaintop, overlooking the city.

In the midst of the public commotion, it soon became apparent that not one of the spectators had come with the intention of *actually* riding the funicular, fearing the cables would snap and spill unlucky passengers down the mountain. In fact, many gathered in anticipation of just such a morbid spectacle.

The Belgian owner, bewildered by their lack of faith in his expertly designed vehicle, quickly offered a large sum of money to the first person willing to take a ride up the mountain. This bribe, or reward,

was just the push the public needed. After the first group returned unscathed, lines of eager riders snaked down the streets.

The new district intended for Mtatsminda Plateau was left unrealized, primarily due to the Russian Revolution, which broke out in 1905. Fifteen years later, when the Bolsheviks invaded Georgia, the Belgian company lost ownership of the funicular they had constructed.

The lack of any real destination did not stop the funicular from becoming a beloved symbol of Tbilisi. Its popularity increased when a grand leisure park was constructed on the plateau in the 1930s.

Today, tourists and locals regularly ride up Mount Mtatsminda on a more modern funicular. They journey up for the views, the park, the quaint outdoor cafés, and a new nightclub, where guests sip cocktails while looking down at the lights of Tbilisi.

\longrightarrow

SYNTAGMA SQUARE

Athens, Greece | c. 1843

Photo (following) by Claire Walker, photo (p. 227) by Nicanor García

Located just a short walk from relics of some of the world's most archaeologically significant sites—the Acropolis and its Parthenon, and the Temple of Olympian Zeus among them—is Athens's Syntagma, or Constitution, Square.

The square is a teeming commercial and political center where locals connect with friends, and tourists flock to witness the slow, deliberate changing of the guard, conducted in front of the Monument of the Unknown Soldier. The Presidential Guard, or Evzones, are distinguished by their strange, adorned, deeply symbolic attire and their singular routine.

Their uniforms take nearly three months to stitch together and are carefully assembled by trained craftspeople. The *Phareon* (red cap) symbolizes the bloodshed from the War of Independence. Their kilt-like *foustanella* requires 30 meters of cloth and has 400 pleats, each fold representing a year that Greece was occupied by Turkey. And finally, their long black silk tassels represent the tears shed during those centuries.

Each guard wears two pairs of white woolen stockings, knee garters with tassels, and *Tsarouchia* (black pom-pom-adorned red leather shoes), which feature at least 60 nails on the base to simulate the sound of battle during the ritual they enact daily. Their movements are curious, more closely resembling an experimental modernist dance (with guns) than a typical or efficient handover of official duty. The square is dotted with white and blue cabins, where the replacement guards await their turn or take the occasional load off between shifts.

Though the motions of these strangely clad guards are unique enough to engross daily crowds and perhaps make a few tourists giggle, the ground on which these guards kick, sweep, and stride bears tremendous significance, as this very square has provided the stage for the most dramatic political shifts in our most enduring democracy.

"Athens's constitution is called a democracy because it respects the interests not of a minority but of the whole people...Everyone is equal before the law." It's easy to imagine these words being emphasized by a civics professor in a tweed coat, or perhaps by an unusually mindful politician—but in fact they were stated in 431 BCE by Pericles, during the golden age of Athens. At this time, the city-state was a direct democracy, one in which citizens (albeit only white, male citizens over the age of thirty) participated in legislative assemblies and voted on state policies.

Democracy, though invented by the Athenians, did not survive in Greece, lasting only from 460 to 320 BCE. Afterward, a series of invasions of other empires left the country ruled by a succession of emperors and kings for more than two millennia. In 1834, King Otto built this marble square beneath his new palace and called it, rather unimaginatively, Palace Square.

If you build it...

In short order, the people's dissatisfaction with absolute rule broke through the surface, especially once they had an arena in which to gather and express their collective discontent. On September 3, 1843, King Otto awoke to find Palace Square filled with citizens and soldiers demanding their constitution. Agreeing to such a document would limit his powers and enable citizens to vote for parliament. It would also ensure the right to free speech and freedom of assembly, among many other basic human rights. But the people's demands were accepted by the overwhelmed king, and in celebration, Palace Square was quickly renamed Syntagma Square, Greek for "Constitution Square."

The constitutional monarchy lasted until 1967, when the country experienced a seven-year military dictatorship, known as the Greek junta. The regime threw out the constitution and the freedoms it protected. Those who so much as criticized the government were subject to imprisonment and even torture. When the turbulent regime was ousted in 1974, the people of Greece were determined to finally reestablish a full, permanent democracy. A public referendum overwhelmingly instituted a modern republic, and Syntagma Square was \longrightarrow

→ yet again rejuvenated as a lively center of celebration, ignited as the new president, Michail Stasinopoulos, delivered a rousing speech as the first democratically elected leader of Greece in over 2,200 years.

Syntagma Square re-erupted and became the scene of Athenian political expression during the country's 2010 economic collapse, which incited months of protests. Today, the square remains the site of spirited demonstrations, celebrations, and the specialized changing of the guard—in tribute, solidarity, or upkeep of the ancient cycle of Athenians battling for the democracy they invented.

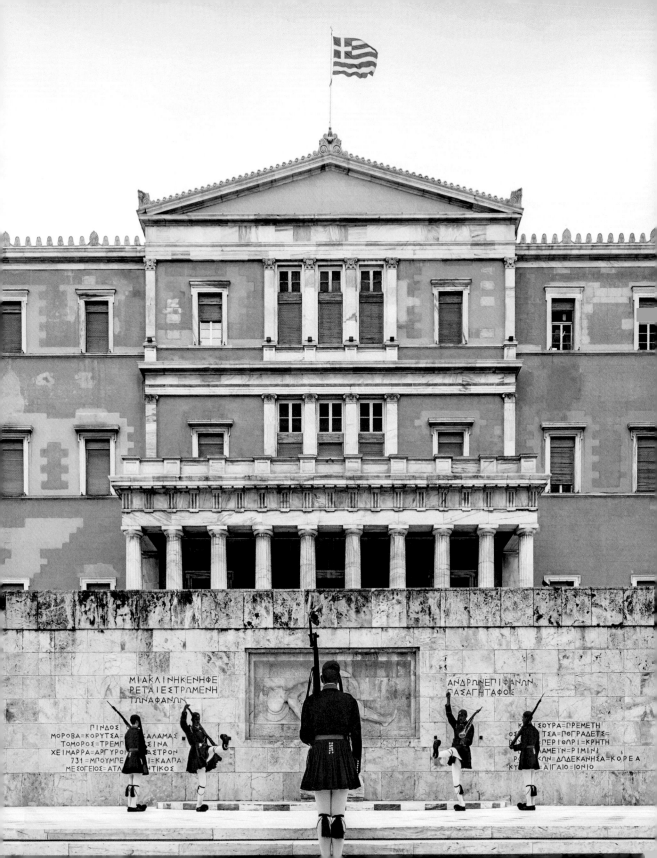

← CASA DE SERRALVES
Porto, Portugal | c. 1930s
Photo by Matías Galeano

→ MARINA DI CARRARA
Tuscany, Italy | c. 18th century
Photos by Alex Gâlmeanu

Originally a private residence, Casa de Serralves and its surrounding park were designed by the second Count of Vizela, Carlos Alberto Cabral, on the site that had once been the family's summer farm. As an enthusiast of French culture and a member the Porto bourgeoisie, Cabral combined a number of influences—neoclassical, romantic, and art deco—into the home over the almost two-decade span of construction.

In 1955, Carlos sold the property to Portuguese entrepreneur Delfim Ferreira under the condition that it would not be changed. This compromise was fully respected...until 1987, when the Portuguese government acquired the property from Ferreira's heirs and added a modern art museum. It was officially opened to the public in 1999 as the Serralves Museum of Contemporary Art, more often called the Serralves Museum, or simply Serralves.

Today, Serralves is considered the most important contemporary art museum in Portugal, and it ranks among the 100 most frequented museums worldwide. The best time to visit Porto is during the annual Serralves em Festa, which features days of art and cultural events, all of which are free to the public.

Carrara, in Tuscany, is known not only for its iconic white and blue-gray marble but also as a seaside resort. With all of Tuscany's inland offerings, you may not realize it has more than 250 miles of coastline where individual beach clubs, also known as lidos, section off areas for their guests.

Typically connected to restaurants and bars, these seaside resorts offer a full-service experience where sandy patrons can enjoy a long, leisurely lunch before returning to their color-coded umbrellas and beach chairs or taking a dip in the Ligurian Sea.

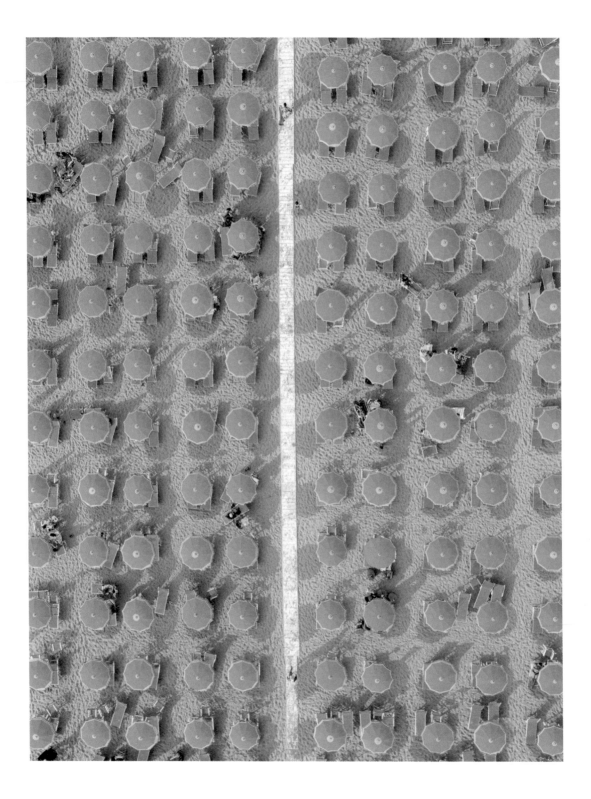

OUR LADY OF THE ROCKS
Bay of Kotor, Montenegro | c. 1452

Photo by David Axelrod

STRIPED BUNGALOWS
Vieira de Leiria, Portugal | c. 1800s

Photo by Raquel Tereso de Magalhães

Perast is among a few well-preserved medieval cities winding around the Bay of Kotor. Spectacular roads stitch together the towns and inlets of the bay, or "Boka." Yet despite the region's bounty of spectacles, Perast's most famous landmark is this artificial islet, with a curious history, surrounded as much by legend as it is by water.

Lore has it that in the mid-fifteenth century two brothers, both seamen (one with a badly injured leg), discovered an icon of the Madonna and Child on a pile of rocks. They took it home, and the ailing brother's leg miraculously healed overnight. The next day they returned the Madonna and sailed away, swearing an oath to honor her.

Upon each return from a successful voyage, the brothers added a rock to her pile. Other sailors followed suit in hopes of being similarly blessed.

Over time, Gospa od Škrpjela, or Our Lady of the Rocks, thus came into being, and a tiny Orthodox chapel was built upon it to protect the statue. In 1600 the Venetians overtook the region and built a Catholic chapel to replace the original, while bolstering the islet with sunken or seized ships loaded with rocks.

These legends cannot be verified, but we do know that every year at sunset on July 22, the *fašinada* is held to honor the day the brothers found Our Lady. Local families gather and take boats out to Gospa od Škrpjela, where they throw rocks into the sea to widen the surface of the hallowed artificial island.

Vieira de Leiria, a sleepy seaside town whose name rolls off the tongue, is known for its fishing shacks and traditional bungalows painted in eye-popping candy stripes. Those seen here are part of a small market by Praia da Vieira beach. Open for the summer season, these stalls sell ice cream, beach toys, and the like, while blending seamlessly with the typical striped homes of the region.

The town was once surrounded by a massive forest of maritime pines planted in the thirteenth century to stop the sand dunes on the coast from spreading to the farmland around Leiria. Shipbuilders proliferated in this region, where the fishing community had made a dangerous living on the coast for hundreds of years.

The number of shipbuilders has dwindled, but today's holidaymakers still share the beach with fishermen in modern trawlers and traditional crescent-shaped boats. Anyone craving the freshest fish can walk from their vibrant homes over to the boats to go purchase that day's catch.

MIDDLE EAST
& AFRICA

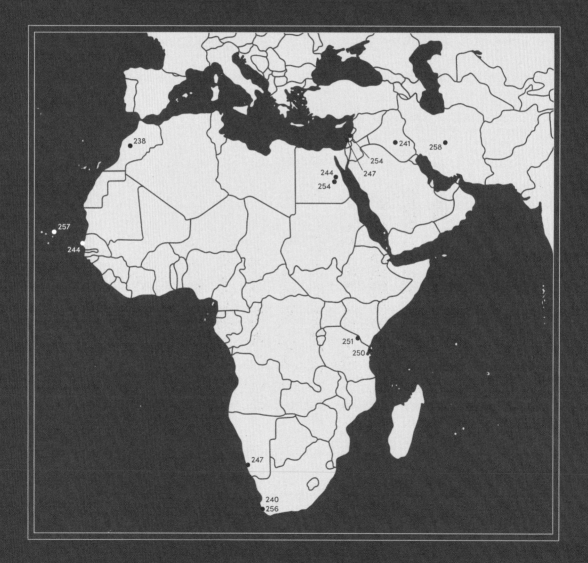

AMANJENA

Marrakech, Morocco | c. 2000

Photo by Sarah Murphy

This keyhole door leads you into Morocco's Aman-jena, or "peaceful paradise," a luxury hotel in the Palmeraie suburb of Marrakesh. The hotel sprawls amid olive orchards, offering access to the harsh canyons of the Atlas Mountains, a surfer-friendly coastline, and the Agafay desert—where wheat and wildflowers predominate in spring and the arid climate returns in summer and autumn. The perfect balance to unlock the wonders of the seasons.

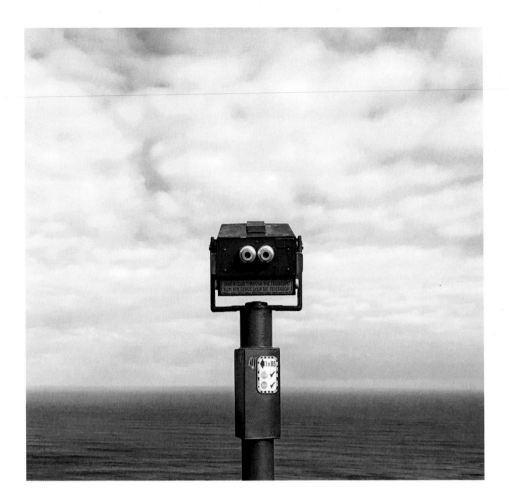

DIAZ POINT VIEWFINDER
Cape Town, South Africa | c. 1980s

Photo by James Cairns

From this aerial vantage point on Cape Town's Table Mountain, no matter where you train your gaze, there is something that begs to be magnified. Watchers from the mountain can observe the peninsula's 2,285 native plant species (more than exist in all of Britain). Meanwhile, baboons, flamingos, or even hippos might meander into view.

Straight ahead, in the waters off Cape Town, the Atlantic and Indian Oceans begin their flirtation, set

to meet about 100 miles beyond that point, at Cape Agulhas. Nonetheless, their opposing currents churn up an abundance of nutrients, feeding a lush ecosystem. As a result, depositing a rand and peering through this viewfinder is likely to yield a show of otters, seals, penguins, humpback whales, and even sharks amicably enjoying this diverse, swirling meeting of waters.

NAJM AL-IMAM RELIGIOUS SCHOOL

Najaf, Iraq | c. 2014

Photo by Osama Sarm

Below these stunning blue tile mosaic windows and inlays is the name Najm Al-Imam, scripted in Arabic. Najm Al-Imam means "the Star Imam," a title given to Muḥammad Ibn al-Ḥasan Tūsī (1201–1274), a Persian scientist from Najaf, Iraq, where the school is located.

After Mecca and Medina, Najaf is the third-holiest site for Shia Muslims. Pilgrims gather here from across the world to pay respects to ʾAli ibn Abi Talib (601–661), the first imam and spiritual founder of the Shia branch of Islam. Over the centuries, libraries, convents, and schools were built around his shrine, establishing the city as a center of religious scholarship.

The city has played a pivotal role in modern Islamic history for other reasons—among them having hosted Ayatollah Khomeini for his fourteen years of exile in Iraq, beginning in 1965. Later, Saddam Hussein targeted the shrines of the Shia holy city, and in 2003, an invasion by U.S. forces left Najaf in a shattered state.

But Najaf is being transformed and rebuilt, as evidenced by institutions like Najm al-Imam. At the center of this transformation remains the encrusted golden-domed shrine to Imam Ali, thanks to whom, as one Hadith puts it, the city remains a hallowed "gate of knowledge." Today, the streets of Najaf are filled with scholars and pilgrims, as they have been for generations.

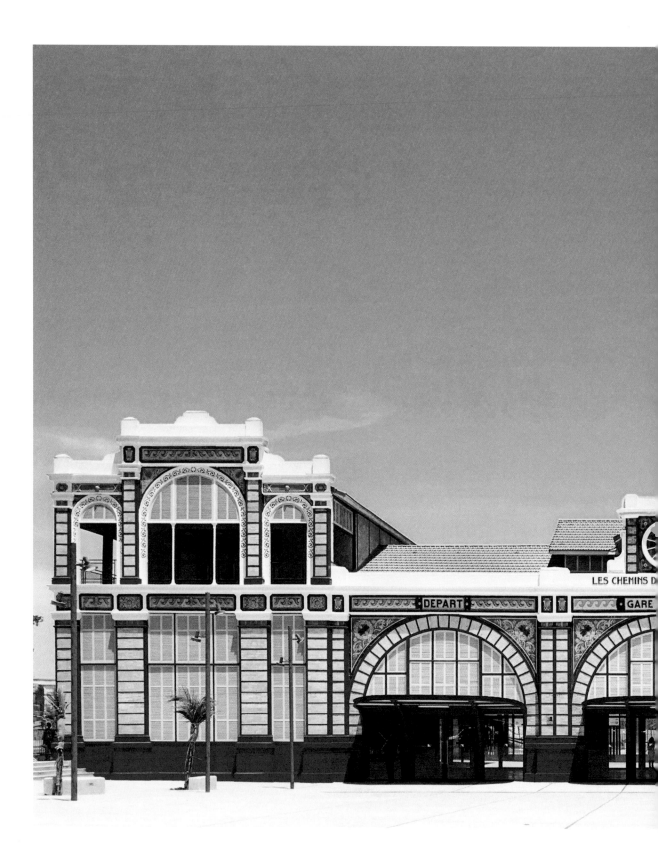

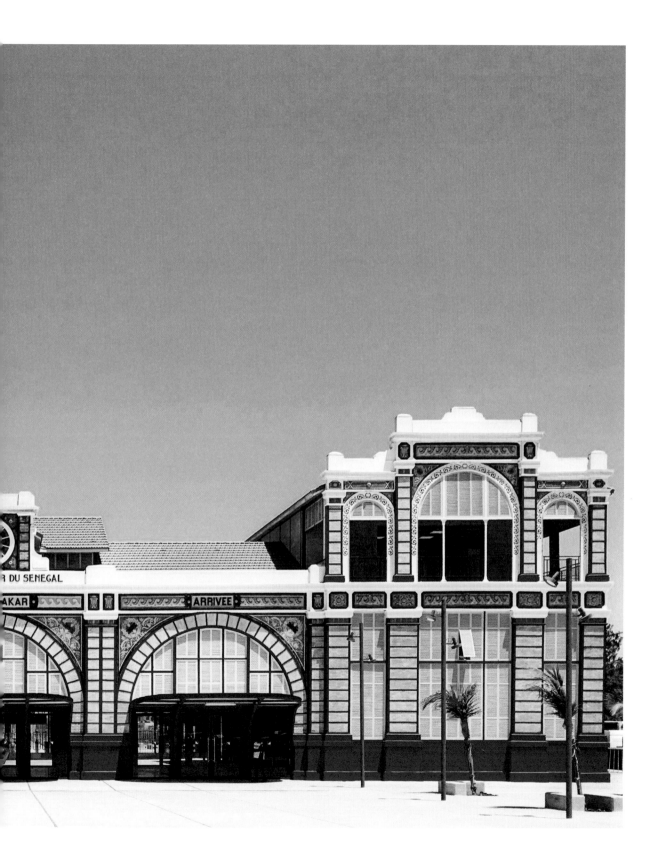

DAKAR RAILWAY STATION

Dakar, Senegal | c. 1885

Photo by Sheryl Cababa

COLOSSI OF MEMNON

West of Luxor, Egypt | c. 1350 BC

Photos by Rachel Kafka

Under blue skies, the candy-colored design of Dakar's station appears surreal, somehow taken from a children's train show. But this architectural throwback also serves as a stark reminder of Senegal's colonial past and inclusion in the federation of French West Africa.

Dakar's vibrant station neighbors the city's Atlantic port, offering global transport of raw materials. It was initially constructed as the terminus of the nearly 800-mile-line that began inland in Bamako, Mali, but in recent years has been reduced to a trail of ruins.

The city of Dakar, however, has developed intermittently around its essential harbor and station, despite periods of neglect due to national strife. For a time, the return to a regular passenger service seemed so unlikely that plans were developed to turn the station into a museum. But today, after restoration efforts and a fresh coat of red paint, trains are running through the station again, connecting the harbor to the airport thanks to the recent development of the high-speed Dakar Regional Express Train (TER).

Stationed just outside the Colossi of Memnon (also *el-Colossat* or *es-Salamat*) is this unassuming hut, established for Egypt's Tourism and Antiquities Police, a dedicated branch of the force. Its stations are found at the country's most frequented sites, such as this nearly 4,000-year-old monument outside the modern city of Luxor.

The Colossi of Memnon are twin statues depicting the fourteenth-century Pharoh Amenhotep III. Each shows the pharaoh seated upon a throne, hands resting on his knees, gaze facing east, toward the Nile. His wife and mother are etched into the front throne beside his legs. Each was carved from a single block of quartzite sandstone, reaching 60 feet tall and weighing 720 tons. They acted as sentries, towering over Amenhotep's memorial temple, though they were constructed while he was still alive. Beneath them, he was adulated as a living god.

From ancient days to the present, the Colossi have been a popular attraction, hence the need for authorities on the premises. These police are not there *for* tourists in need of assistance, rather to protect their sacred relics *from* quick-handed travelers, as illicit trafficking is a real threat to Egyptian artifacts.

All major Egyptian monuments are protected by this division. Officers wear white uniforms, carry badges and guns, and are often mounted on camels. Although their purpose is to ensure that cultural heritage is not looted or illegally exported, they have also been known to offer themselves as "behind-the-scenes" experts on the monuments they've been tasked to protect—for a price, naturally. So, before agreeing to a tour, perhaps check that your guide is *not* in possession of a special police badge.

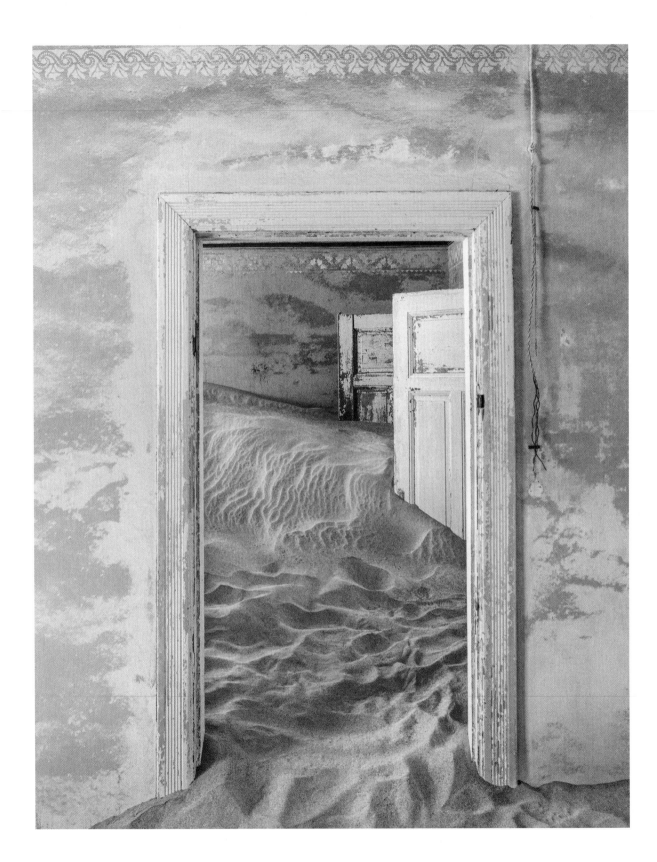

←
KOLMANSKOP
Karas, Namibia | c. 1908

Photo by Alina Rudya

→
SNUNITS
Old Jaffa Port, Tel Aviv, Israel | c. 1928

Photos by Christopher Centrella

Kolmanskop is a ghost town in southern Namibia. In 1908, miner Zacharias Lewala found a diamond while working in the area. Shortly after its legitimacy was confirmed, diamond miners from Germany—which colonized Namibia at the time—descended upon Kolmanskop.

The earliest arrivals were rewarded with significant wealth. The residents built up the village in the architectural style of a German town. A hospital boasting the first X-ray station in the southern hemisphere soon sprung up—followed by a power station, school, casino, ballroom, and the first tram in Africa, which linked the growing town to Lüderitz, on the coast. European opera troupes and various artists came to perform for the affluent, eccentric colonists of Kolmanskop.

After World War II, the diamond field grew depleted. Many of the town's inhabitants rushed south, where larger diamond deposits had been discovered. The town was ultimately abandoned in 1956—only a few decades after its peak: the days when a lazy shuffle through the sand could yield pure diamonds.

In 2002, a local private company began to manage Kolmanskop as a tourist attraction, busing visitors in to explore and photograph the mysterious, sand-covered town. Today, about 35,000 visitors explore the surreal site each year, giving people the opportunity to marvel at how swiftly sand moves through the hourglass of time, and the doorframes of unattended homes.

Following are two *Snunit* ("swallow") sailboats, navigated by Jaffa Sea Scouts, a maritime subgroup of Israel's equivalent of Boy and Girl Scouts. These swallows set sail from the storied harbor of the ancient city of Jaffa, from which Tel Aviv has grown. Among the oldest ports on earth and ideally placed to fend off strategic attacks, the ancient port is drenched in bloody history. Today, it is home to local fishermen, a promenade along the Mediterranean, an inactive lighthouse, and a bustle of ambitious Sea Scouts.

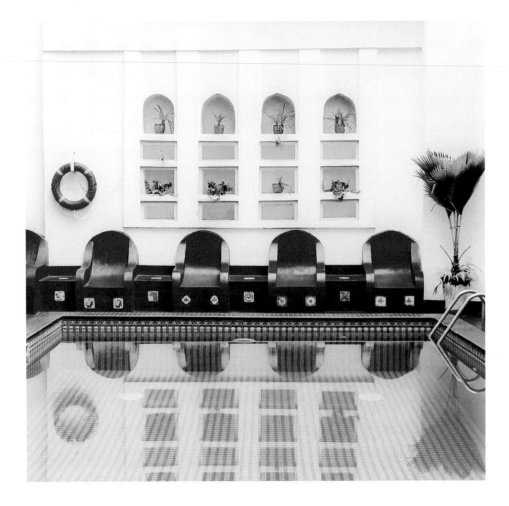

DHOW PALACE

Zanzibar, Tanzania | c. 1559

Photo by Damien Poeymiroo

The original owner of 571 Bhagani Street in Zanzibar, Tanzania, was Sheikh Muhsin bin Mujbia in 1559. For more than three centuries his descendants owned the property, until it passed on to a different clan. The mansion was then leased to a sequence of tenants until the government nationalized the property in 1964.

Twenty years later, the property was renovated under the ownership of a family named Muzammil. The work took more than six years, as the family insisted upon using the materials from which the original building had been constructed—and only a very small handful of artisans understood how to carry out the traditional process. In 1993, it was officially opened as a hotel.

The new name, *Dhow Palace*, comes from the Arabic word *dāwa*, referring to sailing vessels that have carried people, goods, and treasures to and from Zanzibar for hundreds of years.

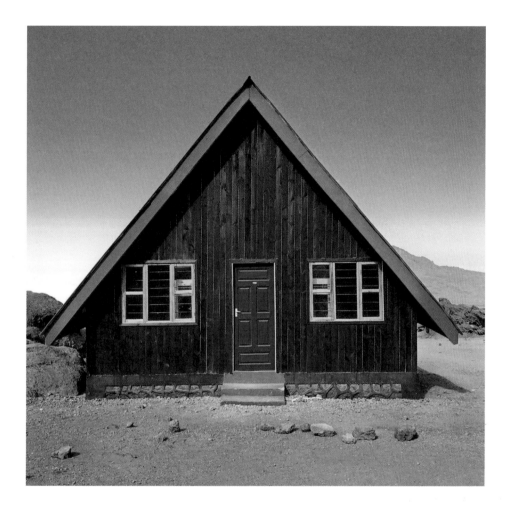

KIBO HUT

Kilimanjaro, Tanzania | c. 1932

Photos by Robert Hune-Kalter

Standing well above 15,000 feet, Kibo Hut is the last camp on the Marangu route of Mount Kilimanjaro in northeastern Tanzania, near the Kenyan border. Kibo is the extinct volcano whose Uhuru Peak is the highest in Africa. Referred to as the closest place to heaven, it breaks through the clouds at 19,340 feet.

German Hans Meyer, a geographer, reached the Kibo summit in 1889 with Austrian mountaineer Ludwig Purtscheller. Nearly every climber who has summited since has recorded his or her thoughts about the extreme accomplishment in a book stored in a wooden box at the top.

Many thousands of people attempt to summit Mount Kilimanjaro each year, no doubt because it is possible to reach the top without specialized mountaineering gear. Should you choose to brave this endeavor, push to the back of your mind the nagging thought that the name "Kilimanjaro" was once—although incorrectly—thought to mean "we failed to climb it."

← VALLEY OF THE KINGS

Luxor Governorate, Egypt | c. 1539 BCE

Photo by Sofia Pomoni

→ CAMEL CROSSING

Masada National Park, Israel | c. 2001

Photo by Andrew Weaver

From the sixteenth to the eleventh century BCE, ancient Egyptians excavated and embellished rock-cut tombs for the pharaohs and nobles of their New Kingdom (Eighteenth to Twentieth Dynasties). These hallowed resting places comprise Egypt's Valley of the Kings, which stretches along the west bank of the Nile, near Luxor.

The valley is among the most important archaeological sites in the world. Exploration efforts are still active: discoveries made in 2008 raised the count to 63 tombs, ranging in size from a simple pit to a complex system of 120 underground chambers.

Within many tombs (none of which are permitted to be photographed) remain murals of mythological scenes, hieroglyphics, and ancient graffiti from Greek, Latin, Phoenician, and Roman cultures—all revealing puzzle pieces of shared history.

In the eighteenth century, Napoleon Bonaparte commissioned detailed maps of the Valley of the Kings. New burial places continued to be found throughout the nineteenth century, until 1912 when an American explorer determined that the site had been fully excavated. A mere decade later, British archaeologist Howard Carter proved him wrong, by leading the expedition that uncovered the tomb of King Tutankhamun. In addition to King Tut's mummy, the intact tomb was packed with priceless artifacts—including a golden death mask, a solid gold inner coffin, and a funerary chariot. Although King Tut was a minor pharaoh, the riches discovered made it one of the most famous archaeological discoveries of all time.

Tut's tomb also reminds us that these chambers held more than inanimate objects that belong in a museum. Rather, they were spaces filled with real human beings who loved and were loved, and they contained eerie yet touching tokens of their inhabitants' humanity—one of those discovered in the tomb of Tutankhamun was a lock of his grandmother's hair.

Pausing at the intersection of the rocky, arid expanses of Israel's Negev Desert and this triangular traffic signal, you might expect to see Arabic Bedouin nomads riding beside you, clad in traditional woolen tunics and red and white headdresses. But today, only imagination could yield this sight: the Bedouin people of Israel abandoned their nomadic lifestyle over a century ago, and now camels in this UNESCO world heritage site are ridden almost exclusively by tourists seeking the romance of a bygone era.

However, these rides are ill-advised for tourists who struggle with motion-sickness. Camels walk by moving both legs on one side and then both legs on the other, rocking side-to-side—one of several reasons why these trusty creatures have been nicknamed "ships of the desert."

GREEN POINT LIGHTHOUSE
Cape Town, South Africa | c. 1824

Photo by Barry Havenga

Cape Town's Green Point Lighthouse was the first lighthouse on the South African coast. Constructed in 1824, it warned oncoming ships of the rocky coast with the help of only two lanterns, fueled by sperm whale oil.

Until the opening of the Suez Canal in 1869, all ships wanting to pass between the Indian and Atlantic Oceans were forced to sail around the southern tip of Africa. Cape Town was a layover port, where sailors could stock up on provisions and enjoy a night of brandy and solid ground after long months at sea.

Green Point has since been declared a national monument, and remains the oldest operational lighthouse in South Africa.

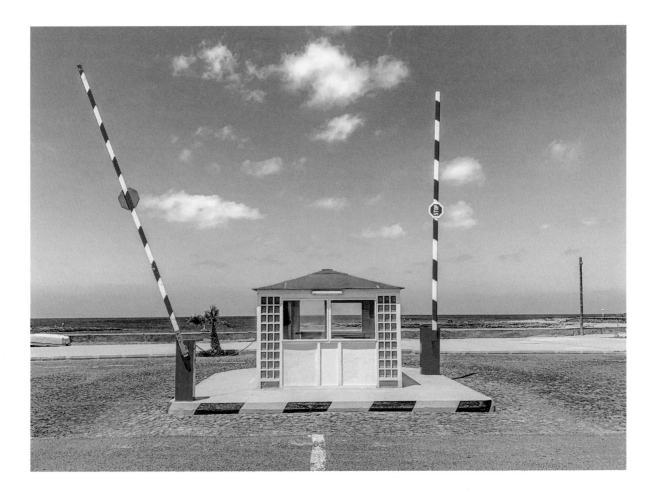

MURDEIRA

Sal, Cape Verde | c. 1998

Photo by Aude Olesen

Sal is one of the ten islands of Cape Verde, off the coast of West Africa. Discovered in 1460, its name was revised to Sal (the Portuguese word for "salt") when two large deposits were discovered.

The island remained sparsely inhabited until the late eighteenth century, when the salt industry began to thrive. But Sal is also home to abundant natural wonders like its Blue Eye—a collapsed cave with a water inlet into which one can peer and see an iridescent "eye" of illuminated seawater gazing back.

If a staring contest with the sea does not entice, the terrain is exceptionally diverse: this beach-framed island is distinguished by miles of desert so barren that it draws comparison to the reddish-brown shade of Mars.

Originally a small settlement of fishermen, the quaint village of Murdeira has been transformed into a tourist destination: the Aldeamento Turístico da Murdeira, a semi-gated community. But one should not be surprised to see an unmanned post at the entrance of such gates, which open to a resort. Cape Verde infamously runs on its own time; with ample reasons to slow down and savor this largely unspoiled isle, there is little reason to rush.

MIDDLE EAST & AFRICA

YAZD SCIENCE MUSEUM
Yazd, Iran | c. 1991
Photos by Angelo Zinna

Centuries ago, scholars settled in Iran's Yazd, the City of Windcatchers (a windcatcher being an ancient architectural cooling system) and established it as a center for scientific learning. So it serves as an apt home for the Yazd Science Museum, founded in 1991 as an extension of the Iranshahr School.

An exhaustive range of science fields are represented within the museum. Among them, you can explore a detailed forest amid real (taxidermied) animals—or try your hand at the basics of this art of preserving creatures. For those happy to keep their hands clean while still experiencing a healthy blend of awe and queasiness, the biology section exhibits life at all its stages, from embryo formation to a roughly 800-year-old woman's skeleton.

SOUTH, CENTRAL, & EASTERN ASIA

268
306

296

289

293
302

262
281
300
310

305 278

315 314

267

274

303

257

274
286

290

270
286 281

313

299

290

293

291

264 265

288
310

279

TOKYO TAXI

Tokyo, Japan | c. 1912

Photo by AccidentallyWesAnderson

Tokyo is home to thousands of taxis that chauffeur 14 million residents and visitors all over the sprawling city. Yet a taxi in the Japanese capital is not the icon it might be in London or New York. It's also not a particularly common mode of transport in Tokyo. With trains that have earned global renown for punctuality and speed, many prefer public transport.

In the event that you do hail a cab, look out for the color of their license plates and lights: Licensed taxis use green plates (as opposed to the white and yellow plates of privately owned cars). Vacant vehicles display the characters 空車 (*kuusha*, "empty car"); if occupied, you'll see 賃走 (*chinso*, "running the meter").

There is no standard color or design for a taxicab; the largest companies distinguish themselves by hue. The cars of Tokyo Yonsha and its subsidiaries are all either lemon yellow with a red stripe or black with globes for lights. The Green Cab group, with some 60 subsidiaries, have the peppermint-colored body seen here. The Tokyo Musen group are green with orange stripes; Checker Cabs are orange with a checkered white stripe; and Kojin are white with yellow lights that look like snails.

Once you've hailed your taxi, your door will open automatically, as operated by your driver. (This feature was made standard due to its convenience, coupled with a desire to excite global riders at the 1964 Olympics.) Drivers are also dressed to impress, in uniforms including white gloves, hat, and possibly a surgical mask. Don't be alarmed: it's just another part of the colorful cab adventure that comes with getting around Tokyo.

COASTAL LINE RAILWAY STATION
Midigama, Sri Lanka | c. 1895
Photo by Christina Pérez

These characters, seen above the ticket counter window, are written in traditional Sinhala script. It is an "abugida," or "alphasyllabary"—a writing system in which consonants and vowels are written as a combined segment. The symbols cannot be split. No letter stands alone.

"අඟුරු කකා වතුර බ෦බ෦ කොළඹ දුවන යකඩ යකා" is Sinhala for "coal-eating, water-drinking, sprinting to Colombo metal devils," which was a reference to trains when they first arrived in Sri Lanka (then known as Ceylon). Tracks were first laid in 1864 by the British colonial government, who were eager to haul goods such as tea and coffee from the verdant hills to Colombo (the commercial capital), and then to the world at large.

The scenic Coastal Line is now an essential mode of transport, accounting for some of the busiest rail travel on the island. During the 2004 Indian Ocean tsunami, a train was swept entirely off the track, resulting in one of the worst tragedies in rail history. Foreign relief efforts were offered, but the most substantial and immediate restorations were the result of impressive local efforts. Renovations continue, but the Coastal Line is back to running for nearly 100 miles through this stunning, resilient country.

AMANWELLA
Tangalle, Sri Lanka | c. 2005

Photo by Ranmalee Dias

Derived from the Sanskrit word for "peace," *aman*, and the Sinhalese word for "beach," *wella*, the coastal resort of Amanwella fulfills the idyllic promise of its name. Located in the southern port town of Tangalle, the resort also exemplifies the style known as tropical modernism.

The movement, launched by Sri Lanka-born Geoffrey Bawa, softens modernism's formal qualities and uses raw local materials—so that the surrounding environment dictates the structures constructed within it. The late architect inspired this fresh, open aesthetic for his country and others nearby. And Amanwella, with its clean angles and authentically sourced lines of entry, is among the warm locales that pay tribute to Bawa's enduring vision.

HUMAYUN'S TOMB

New Delhi, India | c. 1570

Photo by Dirk Rohde

In 1556, Emperor Humayun, his arms filled with books, was descending his steps when he heard the siren calling the people of New Delhi to prayer. Startled, the emperor took a knee in reverence, as was his tradition. Catching himself within the folds of his robe, he lost footing and took a tragic tumble down his newly polished grand staircase, knocking his head along the way. Within a matter of days, the emperor was dead.

His unexpected end was especially unfortunate, as within a mere six months he would have regained control of his empire after having spent fifteen years at war with his rebellious brothers, who all aspired to unseat him. His bereaved wife, Empress Bega Begum, commissioned the spectacular Mughal garden tomb as her late husband's resting place. Fourteen years later, in 1570, the dynastic mausoleum was completed. Over time, it became known as the "dormitory of the Mughals"; buried within its chambers are more than 150 members of the royal family.

In the sixteenth century, Humayun's empire covered a large expanse of land in South Asia, spanning 1 million square kilometers and including what is now India, Afghanistan, Bangladesh, and Assam. Consequently, Mughal architecture fused what we now identify as Indian, Persian, and Turkish stylistic influences: large bulbous domes, elaborate ornamentation, minarets, enormous halls, and grand vaulted gateways.

Viewing those elements at Humayun's Tomb—the gentle slopes of the white dome, the towering minarets, the high arches—one can't help but compare the magnificent building to the iconic Taj Mahal. In fact, all the features that made the Taj globally recognizable were first showcased at this garden tomb, which predates its infamous architectural cousin by sixty years.

In addition to being visually spectacular, the tomb employs an array of Islamic symbolism. The burial chamber is aligned on the north-south axis, so that Humayun's face is turned toward Mecca. According to religious tradition, science, mathematics, and religion are indivisible—which infuses numbers with spiritual meaning. One represents God in its absolute uniqueness. Two represents the eternal balance and duality of all things. In Humayun's Tomb, the number eight is featured most prominently, as it represents paradise. According to many interpretations of the Quran, eight angels sit on eight thrones that surround the world, corresponding with the eight corners of space that make up the universe. And so the tomb's main chamber was built as an octagon; within it are eight chambers, which in turn each contain eight smaller chambers.

Few aspire to have their greatest legacy be their tomb. But Humayun's eternal resting place arguably bears greater cultural significance than anything the emperor achieved in his life, as it was the first such tomb on the Indian subcontinent, inspiring major architectural innovations that are still celebrated centuries after the ruler stumbled.

TURKEY FERRY LINE

Istanbul, Turkey | c. 1987

Photo by Christopher Centrella

There are few places on earth where you can cross from one continent to another while also remaining in the same country in under twenty minutes. But simply take a ferry from Istanbul's Karaköy neighborhood (in Europe) to its Kadiköy district (in Asia), and you'll be doing just that.

From ancient Greek times, Istanbul has been a stopover for ships crossing from the Mediterranean to the Black Sea—with a singular location that has made the city a strategic capital for millennia. Until 1973, when the first bridge was built, the only way to traverse the city was by boat.

And so a ride on the Turkey ferry is a voyage not only across continents but through time. Istanbul's shorelines are rich with architecture from every era in modern history, from the awe-inspiring Hagia Sophia to the hundreds of wooden waterfront mansions known as yalis. Those lucky enough to cross the Bosporus at sunset will see the monuments of the city light up, as the iconic minarets of mosques etch blazing red skylines across two continents, both within sight.

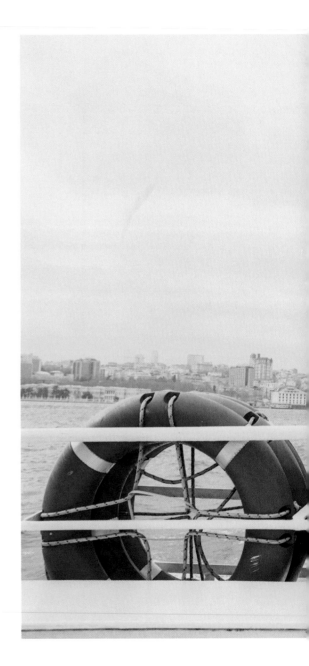

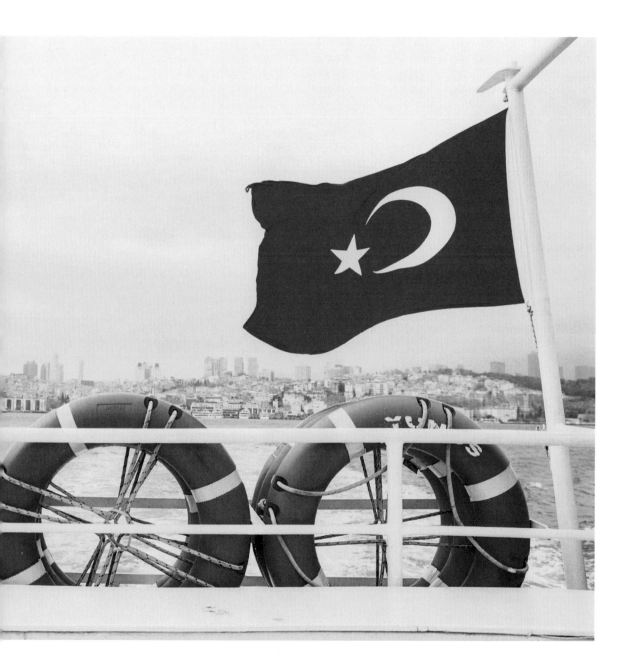

CHOI HUNG ESTATE

Hong Kong | c. 1963

Photo by Ludwig Favre

Choi Hung means "rainbow" in Cantonese, a fitting name for this bright, immense public housing complex that was built to house nearly 43,000 people.

In the lead-up to World War II, Hong Kong welcomed a huge influx of refugees, driven primarily by the Japanese invasion of China and ensuing civil war. With little room to accommodate the flood of people, hundreds of thousands were forced to live in sprawling, overcrowded shantytowns and squatter huts.

After a devastating fire destroyed one of these refugee areas, the Hong Kong Housing Authority erected massive residential blocks on the property, beginning with Choi Hung Estate. Opening in 1963, it was the largest public housing estate in the world.

Public housing in Hong Kong does not carry the same judgmental connotations it holds elsewhere. This is partially because so many people depend on it, and partially because its success has played such a crucial role in Hong Kong's urban and economic development. Since the Choi Hung Estate was built, housing policy has been pursued aggressively by the government, which is acknowledged to be the "single largest landlord, developer, and operator of housing within the territory."

Beyond the estates' impressive functionality—creating affordable homes for almost half the population of such an expensive city—they're featured in marketing and media campaigns of all stripes. The clean, striking layers of colors yield such aesthetic satisfaction that, much to the dismay of many residents, these recreational areas are very often filled with more photographers than basketball players, and more selfie-sticks than baseball bats.

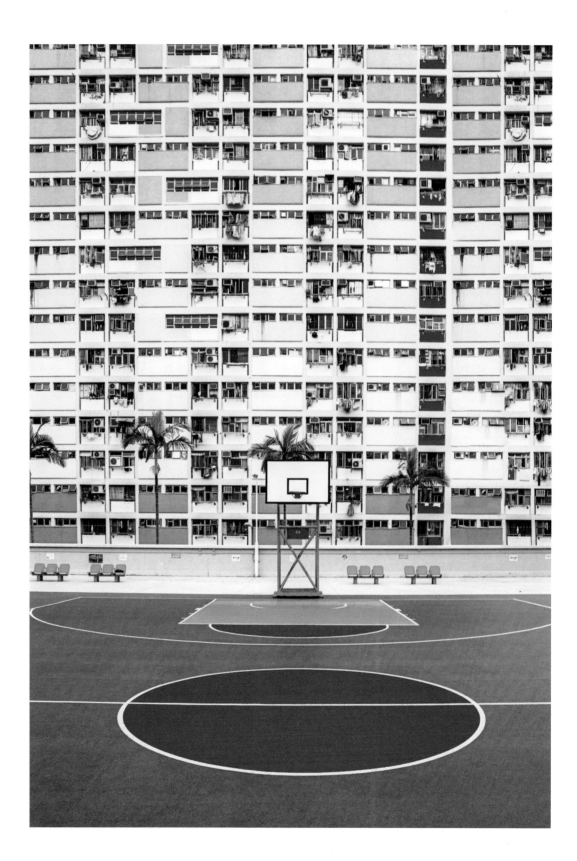

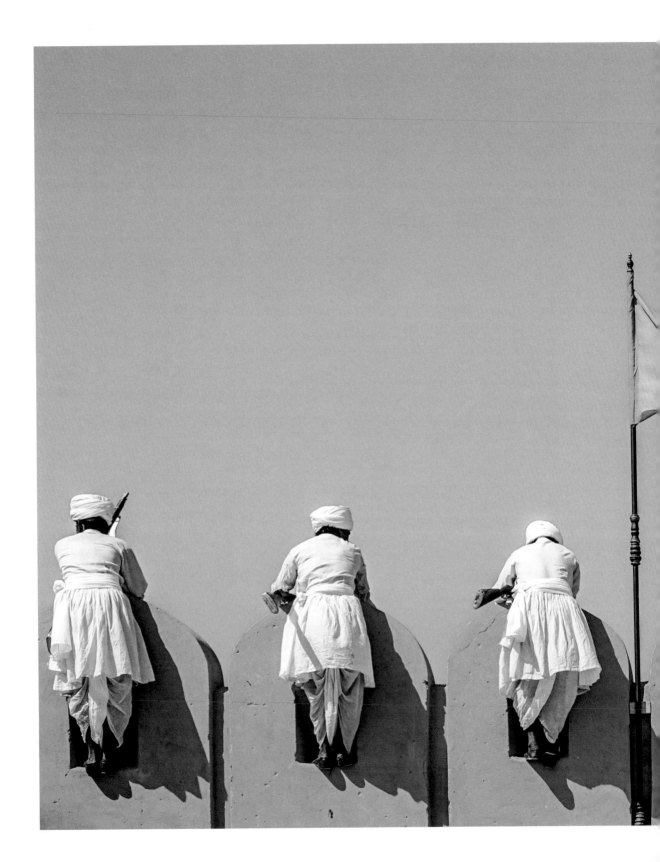

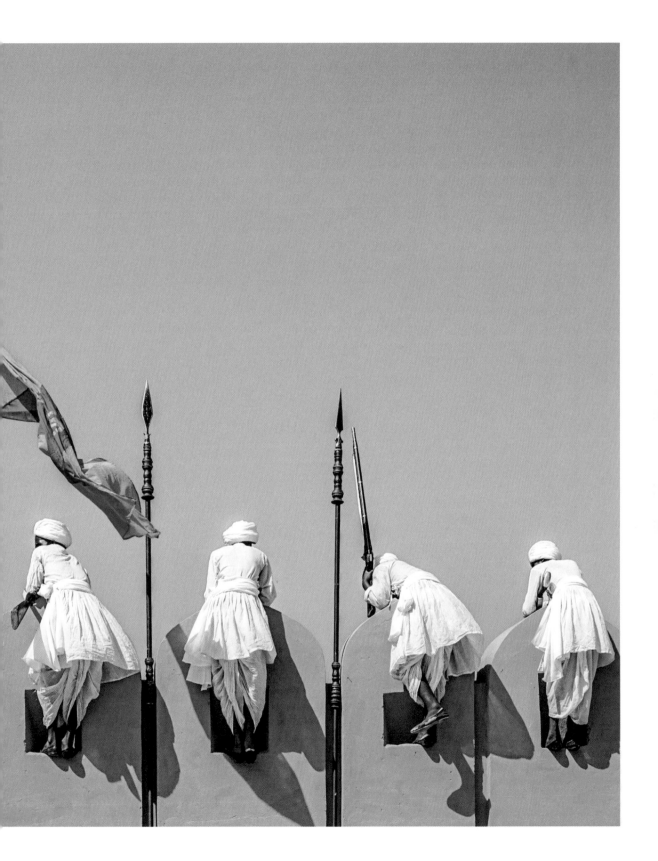

←

AMER FORT

Rajasthan, India | c. 1592

Photo by Chris Schalkx

→

PALACE OF THE WINDS

Jaipur, India | c. 1799

Photo by Beth Pell

Amer Fort, both royal palace and military stronghold, stands on a hill over Maota Lake. Construction of the impenetrable red sandstone and marble began in the sixteenth century at the direction of Maharaja Man Singh I, a commander in the Mughal emperor Akbar's army.

The fort rises on four levels, each with its own courtyard. Inside, among the opulent rooms are the Diwan-e-Aam, or Hall of Public Audience, resplendent with mosaic glass works, where the king met his ministers and welcomed common men to hear their requests. The Sukh Niwas, or Hall of Pleasure, even featured an ancient method of air-conditioning, where air passed over channels of perfumed water to keep the palace cool.

While the fort presents a commanding yet basic exterior, inside reveals an almost absurd attention to clever details. A "magic flower" marble panel, depicting two butterflies hovering over a flower, is meant to be spun, revealing seven possible images: a lotus, an elephant trunk, a fishtail, a scorpion, a lion's tail, a hooded cobra, or a cob of corn. Choose your own adventure.

The fort's most beautiful feature is inarguably its Mirror Palace, designed as a gesture of love. A queen of the fort used to love sleeping under the stars as a child. But ancient custom didn't allow women to sleep in the open air, so her king called on the best architects in the region to deliver her the gift of the cosmos within the palace walls. Their solution was to craft gorgeous detail out of glass for the walls and ceiling. When a mere two candles are lit, thousands of stars appear to glitter beyond the ceiling.

Jaipur is India's "pink city," known for the naturally rosy sandstone from which much of it was built, and the pink color many of its buildings were painted as a welcome to the Duke of Windsor, Prince Edward, during the British Raj (1858–1947).

Sprawled out along the banks of Lake Pichola, City Palace stands within a complex encompassing numerous stunning buildings, temples, courtyards, and gardens. The most recognizable building is the Hawa Mahal, or Palace of the Winds, five stories of carved red and pink sandstone constructed in 1799 as part of the women's section of City Palace. The Palace of the Winds has 953 windows with lace-like screens behind them, allowing the breeze to circulate and cool the palace. More importantly, the design allowed the ladies of the royal court to observe the happenings and drama of the streets without being observed themselves.

Our man in pink, though well-dressed for the city, was evidently unaware of the storied palace's ingenious architecture or of the hundreds of windows encircling him, each of which would allow those above ample opportunity to observe his text messages.

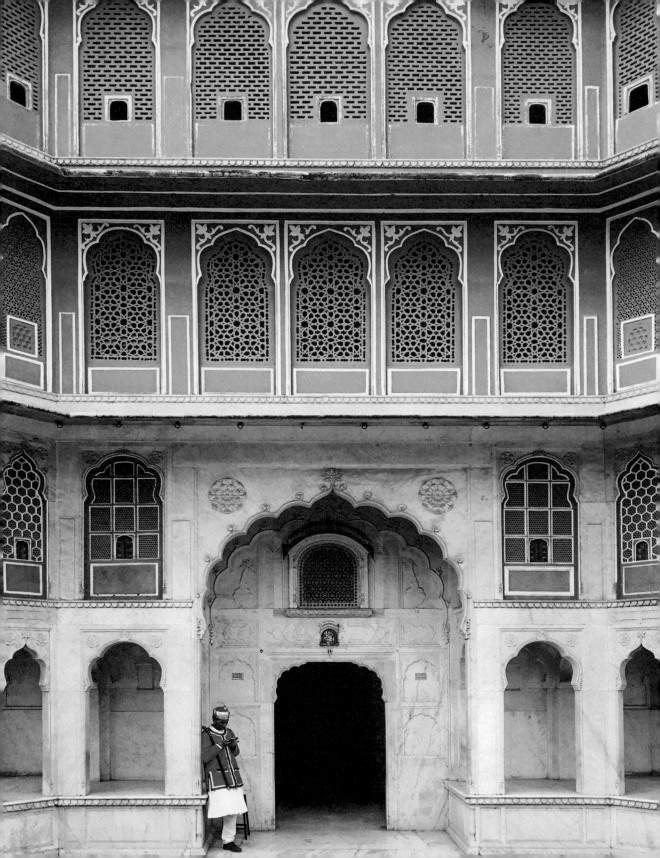

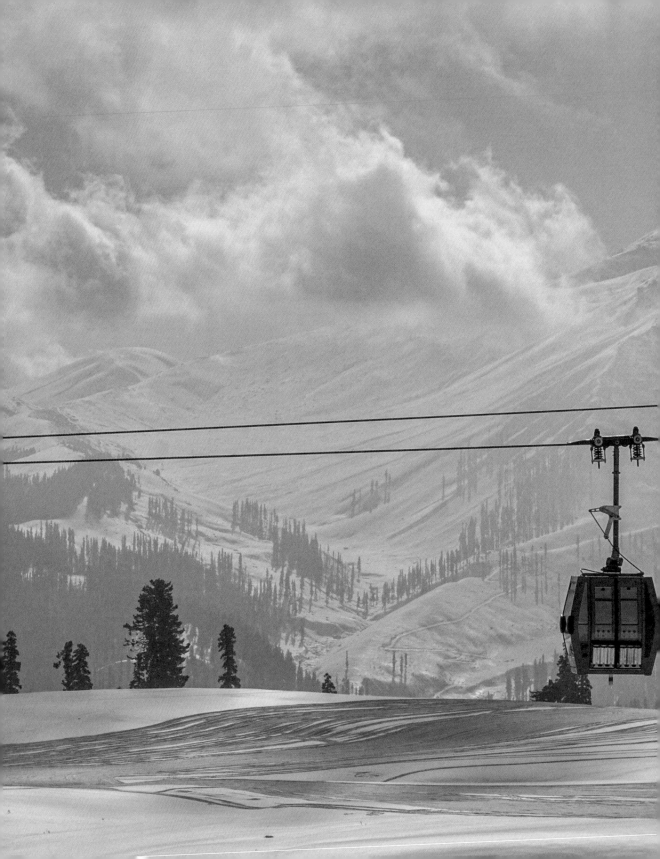

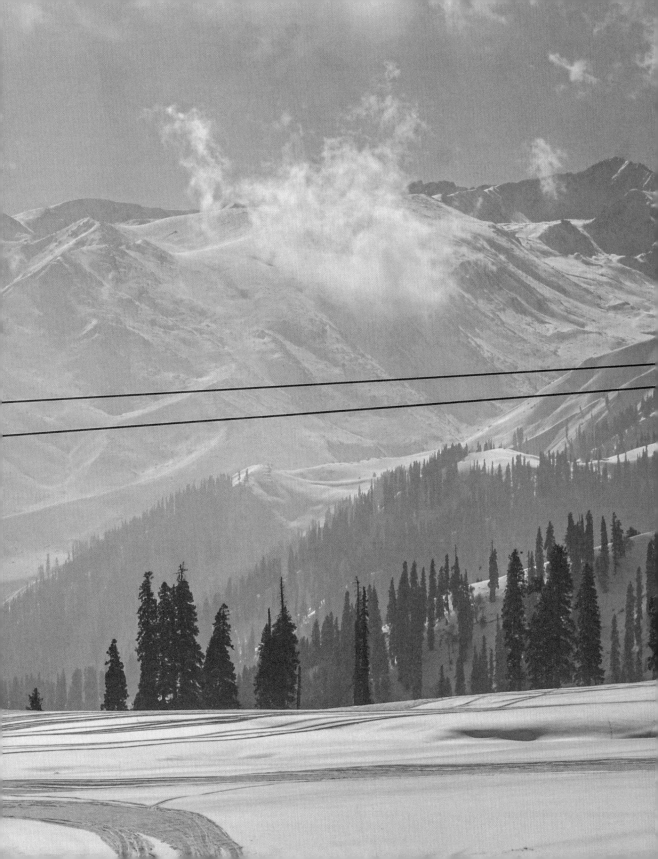

GULMARG GONDOLA

Gulmarg, India | c. 2005

Photo by Pratyush Thakur

Shortly following the country's Independence, the Indian government sought to develop a national venue for winter sports. In 1960, the Department of Tourism invited Austrian Alpine skier Rudolph Matt to select an ideal location. He pinpointed the town of Gulmarg, in Jammu and Kashmir, set against the backdrop of the Himalayas and surrounded by lush, dense forests. Gulmarg is now counted among the best ski spots in the country, but the journey to achieving that reputation has been no bunny slope.

Initially, Gulmarg only had a few basic lifts, none of which could reach the grand summits. In 1987, the government set about transforming the town into a ski resort of international renown, replete with an extreme, impressive lift. The Jammu & Kashmir Cable Car Corporation was created, and a French company was commissioned to assist in the ambitious undertaking. Due to "unprecedented situations," the plans weren't completed until 1989.

The French crew was dispatched just as the Kashmir insurgency was rising, making working conditions increasingly intense. On the site, the situation came to a head in 1990, when rebels kidnapped two French engineers. They were released quickly, but construction was delayed until the following year, when Phase 1 was finally inaugurated.

Tensions among the workers were exacerbated by the conditions on the mountains: extreme altitude, untrod ground, frequent avalanches, fierce winds, and freezing temperatures. The ambitious project was paused again and remained in perilous limbo until the 2003 cease-fire.

At last, Phase 2 was completed, and the Gulmarg Gondolas were declared open in May of 2005. Today, during opening hours, the gondolas ferry about 600 people per hour. The first station, from Gulmarg to Kongdori, leads to gentle slopes. But thrill-seekers head to Gulmarg for a second tier, a twelve-minute trip through the clouds that deposits them more than 13,000 feet above sea level, on the slopes of Mount Apharwat, a "true skier's paradise."

Kashmiris are coming to appreciate their gondola and even starting to outnumber adventure tourists. It's certainly respite from an era that rendered recreational activities impossible. The divine gondola ride of Gulmarg is on the upswing, getting more exposure by the year, aided by soaring numbers of local enthusiasts.

SURAKARTA HADININGRAT ROYAL PALACE
Java, Indonesia | c. 1745
Photo by Nabilla Wardhana

Royal Guards stand watch at the entrance to Surakarta Palace to prevent anyone but the King of Solo (another name for Surakarta), and his consorts from entering its doors. Kings have resided here since the palace's completion in 1745. Though the royal family is no longer a ruling monarchy, they are revered and serve as a reminder of a golden era in Java's past.

Rising above the palace is Sangga Buwana Tower. Once a year, the King of Solo (today, Pakubuwono XIII) walks to the top to commune with the nature goddess Nyai Loro Kidul, or Queen of the Southern Sea. In the twenty-first century, the king merely meditates on the power of the goddess. But in ancient times, it was believed that the mythical queen would transform into the king's bride for the annual visit, to experience a symbolic sexual union. This ritual perpetuated the king's reign by blessing him and the kingdom with the queen's fertility.

←

TAINAN PARK
Tainan City, Taiwan | c. 1917

Photo by Estelle Loiseau

In Tainan Park (formerly Zhongshan Park) in Tainan City, the birthplace of modern Taiwan, retirees in their golden years enjoy a thriving social scene. Senior couples swing slowly during dance classes at this pastel-painted pavilion, while tai chi classes unfold on the grassy lawn. On terraces throughout the park, elderly men spend long hours smoking cigarettes and playing Xiàngqí, also known as Chinese chess. If you're lucky, an invitation might be extended to join in. And if you're luckier, somebody will start sharing stories of Tainan.

They might relay that Tainan is the origin for the name of the country today, or that the park was created by the Japanese in 1917 during their occupation of Taiwan. Perhaps they will even recount the days after World War II, when tens of thousands of the colonizing Japanese were ousted and forced to return to their homeland.

They might also enlighten you, between games, as to the significance of the Qing dynasty stone archways in the park—the last remaining structures of their kind. In Chinese culture, archways symbolize dedication, generally to one's country. And rainbows such as these were placed in Tainan Park as a way to honor all those who had fought against foreign rule for Taiwan, with devotion and with pride.

→

JAPAN RAILWAYS
Tokyo, Japan | c. 1987

Photos by AccidentallyWesAnderson

Japan has the world's busiest rail network, with a daily ridership of 18.5 million. Forty percent of passenger travel in the country is on its railways (compared to the United States, where 90 percent of travel is on roadways). It's no wonder: Japan's rail is reliable to a degree that other nations find unfathomable. It is neither unreasonable nor unheard-of for people to set their watches based on the practially guaranteed precision of their train's arrival. In fact, the system is so confident of its service that passengers have been given refunds if trains are even a minute or two late.

This punctuality is a well-known feature of Japanese travel, however, a lesser-known aspect is the trainspotters—and their corresponding titles. Journalist Anna Fifield described in the *Washington Post* a few varieties of these experts and their obsessions: she discovered *nori-tetsu,* people who enjoy riding on trains; *yomi-tetsu,* who pore over schedules; and *oto-tetsu,* who make recordings of the sounds of the trains as they go by (for recreation). Some are less intrigued by the trains and more focused on their surroundings and perks of riding, such as *eki-tetsu,* students of the stations themselves, and *ekiben-tetsu,* fanatics of the bento lunchboxes sold at said stations.

None of these curious hobbies or obsessions would be possible without those who actually make the trains run: conductors, drivers, and station staff.

These white-gloved specialists have unique habits of their own—most notably the physical gestures and vocal calls they perform, which are a crucial aspect of the trains' efficient operation. The theatrical signals and seemingly random yelps are a Japanese industrial safety method known as pointing-and-calling, which greatly reduces workplace error (and has been adopted by New York's subway system...to notably lesser success).

Should one be interested in taking in this efficient show, keep an eye out for the station staff in Japan whose job it is to make sure that the platform is free of debris or fallen passengers. Employing both physical and audible communication, they animatedly point down the track, appearing to give emphatic acknowledgment to an apparition, before theatrically sweeping their arm along the length of the platform—eyes following the hand—before shouting what amounts to "All Clear!" The process is repeated as the train departs, and acknowledged by the staff aboard, such as these gentlemen (who may also be among the *ekiben-tetsu,* in solemn search of the ideal stand from which to purchase his preferred bento box).

VICTORIA PARK TENNIS CENTRE
Causeway Bay, Hong Kong | c. 1982
Photo by Rex Wong

CHABUTRA ON LAKE PICHOLA
Udaipur, Rajasthan, India | c. 1362
Photo by Lucas Dedrick

Built on the site of a former typhoon shelter, Victoria Park is an oasis of calm in the midst of Hong Kong's frenetic Causeway Bay neighborhood. Located within the park, the beautiful turquoise of Center Court hosted the Salem Tennis Open, sponsored by Winston-Salem, until the city's 1999 ban on tobacco advertising.

Tennis would return, but beyond sport, the park is a natural hub for civic life. The weekly Sunday program, *City Forum*, is broadcast here and plays host to debates on issues of the day by politicians and prominent local figures. The show also draws a reliable crowd of older men known as the "uncles" of Victoria Park. These "indigenous communist" gentlemen object to any opinions expressed that diverge from those sanctioned by the Communist Party of China, and are known occasionally to take backhand swings at fellow debaters with their canes.

Lake Pichola is a man-made freshwater lake, 2.5 miles long and 1.8 miles wide, created by Banjara tribesmen under the rule of maharajas ("great kings") of the Mewar Kingdom. It is one in a series of interconnected lakes that form a chain around the handsome valley of Udaipur. Though the city overlooks several lakes, Pichola has long held the most intrigue. Right in the middle of this fairy-tale lake, on one of its four islands, sits the Lake Palace, or Jag Niwas, originally the luxurious summer home of Maharana Jagat Singh II (1707–1751) and today a five-star hotel.

The islands were developed with marble temples, bathing ghats, security lookouts, and chabutras (raised platforms, normally within a larger courtyard), such as the one on which our guard is jauntily posed. The most infamous of these platforms, Natini Chabutra, was built to commemorate a tightrope walker from the nineteenth century. By many accounts, a teenaged Maharana Jawan Singh (1821–1838) drunkenly offered up a challenge to those around him: if anybody successfully used a tightrope to cross the lake, he would give them half the Kingdom of Mewar.

Emboldened by the potential reward, a tightrope walker accepted the challenge and began her perilous walk. She had nearly reached the end when she was sabotaged: the rope was cut before she reached the bank of City Palace. As the tightrope walker plummeted into the lake, she is believed to have shouted a curse upon the maharana's family—that they would have no direct descendants or male heirs. To date, six out of the seven succeeding Jawan Singhs were adopted sons.

The brave, betrayed tightrope walker tragically anticipated Rudyard Kipling's advice about this mystically gorgeous lake. In *Letters of Marque* (1899), he wrote: "If the Venetian owned the Pichola Sagar he might say with justice—: 'See it and die.'"

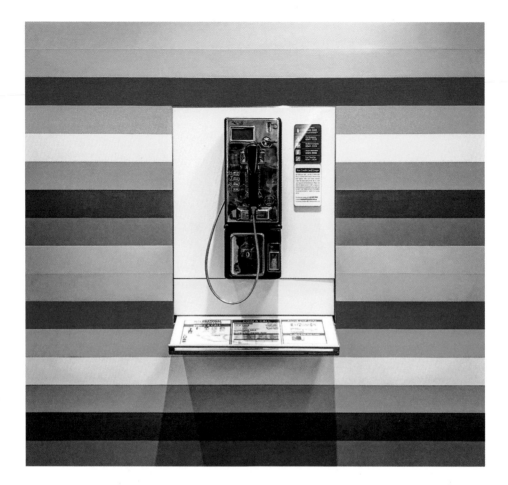

SINGAPORE CHANGI AIRPORT

Singapore | c. 1981

Photo by RJ Damole

Changi Airport ranks beside Tokyo's Narita as Asia's largest airport, and was officially opened in December 1981. Since then, it has become more sophisticated by the year, developing into far more than a place to take off and land.

Among several attractions, it contains a tropical butterfly garden, an orchid garden, a cactus garden, and other botanic areas; a vast array of modern art pieces (such as a massive steel wire bird installation, copper rain droplets, and a 120-foot-long mural depicting the eclectic culture of Singapore); a giant trampoline; a canopy net bridge; a simulated cloud zone; a hedge maze *and* a mirror maze; a "heritage zone" that offers travelers a glimpse of life in 1930s Singapore, complete with a six-minute theatrical performance; and the world's tallest airport slide.

So, you wouldn't be faulted for thinking that this rainbow wall and its public phone were yet another marvel to enjoy before your flight. But Changi Airport is as functional as it is beautiful, and these public pay phones are found in each departures terminal. Local calls are free.

BEIJING NATIONAL STADIUM
Beijing, China | c. 2008

Photo by Jonathan Bell

From the inside, Beijing's National Stadium, the "Bird's Nest," looks like a standard world-class arena...or perhaps a watermelon...but it is far more than that. In fact, the Nest is the most innovative steel structure humankind has ever created.

Designed for the 2008 Summer Olympics and Paralympics by Swiss architects Jacques Herzog and Pierre de Meuron, Chinese artist and activist Ai Weiwei, and the chief architect of the China Architecture Design & Research Group, Li Xinggang—the only requirements were that it had to be inspiring and able to withstand an earthquake.

Beijing wanted to put forward their National Stadium as a "Monument of New China," and a sign of Beijing's progress. Thanks to the work of up to 17,000 workers, the Bird's Nest is not just the world's most intricately constructed stadium, but also the largest steel structure in existence.

The stadium curves like a saddle but uses interlocking steel parts that resemble a lattice of twigs—hence its nickname. The beautiful "nest scheme" was inspired by traditional Chinese ceramics. Seemingly random, the pattern actually is governed by a complex geometry. Standing back to behold the interwoven strands of the elliptical arena, the stars of the Chinese flag can be discerned. The ingenious beauty of the structure is so impressive in fact, that one of the popular activities listed on its home page is "admiring its design."

SOUTH, CENTRAL,
& EASTERN ASIA

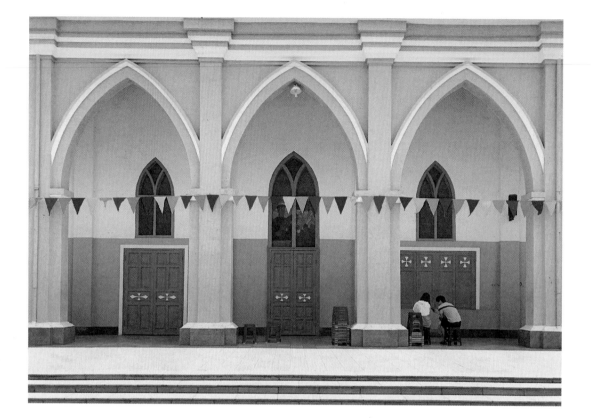

DA NANG CATHEDRAL

Da Nang, Vietnam | c. 1923

Photo by Maki Shinohara

Built in 1923, this cathedral was the only church constructed in coastal Da Nang, Vietnam, during the French colonial period. Standing at nearly 230 feet high, this salmon-pink place of worship was originally named Sacred Heart Cathedral but became known as the "Rooster Church," or *Con Ga*, due to its rooster weathervane keeping watch atop an immense bell tower. Louis Vallet—the priest who built the cathedral for French residents—maintained that the soaring rooster symbolized St. Peter's Gospel stories of repentance and awakening.

The Rooster is sandwiched between two unlikely companions: behind it is a subtle replica of the Virgin Mary, as depicted in France's sacred Lourdes grotto. In front, when the rooster faces southeast, stretches Vietnam's longest bridge—which is shaped, in its entirety, as a tremendous, intricately decorated, fire-breathing dragon, to symbolize power and good fortune. Every weekend by 9:00 p.m., the surrounding area is packed with people gathered to watch as the head spouts fire and water, while multicolored lights illuminate the body, its span winding across the Han river.

Whether due to its rare pink facade, its gentle nod to the blessed Virgin, or its proximity to a fire-breathing dragon bridge, this multilingual church has remained an active home for prayer in Da Nang for nearly a century.

DALAT TRAIN STATION
Dalat, Vietnam | c. 1932
Photo by John Langford

In the late 1800s, Paul Doumer, the governor-general of French Indochina (now Vietnam, Cambodia, and Laos), came up with a plan. He wanted to connect Vietnam's muggy, low-lying area of Phan Rang to the breezy resort town of Dalat, high in the hills—so that French residents could easily escape the heat.

After a decade of planning, work on the railway began in 1903, moving through some of the steepest mountain passes in Vietnam and climbing to almost 4,600 feet. Nearly thirty years, fifty-two miles, and five tunnels later, the train tracks finally reached Dalat.

By then, it was 1932, and the French architects Reveron and Moncet were commissioned to create a station worthy of such an engineering marvel. They created a landmark in grand European style, with nods to the art deco Trouville-Deauville train station in Normandy, capped by sunny yellow tiles.

Later, during the wars against the French and the Americans, Dalat station fell into disrepair, along with the rest of Vietnam's rail system. It wasn't until the 1990s that a four-mile section of the track reopened. Today, passengers ride in vintage-style train cars drawn by a steam engine and disembark at the old station, restored to its former glory with stained glass and the arched ceilings of yesteryear.

And what of the man who inspired the train line? In 1931, just before the tracks reached Dalat, Paul Doumer became president of the French Republic. Less than a year later, at a book fair in Paris, he was shot by a disgruntled Russian—making him the only French president assassinated by a bullet.

SOUTH, CENTRAL,
& EASTERN ASIA

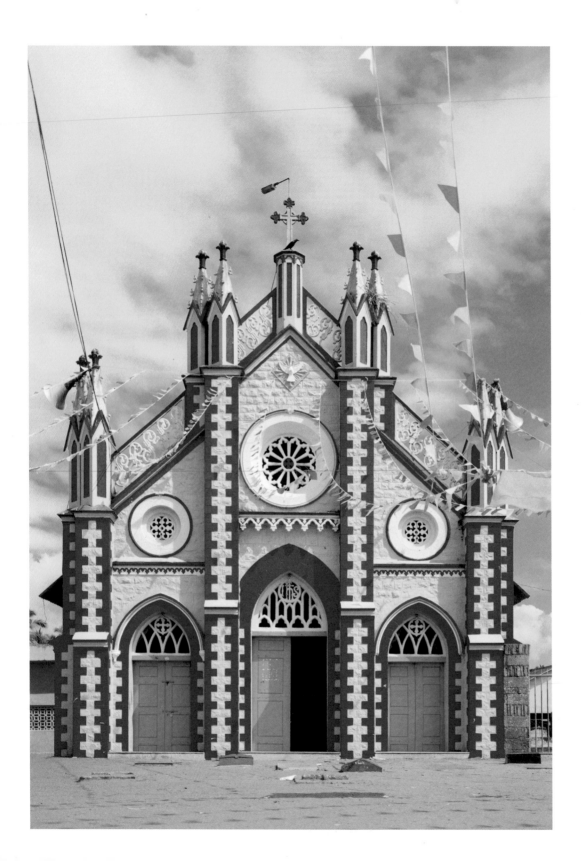

The explorer Vasco da Gama landed near Calicut (now Kozhikode) in 1498. He established the first direct trade between Europe and India, which led to more than 450 years of Portuguese colonial rule along the Malabar Coast of southwest India.

The Portuguese grew rich from the thriving spice trade, with enduring influence (one inheritance of the Portuguese Indian exchange is the popular spicy curry we call vindaloo). In addition to benefiting from India's spices and plants, the Portuguese controlled navigation on the Arabian Sea. When they finally left in 1961, several ports, monuments, and Catholic churches were left in their wake.

Legend has it that the location of the Vizhinjam Old Portuguese Church was chosen after a ship carrying a statue of the Virgin Mary came into rough seas during a sudden and violent hailstorm. The crew prayed to the statue, and after landing safely vowed to send it back out to sea in a small boat, then to build a church wherever it settled. To this day the statue remains at Vizhinjam and is said to bless and protect sailors and all those who travel by water.

Construction of the North Korean capital's small Metro network began in the late 1960s, becoming fully operational by 1978. Today, trains play music and propaganda over their loudspeakers and carry between 300,000 and 700,000 passengers each day. They operate every two minutes when ridership is at its peak, and a ride costs the equivalent of only a quarter of a penny.

The Metro was constructed with assistance from China, which sent technicians to help install equipment, including this 210-foot-long escalator. The descent to the train platform takes more than three minutes; Kyiv's Arsenalna stop is the only Metro station in the world deeper than Pyongyang's.

The Pyongyang Metro's track sits over 360 feet underground and does not have any aboveground connections. The stations were built to function as bomb shelters, with blast doors placed throughout the tunnels. Should citizens be stuck, at least they can bask in luxury: each station, designed as an underground palace in a variety of bright colors, is decorated with marble, paintings, mosaics, and sculptures.

Station names typically do not refer to their locations; instead, most names reflect themes from North Korea's socialist revolution (for example, Renovation, Victory, Unity). One exception is Kaesŏn ("Triumph") Station, which sits beneath the capital's Arch of Triumph.

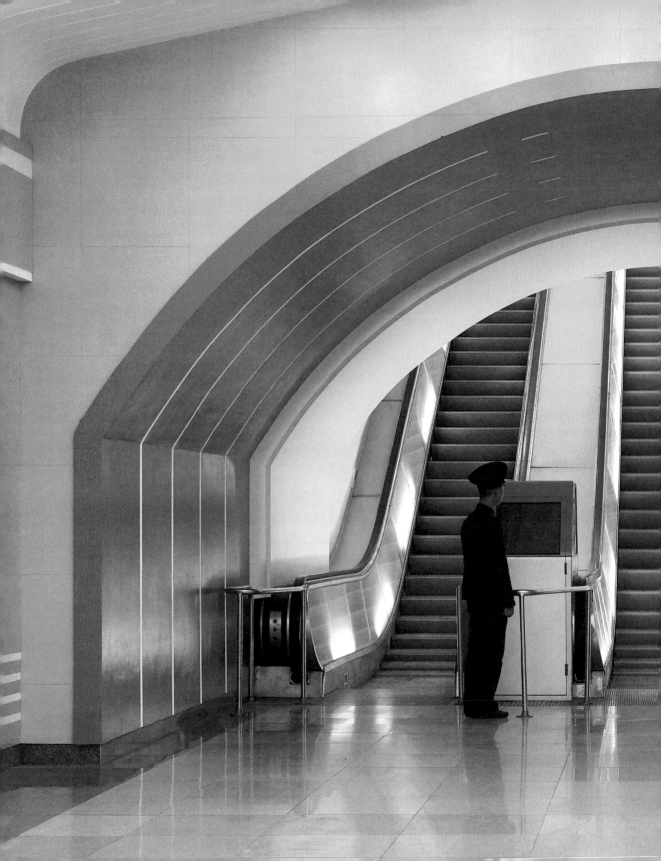

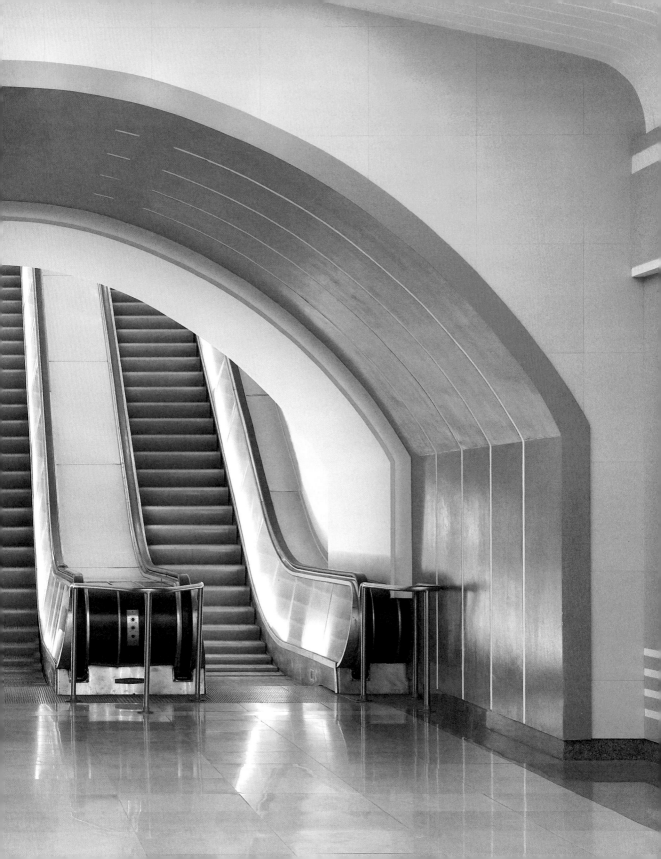

OLYMPIC MUSEUM

Sapporo, Hokkaido, Japan | c. 1999

Photo by Kay Gulledge

Major Theodor Edler von Lerch, an Austro-Hungarian soldier, brought skiing to Japan when he visited in the winter of 1911 to observe the Imperial Army, which had just won the Russo-Japanese War. In exchange for instruction, he consulted with the army, leaving them with the key suggestion that they adopt skiing to assist soldiers in snowy terrain.

It has since grown to become one of Japan's most popular sports, supported by bountiful powder deposited by cold winds from Siberia. Such ideal conditions won Japan the ability to host the 1972 Winter Olympic Games in Sapporo—the first to occur in Asia. (Tokyo had previously won the bid for the 1940 games, but the Japanese government forfeited the opportunity due to World War II.)

The 1972 games were not without their own controversy. Just three days before the epic flame was lit in northern Japan, the retiring president threatened to disqualify forty skiers for receiving professional endorsements. The committee rejected the extreme suggestion but agreed to make an example of skiing's most commercialized star, Austrian champion Karl Schranz. All other offenders were allowed to participate, and the games were a huge success.

This collection of skis, in Sapporo's Olympic Museum, continue to celebrate that glory, while exhibiting the history of winter sports in Japan. Visitors can also simulate the experience of launching off of a ski jump, riding a bobsled, and spinning on ice skates. But, as the particular focus is Japan's inaugural Winter Games, please note that none of the above skis bear any trademarks, branding, or endorsements.

NORDIC CLUB
Dhaka, Bangladesh | c. 1993
Photo by Clara Aloi

These hand-painted tags are used to mark tennis court occupancy at the Nordic Club—an unlikely establishment on the banks of Gulshan Lake in Dhaka, Bangladesh. Tags for adult members are painted light blue, red tags are for visitors, and turquoise tags are for junior members.

The Nordic Club was founded by diplomats and expats living in Dhaka—one of a number of clubs started there by foreign nationals (including the Dutch Club, the German Club, and the Aussie Club.) Members of the Nordic Club are given access to its tennis court and bar. According to Bangladeshi law, alcohol is prohibited—however special provisions exist for foreigners and non-Muslims to consume it within the confines of certain hotels and ace clubs like this one.

Mumbai, India | c. 1900

Photo by Kuber Shah

Established in the early twentieth century, the original iconic movie theaters of Mumbai—India's cinema capital—were once integral to the city's social fabric. South Mumbai still houses some of the earliest theaters, and its citizens are trying to preserve them.

In the cinema district, spanning Lamington Road and Grant Road, almost half of the twenty theaters have shut down. The Novelty Cinema—which released its first silent film on January 1, 1900—was once among them, and has since been converted into apartments. Others are shuttered and dilapidated, mere reminders of bygone days.

These theaters were once venues with red carpets and silver jubilee shows—1,000-seat halls that would be packed to capacity. One theater, the Naaz, was so popular it even had a soundproof room for parents to attend to crying children without disturbing other moviegoers. At the Maratha Mandir Theatre, *Mughal-E-Azam*—an epic Bollywood drama—opened in 1960 and played for six years straight. Interviewed in 2012, the managing director remembered the premiere, when "Dilip Kumar came on a horse. There were elephants all over the place."

That golden era of Indian cinema turned from black-and-white classics to color action films, giving rise to a proliferation of multiplexes, which took over around the turn of the twenty-first century. Several of the old theaters, however, are still open. These days, they tend to screen soft porn, Bhojpuri movies, or old Bollywood films. Business has ebbed for years now, though numbers rise in the summer, when many people come in for the air-conditioning.

A number of the owners have held fast to their passion. Interviewed in 2016, R. P. Anand, of Naaz Cinema, which closed in 2011, said that at the age of eighty-four he still walked into the theater at 3:00 p.m. every day and sat there until evening. Sanjay Vasawa, of the Edward, told an interviewer that he considered the theater home: his father not only spent countless hours working there, but resided in the green room as well, bedding down once the patrons had cleared out. And at the Alfred, manager Huzefa Bootwala said in 2016, at the age of sixty, that he had worked at the theater for thirty-six years. "I will continue working here until the theatre closes, or until I die."

KABUKI-ZA THEATRE

Tokyo, Japan | c. 1889

Photo by AccidentallyWesAnderson

Kabuki (歌舞伎) is a classical Japanese art form, a dance-drama performed as a colorful extravaganza of design, music, and artful stagecraft, with centuries of history behind it. It is easily identified by its unique style and the performers' striking stage makeup. The root of the name is believed to be the verb "kabuku": "to lean" or "to be out of the ordinary."

A three-hour Shinkansen (bullet train) ride from the original Kabuki-za in Tokyo will get you to Kyoto. There you will find a statue of a woman holding a fan, with a sword slung over her shoulder. This is the originator of kabuki, Izumo no Okuni.

Okuni had learned to perform traditional Shinto dances and songs at the shrine where her father was a blacksmith. In the early 1600s, she was sent to Kyoto to work as a performer, and to solicit contributions to send back to the shrine. Instead, she became the pioneering artist of an experimental new art.

Okuni regularly gathered a troupe of female performers to entertain burgeoning crowds with risqué dances and cross-dressing comedy. Her most popular performances were the dual roles of a samurai seduced by a prostitute; perhaps heightened in appeal by performers often doubling as prostitutes, themselves.

Audacious and strange, the subject matter and approach garnered tremendous acclaim, and Okuni was even asked to perform for the emperor. Following her success, new troupes of female performers formed to practice the art of what came to be called "Kabuki."

Contrary to its popularity, the Shōgun government was never a big fan of Kabuki or of the disruption it brought to the established social order—especially considering the performances often saw multiple classes intermingling. Women's Kabuki (onna-kabuki) was banned in 1629 for its eroticism. Young boys stepped into female roles in wakashū-kabuki, but they too were generally available for prostitution, and that form was also banned. Ultimately, Kabuki would be performed by adult men, yaro-kabuki, who played both female and male characters.

Today, the onnagata is the term for the art form's specialist men who play female roles, since no women have appeared onstage since the 1629 ban. Among their techniques is the mie, a pose in which profound emotions are shown in flashes of exaggerated expressions. The sequence is emphasized by resounding wooden clappers to convey the sense of moments frozen in time, as though the audience were watching an intense, living slideshow.

Another feature is kurogo, a word originating from Kabuki stagehands, dressed in black. Kurogo employ enchanting stage techniques that include seemingly impossible costume changes onstage. For instance, an evil priest transforms into the hero without leaving the stage. The same actor is re-dressed in less than five seconds, with a new outfit, wig, and props.

Kabuki theaters were trendy gathering places where audiences could catch up on fashion and the events of the day while the entertainment showcased new music and renowned actors. Performances lasted from morning until sunset, with refreshments provided by nearby teahouses.

The art form is often linked to the birth of pop culture in Japan. Typically featuring ordinary people facing down samurai, and conceived as entertainment for every stratum of society, it has long been the most popular traditional Japanese form of theater and an integral part of the nation's artistic legacy. Those who have the privilege of enjoying a Kabuki show would do themselves a favor by leaning forward and savoring the out-of-the-ordinary performance.

MANGYONGDAE CHILDREN'S PALACE

Pyongyang, North Korea | c. 1989

Photo by Christopher Egeberg

North Korea's former supreme leader Kim Il-sung once declared that "children are the kings of the country." Consequently, many cities have some version of a "schoolchildren's palace," devoted to education with a healthy dose of state propaganda.

The Mangyongdae Children's Palace is the largest of its kind and can accommodate 10,000 children daily. Established in 1989, two years before Kim Jong-il took the reins of government from his father, the "palace" was opened to kids and young adults for extracurricular activities, such as classes in which military choruses were composed by kindergarteners.

Since its refurbishment on orders of Kim Jong-il's son, Kim Jong-un—who took over in 2011—it has become a carefully scripted tour stop for those allowed into the country. A performance is usually involved, which begins with students singing as a video montage rolls behind them. The footage includes patriotic images of North Korea, fireworks, and Kim Jong-un's rocket and missile launches, and the songs feature lyrics about children wanting to be pilots and artillery gunners. The final act features a projection of the face of Kim Jong-un, the child who is indeed the king of the country.

GRAND HOTEL TAIPEI
Taipei, Taiwan | c. 1952
Photo by Jenna Diaz

The Grand Hotel is a landmark fourteen-story pala-tial building located in Taipei's Zhongshan District, perched between a lush green mountainside and the capital's energetic urban sprawl.

After former President Chiang Kai-shek fled to Taiwan in 1949, having been defeated by Mao's Communists, he found it difficult to offer foreign dig-nitaries sufficiently impressive accommodation. His forward-thinking wife, Soong Mei-ling, suggested building an elegant hotel on Yuanshan Mountain—directly atop ruins of the Taiwan Shinto Shrine, a vestige of Japanese rule. Generalissimo Chiang embraced the idea and planned for a structure that would elaborately showcase Chinese culture and architecture to the West. It succeeded: the creation was rated one of the world's top ten hotels in 1968.

Intricate depictions of dragons appear through-out, inspiring the hotel's "Dragon Palace" nickname.

Some are explicit—like the Golden Dragon Pavilion—but subtler versions command a significant pres-ence, as 200,000+ dragon carvings and drawings decorate the hotel.

In 1995, a devastating fire destroyed the roof. After three years of steady construction the hotel reopened with rooftop dragon head adornments symbolically shifted to ward off future fires. The leg-endary beasts not only embody power and luck but are also ambassadors of rain and water.

Each of the eight guest floors represents a dif-ferent dynasty. Everything from the traditional folk art to the fabric of the bedding pays tribute to the level's historic identity. But no room comes near the magnificence of the presidential suite, which con-tains Chiang's writing desk and Madame Chiang's makeup table. This lodging and its antiquities can be yours to behold for a cool $5,500 per night.

SOUTH, CENTRAL,
& EASTERN ASIA

GREAT MOSQUE OF HERAT

Herat, Afghanistan | c. 1446

Photo by Matthew Longmore

Arguably the most beautiful example of Islamic architecture in all of Afghanistan, the Great Mosque of Herat's nearly six-century history has been almost as tumultuous as that of the country. Both mosque and nation make evident Afghans' resilience and determination to overcome challenges and rise again.

Construction of the mosque began in 1200, but the building fell into ruin only two decades later, after Genghis Khan conquered and pillaged the region.

It has been rebuilt, destroyed, and restored many times since, and each new effort has built upon what came before.

The structure was damaged anew during the Anglo-Afghan wars of the early twentieth century, and 1943 brought a major overhaul in which a tile workshop was created onsite—an ongoing contribution to the magnificent mosaic that adorns this house of worship.

CAT

Istanbul, Turkey | c. Forever

Photo by Evynne Doue

"Without the cat, Istanbul would lose a part of its soul," claim residents of this ancient metropolis. With a foot in both Asia and Europe, the city that shares two continents also shares its space with hundreds of thousands of four-legged felines.

In the Ottoman era, when Istanbul served as the most important center of international trade between the East and West, ships brought these stowaways from all corners of the earth. Today they are considered neither domesticated nor feral—darting through the urban landscape, sunning themselves on wooden docks along the harbor, surveying the city from rooftops, and claiming the best seats at outdoor cafés.

Istanbul is the ultimate diverse city, with a history of clashing cultures: traditional vs. modern; religious vs. secular. However, one trait that unites Istanbulites is their affinity for cats. Many empathetic city dwellers offer tender attention, from placing bowls of food and water on the sidewalk to collecting money to care for sick animals. Even the Hagia Sophia has its own famous cat, Gli.

One legend dates to the time of the Prophet Muhammad, who some say was saved by a cat from the bite of a deadly serpent. In gratitude, he granted felines their lifesaving ability to always land on their feet.

YASUDA AUDITORIUM, UNIVERSITY OF TOKYO

Tokyo, Japan | c. 1925

Photo by AccidentallyWesAnderson

REGENT SINGAPORE HOTEL

Singapore | c. 1982

Photo by Matias Galeano

The University of Tokyo is a public research university widely considered the most selective and prestigious in Japan. Established in 1877, it serves about 30,000 students across five campuses. Its faculty, researchers, and graduates count seventeen prime ministers, sixteen Nobel laureates, and three astronauts, among other luminaries.

Early in the twentieth century, prominent entrepreneur Yasuda Zenjiro was concerned that the esteemed institution did not have a building grand enough to receive the Japanese emperor on his visits to the capital. So he took it upon himself to donate the funds to construct the dynamic Yasuda Auditorium. The iconic brick clock tower and atrium were completed in 1925 and became the new symbol of UTokyo.

Yasuda unfortunately never got to see his building; he was killed in 1921 by a nationalist enraged by Yasuda's refusal to offer money to a struggling worker's hotel. He was mourned by many whom he never met...most notably his great-granddaughter, Yoko Ono. According to a biographer, when her husband John Lennon first saw Yasuda's photograph, he said, "That's me in a former life," to which Ono replied, "Don't say that. He was assassinated."

The Regent Singapore is a luxury hotel designed by American architect John Portman in 1982. Portman revolutionized hotel designs in the United States, then Asia, ingeniously using colossal spaces and blending modernist and brutalist elements to inspire and overwhelm guests. His iconic designs have even been embraced by Hollywood for their dystopian, sci-fi quality.

Standing in the middle of the Regent Singapore's bright, expansive, pyramid-like atrium causes a disorienting shift in one's spatial perceptions. Looking out from the hotel's interior balconies gives one a full view of the cavernous space extending from the lobby's black marble fountain to the skylight twelve dizzying stories above. Meanwhile, one can trace the path of every guest as they journey through the hotel on exposed spiral staircases, open walkways, and glass capsule elevators.

Influenced by Frank Lloyd Wright, who synchronized his buildings with the needs of the people who used them, Portman ardently believes that open spaces relieve anxiety—particularly in congested cities like Singapore. He wanted his own buildings, especially hotels, to be oases.

His structures prioritize the human experience. Take his signature glass elevators: "Everyone talks on a glass elevator," he explained to the *New York Times*. "You get on a closed-in elevator, everyone looks down at their shoes. A glass elevator lets people's spirits expand. Architecture should be a symphony."

COLOANE LIBRARY

Coloane, Macau | c. 1983

Photo by Alberto Chan

The Coloane Library (路環圖書館) is located in Macau, a Special Administrative Region of the People's Republic of China. Known formerly as Freguesia de São Francisco Xavier, the village of Coloane served as a sea salt farm for China from the time of the Song dynasty until the Portuguese arrived in 1864 and turned Macau into a crucial trading port. Most of its development has been constructed on land reclaimed from the sea, which is perhaps why it was largely used as a pirate base until 1910.

Conveniently built the year after the pirates had set sail, this buttercup-yellow mini temple was designed in the traditional Portuguese architectural style, and initially served as the a public elementary school. Its function was changed several times until it was remodeled as a library in 1983. With only twenty-two seats, it hosts a collection focusing on children's books, periodicals, and popular novels. And while no puppies or pets are permitted to peruse—or occupy any of the library's indoor seating, for that matter—they are more than welcome to wait on the benches out front.

THE WHITE CYCLONE AT NAGASHIMA SPA LAND
Kuwana, Japan | c. 1994
Photo by Paul Hiller

Nagashima Spa Land opened in 1966 with close to fifty amusement park rides and a hot springs water park. Spa Land's ten roller coasters command the longest lines—the most famous being the Steel Dragon 2000, which spans the entire length of the park and ascends a hill reaching 318 feet into the sky.

Close behind it in popularity was the White Cyclone, a wooden roller coaster that opened in 1994. The ride was unusually fast for a wooden roller coaster, incorporating elements such as helixes and extreme drops. Wooden coasters are extremely rare in Japan, a country with strong regulations on tree felling; the Cyclone was constructed with enough timber to build nearly a thousand homes. When time came for renovation, it was replaced by a steel-tracked coaster named Hakugei, or the White Whale.

After a fourteen-year run, the Cyclone made its last spin in January 2018. The White Whale surfaced a year later, offering a smoother, more durable ride and an extra 40 feet of a drop—perhaps to compensate for rider nostalgia.

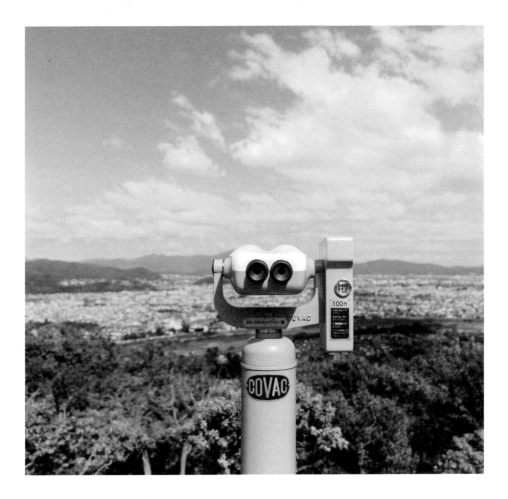

ARASHIYAMA MONKEY PARK

Arashiyama, Kyoto, Japan | c. 1956

Photo by AccidentallyWesAnderson

The Arashiyama Monkey Park is located atop Itawa Mountain in Arashiyama, Japan. Home to as many as 130 Japanese macaques, or snow monkeys, these evolutionary cousins of ours are wild—but they follow the grub. Those working in or visiting the park are happy to offer them morsels, from the building atop the hill, at a safe distance of course.

The monkeys stay outside while being fed through wire fencing, preventing particularly peckish primates from nibbling your arm. Visitors are also warned not to stare at the monkeys or to put their face too close to the fence.

That being said, you are more than welcome to put your face as close as you would like to the lone viewfinder just outside the feeding house, and stare off into the spectacular views of Arashiyama and all of Kyoto. Just be sure to leave your bananas inside the feeding hut.

OCEANIA

325

335 332

328

327

338
324 322

321
338
318 335

WHARF SHED

Glenorchy, South Island, New Zealand | c. 1885

Photo by Frida Berg

Glenorchy is a settlement at the northern end of New Zealand's Lake Wakatipu, about thirty miles from Queenstown. Settlers arrived at the base of this exquisite valley in the 1860s, searching for sheep-grazing land. They were followed by prospectors in pursuit of gold and scheelite (a mineral specifically sought for munitions manufacturing during the New Zealand Wars).

For nearly a century, the only access to Glenorchy was by steamboat. As the sole site for all arrivals and departures, this simple shed became the center of the town's activity. Despite its importance to Glenorchy as a social hub, passengers rarely disembarked from the commercial steamers that stopped there, as the wharf grew so wobbly that stepping onto it drew comparisons to "walking the plank."

By the mid-1950s, the 250 full-time citizens of the town came together and initiated a push for a road to connect Glenorchy to Queenstown. Though supported by many, the execution of the project was engineered by two remarkable individuals, each fueled by willpower and love...with extra assistance from a nudge of fate.

Reta Groves was born in 1922 and lived on a remote sheep farm near Routeburn Station, across Lake Wakatipu from Glenorchy. She and her sister, Betty, worked as "land girls" during World War II while the district's men were abroad. They plowed the land, sheared the sheep, and drove farm vehicles from the age of ten.

Across the Dart River, Tommy Thomson grew up on a dairy farm in Dunedin, spending his childhood delivering "billy milk" (goat's milk) throughout the North East Valley. He trained as a mining engineer and surveyor, and went to serve overseas. He escaped the 1942 Japanese invasion of Singapore by a matter of hours, only to venture on a long and hazardous journey home. Within ten days of his return, the Mines Department sent him to Glenorchy to survey areas for mining more scheelite.

Shortly after his arrival, Tommy attended a village dance that featured a game in which proverbs or well-known quotes were written out and cut in half. The women received one half, the men the other. After picking at random, you had to find the person who completed your quote—success yielded a dance partner.

Reta, never really one for games, sighed but obliged her sister, and pulled out the opening line: "Birds of a feather..."

It didn't take long to find Tommy nearby, holding "...flock together."

In the spring of 1945, the two married and soon had three children—Reta went by steamer across the lake to prepare for delivery a week before each of their scheduled birth dates.

She grew tired of relying on the unpredictable, thrice-weekly boat schedules, and worried about access to medical facilities for their growing children. Strong in her convictions, never one to settle, and prepared to roll up her sleeves, she insisted to Tommy that they needed a road to Queenstown.

And so Tommy built a road. First, he evaluated the landscape, deciding where a passageway could be built on the tricky terrain surrounding Glenorchy, which lies at the bottom of what was once a glacier. Then he enlisted the help of fellow villagers, who bulldozed until they were exhausted, then camped, then woke to bulldoze some more. The cycle repeated until Reta, Tommy, and the people of Glenorchy were free to come and go at will. In 1962, as an exclamation point to their Centennial celebrations, a delighted Reta Thomson was the first woman to drive over their newly opened road.

Tommy and Reta remained married for nearly seventy years, until his death, in June 2014. She passed away two years later. They devoted their lives to bettering the future of the whole valley, always working together to make it happen.

Once the road was built, residents were no longer dependent on the steamers, so commercial use of the Glenorchy wharf ceased. But each time the iconic shed has washed away, collapsed, or destroyed due to age or natural disaster, the villagers have rebuilt it. The only difference between the present exterior and that of its predecessors is that the sign, which once faced the water, now faces the village. It serves as home to a historical society and a small museum, complete with information about the changes in landscape, transport over the years, and the birds-of-a-feather characters who enabled Glenorchy's evolution.

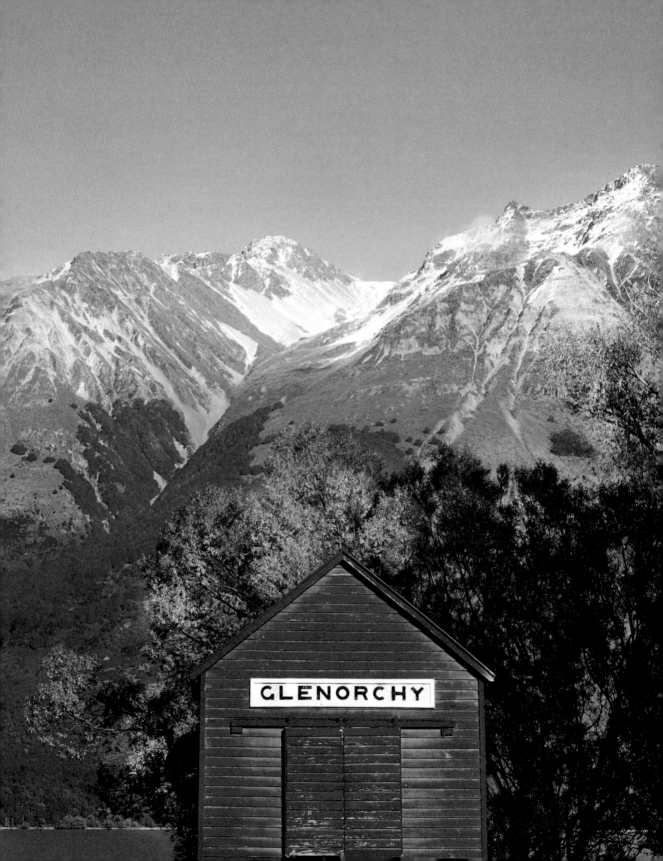

REEFTON COURTHOUSE

Reefton, South Island, New Zealand | c. 1872

Photo by Michael Brown

Nicknamed "Quartzopolis," Reefton was founded after the discovery of rich quartz veins, or "reefs," in New Zealand's Inangahua region. Quartz deposits often foretell the nearby presence of gold, as was the case here.

A major discovery was made in 1870, precipitating a veritable gold rush. With the arrival of so many prospectors came inevitable conflicts, and the need arose for an adjudicating authority. That led to the 1872 construction of the Reefton courthouse, which was followed by the appointment of a resident warden to issue declarations of rights and settle disputes arising from the sudden wealth of the region. One would hope this was also the site of lively discussions regarding whether or not to officially rename the town Quartzopolis.

HOT-AIR BALLOON
Hamilton, North Island, New Zealand | c. 1783

Photo by Marie Valencia

The first manned flight by hot-air balloon was executed in Paris in 1783—making it the oldest flight technology to successfully carry humans. Throughout the world, one can find fervent enthusiasts and lively international festivals celebrating the joy and romance of this first aircraft. Among those is New Zealand's Balloons over Waikato, a festival held every year over the lakes of Hamilton from sunrise until the ZURU Nightglow, when the balloons are illuminated as music is performed. The festival closes with a fireworks display (after the balloons have landed, of course).

Avid balloonists have unique rituals, most notably the tradition that each time a hot-air balloon lands, champagne is shared. The story goes that when hot-air balloons were first being tested, farmers believed that they were strange creatures or aliens descending from the skies and landing in their fields. To allay those fears, hot-air balloon pilots would share a bottle with the farmers.

But nobody in the history of ballooning—from its French inventors to billionaire Richard Branson, who crossed the Atlantic in the vessel—deserve that champagne toast more than an Iowan named Emma Carroll. The oldest successful human to fly the oldest successful human-carrying technology, Emma made a buoyant hour-long flight over her home state in 2004, when she was 109 years old.

KOHEKOHE CHURCH
Awhitu Peninsula, North Island, New Zealand | c. 1886

Photo by Kalpesh Tailor

Among the definitions for Awhitu are "a longing to return" and "to yearn for." This New Zealand peninsula delivers on either interpretation. Perched amid a vision of serenity that anybody would yearn for sits Kohekohe Church.

Built by a Waiuku native, this Presbyterian church was used for prayer services and Temperance meetings until it was decommissioned in 1976. In 2012, two local teachers, Patsy Deverall and Antonella Coppolino, bought the one-room church and fixed it up for hire and events.

Though all kinds of renovation were necessary, the frame remained intact throughout decades of neglect. Such resilience and durability leads one to doubt that the little church was constructed entirely from the native Kohekohe tree—which is also known by its distinctively flimsy name, Vanessa's Sneeze Leaf.

CRAWLEY EDGE BOATSHED

Perth, WA, Australia | c. 1930s

Photo by James Wong

At first, there was just a trickle of tourists who would occasionally snap photos of the Nattrass family's little boathouse, a sweet exclamation point capping off a rickety boardwalk on the Swan River in Perth, Australia. But the tourists kept coming back, growing from that trickle into hundreds. Then thousands. The numbers of tourists have grown so overwhelming that in 2019 the city of Perth decided to spend $400,000 on a solar-powered toilet facility to serve them.

Once threatened with demolition by the Australian government, the Crawley Edge Boatshed is the most photographed spot in Perth, and tourists wait their turn along the waterfront to take selfies in front of what has become an iconic landmark. Some researchers are even studying the Blue Boathouse phenomenon to better understand how photo sharing led to this remarkably unremarkable organic online popularity.

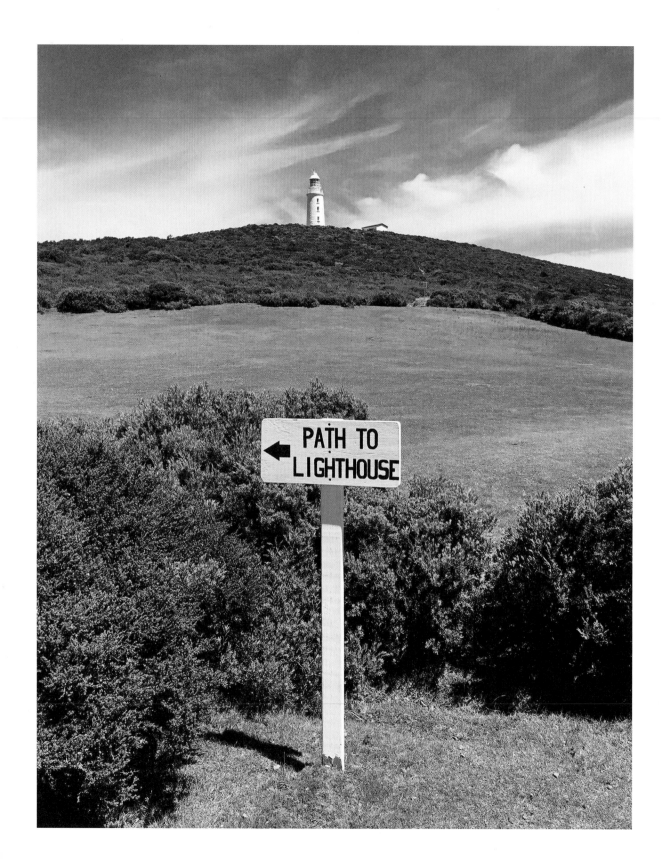

CAPE BRUNY LIGHTHOUSE
Bruny Island, Tasmania, Australia | c. 1838
Photo by Phoebe Dennis

Standing 374 feet above the wild coastline of Tasmania is the Cape Bruny Lighthouse. Now inactive, it is the second oldest remaining lighthouse tower in Australia and was continuously manned for 158 years.

Built using locally quarried rock that was primarily installed by convict laborers, when first lit in 1838 its lantern originally burned a pint of sperm whale oil every hour.

Cape Bruny was home to Australia's longest-serving lighthouse keeper, Captain William Hawkins, who served as the sole superintendent between 1877 and 1914.

In 1993, when John Cook, the last keeper, was made redundant, he said, "I didn't want to leave... When the time came I was very sad, everything was becoming automated. It was like the tide coming in and you couldn't stop it."

The lighthouse was later replaced by a solar light-station on the neighboring headland (which may explain the depicted signage). The decommissioned historic tower was transferred to the Tasmanian Government and ultimately became part of South Bruny National Park.

ELPHIN SPORTS CENTRE
Launceston, Tasmania, Australia | c. 1964
Photo by Pippa Mott

Table tennis is played at the highest levels of global sporting competition—at the Olympics, Commonwealth Games, and Paralympics. But there is no consensus on exactly where this form of mini-tennis was first played.

The earliest patent was issued to an Englishman named David Foster in 1890, for "Parlour Table Games, which includes table versions of Lawn Tennis, Cricket, and Football"—likely early incarnations of Ping-Pong, air hockey, and foosball. But disagreements abound on this point, as other reports suggest that officers of the British army developed their own version of the game while stationed abroad, using paddles improvised from cigar box lids, balls made of cork, and a row of books as a net.

Since then, the game has gone by many different names. As the nineteenth century became the twentieth, the options included Gossima, Whiff Waff, Parlour Tennis, Pom-Pom, Pim-Pam, Clip-Clap,

Netto, and Tennis de Salon. The two names that stuck were table tennis and Ping-Pong.

No matter the name, the footwork is more specialized than you may expect, and is one of the first techniques that any serious player must master. Proper table tennis shoes should be light, with a thin outsole, low heel cap, and good protection on both sides. Above all, the sole must offer excellent grip. World-class players take countless swift baby steps, in addition to making lateral moves.

The Elphin Sports Centre, in Launceston, Tasmania, looks out for its players. It has hosted multiple championships since its opening in 1964, and while table tennis is not its primary attraction, it does have dedicated courts. To protect players and to ensure the upkeep of their courts and specialized floors, Elphin prohibits patrons from strolling in, casually smoking cigarettes or perhaps even wearing a pair of Chucks.

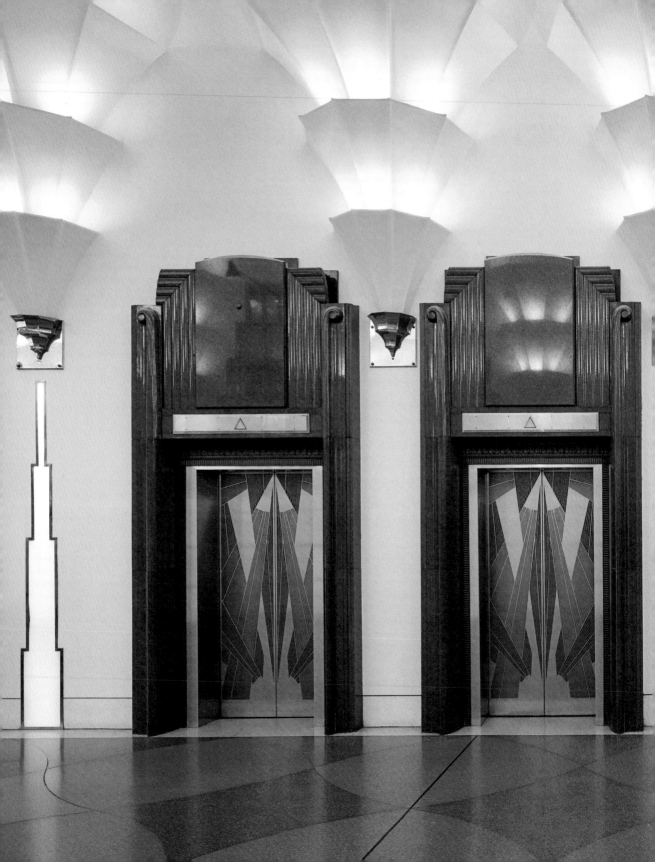

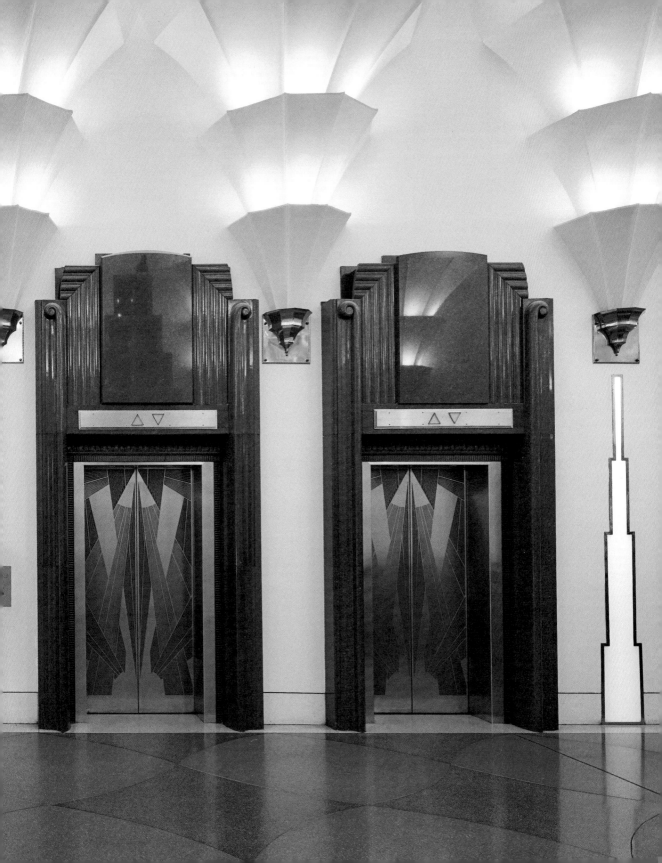

HENRY DAVIS YORK BUILDING
Sydney, NSW, Australia | c. 1938
Photo by Bates Smart

NORTH SYDNEY OLYMPIC POOL
Sydney, NSW, Australia | c. 1936
Photo by Adam Murphy

From the sleek, streamlined geometry of its lobby floor to the ancient sandstone Egyptian motifs on its tower, the 11-story Henry Davis York Building (formerly The Mutual Life & Citizens Building) is admired as one of the foremost examples of art deco design in Sydney, Australia. Featured prominently on the tower is a relief sculpture of the former MLC company's logo known as "Strength in Unity," which depicts a man attempting—rather unsuccessfully—to break up a bundle of rods.

In April of 1936, the North Sydney Council acquired a prime site upon which they built a modern facility hailed as "the wonder pool of Australasia" due to its sophisticated aesthetic and state-of-the-art filtering system. Built largely in the Functionalist style, which emphasizes symmetry, and hints of art deco, the Olympic Pool was filled with treated seawater, pumped in from the harbor.

At its opening, North Sydney Alderman C. C. Faulkner exalted the accomplishment: "Imagine the most perfect sapphire in the world—colossal in dimensions, blue, with a radiance that dazzles yet soothes; that is what the water in the Olympic pool is like."

With its dazzling water and ideal location beside the Sydney Harbour Bridge and Luna Park, the pool was twice the venue for the British Empire Games, as well as many national championships. It has remained in continuous operation since its illustrious opening—during which time eighty-six world records have been established in its waters.

But after eighty-four years of operation, the North Sydney Olympic Pool is in need of a costly overhaul—a reality that has severely disturbed locals. "Our swimming spots are under threat," wrote one impassioned journalist, contending that minimizing funds for pools cuts to the core of what it is to be Australian. Residents have asserted that swimming is ingrained in their beings, and that these fluid sanctuaries serve as precious landmarks of inspiration and invention, such as the Australian crawl, also known as the freestyle stroke.

There is some debate surrounding that claim. But down under, local Dick Cavill is credited with developing the technique. Regardless, one thing is not up for debate, and has been made clear by the North Sydney Olympic's challenges: Aussies are very, very serious about their pool parties.

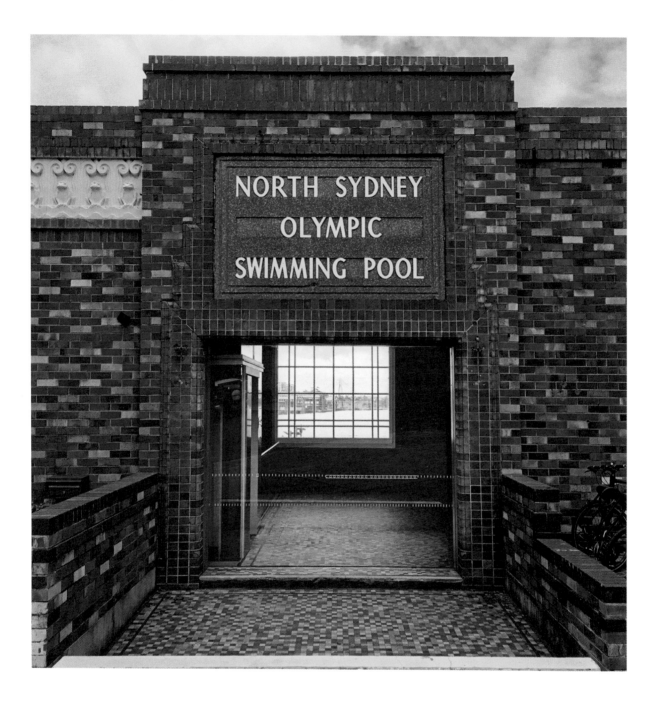

←

DUN & BRADSTREET BUILDING

Adelaide, SA, Australia | c. 1928

Photo by Marco Di Stefano

→

KAYAK ON LAKE TEKAPO

Mackenzie Country,
South Island, New Zealand | c. 1855

Photo by Frida Berg

This contradiction of a building—located in Adelaide, the capital of South Australia—is hulking, severe, and yet conceived in a manner as to allow significant sunlight through its north-facing windows. Finished in 1929, it originally served as office space for an electrical engineering firm.

The structure still stands in the city center, close to the River Torrens, in an area originally inhabited by the indigenous Kaurna people and known as *Tarndanyangga* ("red kangaroo rock"), making it fitting that the building is held up by red bricks.

Dun & Bradstreet, among other things global debt collectors, acquired the site for their Adelaide branch in 1978. In 2012 they were called in to track down thousands of people who collectively owed the state government as much as $260 million in unpaid fines. Two years later, a considerable amount remained outstanding, and the government changed their strategy to one of public humiliation.

The attorney general began publishing the names and birthdays of the top five hardcore defaulters ignoring their fines. The first listing included a twenty-four-year-old who owed $115,000 exclusively in parking and traffic offenses. But years after the campaign began, the debt remained outstanding.

In time, Dun & Bradstreet moved on—but the facade still bears their fine script.

During the summer, the waters of New Zealand's Lake Tekapo turn a magical shade of blue. This marvel is the result of fine particles of rock deposited from surrounding glaciers, which reflect the sun and lend the lake its glowing, almost neon, hue.

Revel in it by day, but train your gaze upward by night. Lake Tekapo has one of the busiest night skies on our planet, which is why the Aoraki Mackenzie International Dark Sky Reserve is based here. Restrictions on outdoor lighting that were put in place almost forty years ago help minimize light pollution, making the area a prime stargazing destination.

Both the lake and the Dark Sky Reserve are in Mackenzie Country. Though Maori people were the first to venture in, Scotsman James McKenzie "discovered" the basin in 1855. In March of that year he and his dog, Friday, drove flocks of sheep from South Canterbury to Otago, attempting to evade capture, as McKenzie was a sheep-herder-turned-sheep-thief.

After an extended search the authorities captured him, but—due to his highly intelligent Collie—they struggled to take control of the thousand sheep he had stolen. As the story goes, Friday carried on herding the sheep on his own until he was finally taken out by authorities. This curious incident resulted in the shepherd's name (with a spelling change) being applied to the region ever since.

In honor of Friday's legacy, local farmers commissioned a triumphant bronze memorial honoring working Collies, which was placed near the Church of the Good Shepherd. Its plaque attributes the statue to, among others, those who "appreciate the value of the collie dog, without the help of which the grazing of this mountain country would be impossible."

FISHING BOAT
Leigh, North Island, New Zealand | c. 1858
Photo by Petra Leary

SKI-PLANE
Tasman Glacier, South Island,
New Zealand | c. 1959
Photo by Frida Berg

Leigh is a tiny, picturesque fishing village (population: ~450) in the Auckland Region of New Zealand. The town's tourist lure, as seen in the community newspaper, the *Leigh Rag*, is: "You *could* come for a day, but you'll be back, so why not book longer."

At nearly fifteen miles long, Tasman Glacier remains New Zealand's largest glacier, despite shrinking drastically in a period of accelerated retreat due to climate change. Tasman has long lured visitors, but boats are not allowed within a mile of its face, as icebergs large and small calve from the glacier. So the upper glacier can only be reached by helicopter or plane.

The only company to offer flights landing on the glacier is Aoraki Mount Cook Ski Planes & Helicopters. Its founder, Henry Wigley, had been passionate about aviation since he was a schoolboy drawing planes in class. As soon as possible, he got his pilot's license, flew for the Royal New Zealand Air Force, then moved into commercial flights.

Wigley was also an entrepreneur of great vision. In the mid-1950s, while flying tourists around Mount Cook to allow his passengers to behold the scale and majesty of the glaciers, he began to imagine a retractable ski that would allow airplanes to take off from an airfield and land on snow. He spent hundreds of hours developing his retractable skis, and piloted the first retractable ski-plane in September of 1955 (with the adventurer Sir Edmund Hillary among his passengers).

Ski-plane trips—or "air safaris"—to Tasman Glacier became a key part of Mt. Cook tourism. Wigley refined his design to include hydraulically operated skis with plastic soles, and eventually placed them on the Pilatus Porter PC-6—a small plane that was so good at taking off from short rough runways it was often used as a substitute for helicopters. Later, a PC-6/B2-H4 Turbo-Porter would be used for cinematic daredevil scenes, most recognizably in the James Bond film *GoldenEye*.

In 1976, Henry became Sir Henry, elevated to Knight Commander for services to the tourist, travel, and aviation industries.

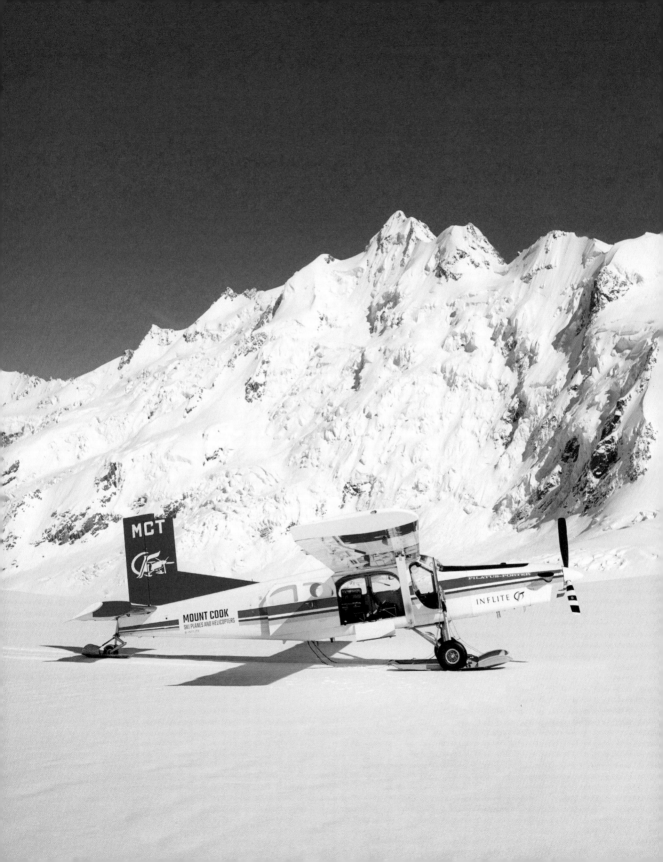

ANTARCTICA

344 Port Lockroy
 Goudier Island, Antarctica

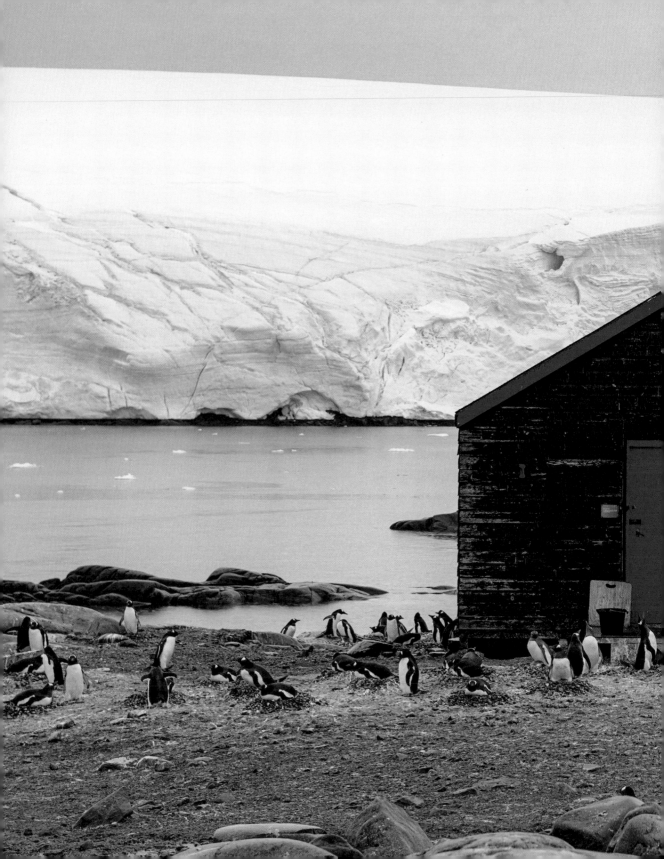

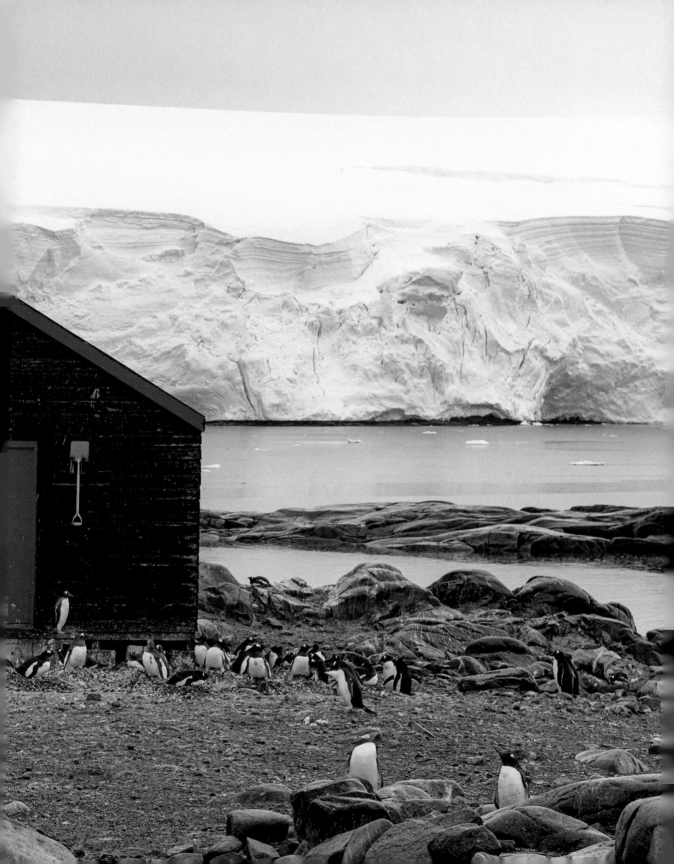

←

PORT LOCKROY

Goudier Island, Antarctica | c. 1904

Photo by Kevin Fohrer

Less than two thousand miles from the South Pole, Port Lockroy is a natural harbor on the coast of the Antarctic Peninsula which can be reached twice a day by boat during the summer. The port is part of the Palmer Archipelago—a family of islands home to research and military outposts for Britain and Argentina.

Discovered in 1904 by the first twentieth-century French Antarctic expedition, Port Lockroy was named for the politician who had helped arrange for backing of the voyage. Then, for the majority of the early twentieth century, the harbor was primarily used by whalers willing to endure the severity of the conditions.

During World War II, the British identified the port's unique strategic placement as a secret outpost, a place from which they could observe enemy U-boat activity in the deep south of the globe. They established a small base, Station A, on tiny Goudier Island as part of a military mission called Operation Tabarin (page 168). Station A continued as a research operation until the early 1960s.

As the only remaining outpost of the base, Port Lockroy was fully restored and now serves as a museum and a post office. Scientific research is still performed on the island, such as studies on the effect of tourism on gentoo penguins—half the island is open to humans, while the other half is reserved for penguins.

The Penguin Post Office and souvenir shop is run by a staff of four who process 70,000 pieces of mail sent to over 100 countries from the intrepid travelers who arrive during the five-month Antarctic cruise season. Visitors are also treated to rare souvenir passport stamps. Due to such swag, its global singularity, and the low bar of competition, the Penguin Post Office remains the most visited tourist site on the continent.

Acknowledgments

To **Wes Anderson**, thank you for creating a world that ignites our imagination, and allowing us to expand on your body of work in a truly tangible fashion. It is a sincere honor. <3

To the **AWA Community**, we said it before and we will say it again: You are the absolute best! Without each and every one of you, this project would never have amounted to what it has become. You bring us a happiness and a fulfillment that we never could have imagined. Thank you for being so amazing; we cannot wait to see what submissions and ideas you share with us next. <3

Amanda, you are absolutely amazing. Your calm, levelheaded approach, your thoughtful understanding, and your unending patience have not only kept me sane but got us to where we are today. You also deserve a gigantic award for putting up with me. <3

Domenica, you helped us realize these stories in a way we could not have imagined. You "got it," unlike many others, and your excitement made it that much more fun for us. Thank you for being amazing at what you do, for caring so much about this project, and for providing much-needed comic relief along the way. <3

Mike and Chris, thank you so much for guiding us through the waters of the publishing world and for sincerely caring about this project—and our mental health—every step of the way. **Janet**, thank you for your laser focus and attention to the most important details. And **Mia**, thank you so much for helping us visualize this project so perfectly, and ultimately making us look prettier than we are IRL. <3

David and Aviva, we could not have made it here without you guys. You have added so much positivity, insight, and comfort to this journey, forever selflessly offering your assistance with our best interests and the best interests of this community at heart. Thank you. <3

To **our Parents**, thank you for putting up with us through this crazy journey and keeping us positive through all the ups and downs along the way. Our love for you is immeasurable. <3

Tammie, Michelle, Allie, Wynn, and Gabrielle, we love you, we love you, we love you. Thank you for being the voices of reason, our sounding boards, and our partners in celebration. <3

To all of **Our Friends**—especially our **NYC Family**—thank you for keeping us sane and providing your insight. We value (most of) your thoughts and input dearly. <3

Also, a massive thank you to **Kelly**, for bringing the power of your words and imagination to this project, and **Gabrielle**, for being our resident Photoshop expert.

Special thanks to: Claire in London, Cristi in Bucharest, David in Dublin, Dirk in Berlin, Elizabeth in LA, Erol in San Francisco, Frida in Berkshire, Jack in Birmingham, James and Karla in NYC, Jeffrey in Buffalo, Joshua in London, Justin in Milwaukee, Kenny in Jakarta, Linda in Berlin, Marcus in Malmö, Marius in Oslo, Mariusz in Warsaw, Matias in Barcelona, Matthew in Boston, Matthijs in Antwerp, Pat in LA, Pavel in Berlin, Piotr in Wrocław, Rachel in LA, Rui in Lisbon, Soo in Edinburgh, Tyler in NYC, Valentina in London, and Waqar in Jacksonville.

To every **Adventurer** who has ever submitted a photo or suggested a location to explore, you guys are the fabric of this Community, thank you, thank you, THANK YOU! <3

And to **Dexter** for being the cutest assistant.

DEXTER GUCCI-BROC'COLI KOVAL
Brooklyn, New York | c. 2015

CONTRIBUTORS

Sam Abrahams | @samlabrahams | samlabrahams.com | Houston, TX | 19

@AccidentallyWesAnderson | AccidentallyWesAnderson.com | Brooklyn, NY | 56, 263, 282, 283, 301, 308–9, 315

Andrew Afram | @andrewafram | andrewafram.com | New York, NY | 146

Waqar Ahmad | @waqonthewildside | New York, NY | 207

Erol Ahmed | @erol_is | erol.com | San Francisco, CA | 37

Ky Allport | @kallport23 | weareoutline.com | Charleston, SC | i

Clara Aloi | @aloiclara | Montà, Italy | 297

David Axelrod | @2straws | 2straws.com | Seattle, WA | 232

Brad Baginsky | @bradbag5 | Birmingham, MI | 38

Paul Bauer | @papapaulbauer | photo.paulbauer.net | Vienna, Austria | 117–19, 136–37

Jonathan Bell | @jonolion | Stone, Staffordshire, UK | 289

Frida Berg | @friiidaberg | fridaberg.com | London, UK | xiv, 319, 336, 339

Bianca Berti | @biancaberti | São Paulo, Brazil | 87

Rachel Bishop | @minimalistportraits | minimalistportraits.com | Seattle, WA | 25

Joshua Blackburn | @coinop_london | joshuablackburn.art | London, UK | 190, 190–91

Natalia Bolotskaya | @natnineteenforever | Moscow, Russia | 103

Moa Boyer | @moaboyer | Los Angeles, CA | 32

Alice Brooker | @alicebrooker & @alice. photo | Chalfont St. Peter, Buckinghamshire, England | 6

Michael Brown | @m_brownoo | Abu Dhabi, United Arab Emirates | 320–21

Adam Buckles | @adam.buckles | Liverpool, UK | 150

Soo Burnell | @sooukdotcom | soo-burnell.com | Edinburgh, Scotland, UK | 166–67, 175

Esme Buxton | @esmebuxtonphotography | esmebuxton.com | Cheltenham, England | 126–27

Sheryl Cababa | @sherylcababa | Seattle, | 242–43

Valentina Caballero | @valentina_caba | Dallas, TX | 134

James Cairns | @jcjames2 | jamescairns.co.za | Cape Town, Western Cape, South Africa | 240

Giancarlo Caramadre Amodio | @hamstler | Bologna, Italy | 210

Ben Carpenter | @bencphoto | bencarpenterphotography.com | London, UK | 148

Marco Catullo | @marco.catullo | La Plata, Buenos Aires, Argentina | 63

Marcus Cederberg | @marcuscederberg | minimalpics.com | Kumla, Sweden | 94

Christopher Centrella | @chriscentrella | chriscentrellaphoto.com | Brielle, NJ | 248–49, 268–69

Alberto Chan | @albertochan & @copper. frenchie | Macau, China | 312–13

Deb Cohen | @thefrontdoorproject | thefrontdoorproject.com | West Hartford, CT | 51

Alejandro Cornejo | @alejandronicolascornejo | Buenos Aires, Argentina | 81

Peter Crosby | @pbcrosby | petercrosbyphotography.com | Livingston Manor, NY | 29

Jeffrey Czum | @jeffreyczum | Buffalo, NY | 66–67, 73

RJ Damole | @sandviich | Cebu, Philippines | 288

Anne Danao | @___geraldanne | London, UK | 139

Simon & Jennifer Darr | @ theseptemberchronicles | theseptemberchronicles.com | Brisbane, Australia | 151

Jimmy De Alba | @jamesandmoose | jamesandmoose.com | Aguascalientes, AGS, Mexico | 84–85

Matías De Caro | @mdcaro | Buenos Aires, Argentina | 71

Lucas Dedrick | @lucas_d_in_nyc | Wichita, KS | 287

Matthias Dengler | @matthiasdengler_ | matthiasdengler.com | Stuttgart, Germany | 130

Phoebe Dennis | @phoebeanndennis | Melbourne | Melbourne, Victoria, Australia | 326

Timothy Desouza | @timothyx01 | London, UK | 98

Claudia Devillaz | @my_tasty_travels | Paris, France | 124

Marco Di Stefano | @berlinimalism | anonyme.co | Adelaide, SA, Australia | 334

Ranmalee Dias | @ranmaleedias | Colombo, Sri Lanka | 265

Jenna Diaz | @jennadiaaz | Long Beach, CA | 303

Lane Dittoe | @lanedittoe | lanejdittoe.com | Los Angeles, CA | 5

Evynne Doue | @douecatmeow | evynnedoue. design | Omaha, NE | 307

Chris Dovletoglou | @wubadee | chrisdovletoglou.com | Seattle, WA | 186–87

Hayley Doyle | @wherehayleygoes | wherehayleygoes.co.uk | Sheffield, South Yorkshire, England | 196–97

Samuel du Plessis | @sa.duplessis | Hong Kong | 169

Emil Edilersky | @threeedil | gettyimages.com/photos/threeedil | Wrocław, Poland | 217

Christopher Egeberg | @flip_flip_flip | flip-music.com | Copenhagen, Denmark | 302

Ludwig Favre | @ludwigfavre | ludwigfavre. com | Paris, France | 271

Joabe Ferreira | @joabesf | São Paulo, Brazil | 189

Kevin Fohrer | @kevinfohrerphotography | kevinfohrer.com | Los Angeles, CA | 342–43

Paul Fuentes | @paulfuentes_photo | paulfuentesdesign.com | Mexico City, Mexico | 11, 22, 173

Matias Galeano | @boluddha | Barcelona, Spain | 228, 311

Alex Gâlmeanu | @alexgalmeanu | alexgalmeanu.com | Bucharest, Romania | 230, 231

Nicanor García | @nicanorgarcia | travelarchitectures.com | Barcelona, Spain | 226

Emily Prestridge | @emprestridge | emilyprestridge.com | Austin, TX | 12

Wendy Quiroa | @wendy.quiroa | wendyquiroa.com | NY, NY | 7

Rebuild Foundation | @rebuild_foundation | rebuild-foundation.org | Chicago, IL | 49

Eric Reichbaum | @reichbaum | ericreichbaum.com | Pittsburgh, PA | 14–15

Marta Rękas | @mrtrks | Warsaw, Poland | 171

Dirk Rohde | @schmurkov | Berlin, Germany | 266

Lucrezia Rossi | @ipaziarossi | rossilucrezianna.wixsite.com/lucreziarossi | Milan, Italy | 177

Alina Rudya | @rrrudya | wherever.me | Berlin, Germany | 204–5, 246

Laura Sandoval | @laurasideral | lau.work | Santiago, Chile | 70

Osama Sarm | @osamaex | Hilla, Babel, Iraq | 241

Federico Sartori | @federicosartori_ | Milan, Italy | 116

Chris Schalkx | @chrsschlkx | ricepotato.co | Bangkok, Thailand | 272–73

Uwa Scholz | @uwa2000 | Berlin, Germany | 123

Kuber Shah | @thekuber | thekuber.com | Mumbai, India | 298

Savannah Sher | @savsher | Montreal, Quebec | 39

Maki Shinohara | @minimalism_tokyo | Tokyo, Japan | 290

Oksana Skora | @oksanaskora | Kyiv, Ukraine | 159

Bates Smart | @batessmart | batessmart.com | Sydney, Australia | 332

Samantha Smith | @saisie | Tulsa, Oklahoma | 8–9

Oksana Smolianinova | @kopakonan_ | Volgograd, Russia | 176

Tanika Sorridimi | @tikipasteljay | Sydney, NSW, Australia | 102

Cailen Speers | @cailenspeers | cailenspeers.com | Toronto, Ontario | 45

Jack Spicer Adams | @jackspiceradams | jackspiceradams.com | Birmingham, UK | 214

Oliver Stolzenberg | @olle.l.olle | Cologne, NRW, Germany | 122

Marius Svaleng Andresen | @lekestove | lekestove.com | Oslo, Norway | 208

Kalpesh Tailor | @kalpeshstailor | kalpeshtailor.com | Auckland, New Zealand | xii–xiii, 324

Raquel Tereso de Magalhães | @raqueltmag | Porto, Portugal | 234–35

Pratyush Thakur | @prtzy | Bir, Himachal Pradesh, India | 276–77

Cathy Tideswell | @yugenphotography_ | yugenlife.co.uk | Leek, Staffordshire, UK | x, 95

Leyla Tran | @secondcitymom | secondcitymom.com | Chicago, IL | 35

Yura Ukhorskiy | @urayxor | St. Petersburg, Russia | 107

Marie Valencia | @em_space | marievalencia.com | Auckland, New Zealand | 323

Matthijs Van Mierlo | @matthijsvmierlo | Antwerp, Belgium | 142–43

Maria Vanonen | @mariavanonen | Helsinki, Finland | 182, 183

Anika Varma Pannu | @hashtaganika | Amsterdam, North Holland, Netherlands | 101

Pavel Vekshin | @p.vekshin | Saint Petersburg, Russia | 50

Katerina Verne | @grin_land | katerinaverne.com | Kungshamn, Sweden | 292

Conrado Vidal | @covidmx | Mexico City, Mexico | 74–75

Claire Walker | @thesilvercherry | London, UK | 215, 218, 227

Marcus Wallinder | @meanwhileinnowhere | Malmö, Sweden | 160

Louise Walsh | @la_walsh | Cambridge, UK | 155, 168

Nabilla Wardhana | @wardhanabilla | Jakarta, Indonesia | 279

Andrew Weaver | @drewmaniac | Arlington, TX | 255

Cole Whitworth | @colerwhitworth | colewhitworth.com | Seattle, WA | 40

James Wong | @_jameswong | jameswong.co | Melbourne, Victoria, Australia | 325

Rex Wong | @rex_wch | rexwch.com | Hong Kong | 284–85

Alexander Wormald | @cheapshirt_ | Liverpool, UK | 172

Anastasia Yakunina | @ashktravels | London, UK | 156

Matt Ziegler | @zieglemt | Chicago, IL | 132–33

Angelo Zinna | @angelo_zinna | angelozinna.com | Amsterdam, Netherlands | 258–59

BY LOCATION

INDEX BY TITLE

ABOUT THE AUTHOR

Wally Koval founded the @AccidentallyWesAnderson community on Instagram in 2017, and it has since grown to more than a million Adventurers. Wally curates and publishes daily content with the help of his wife, Amanda, and their dog, Dexter, in Brooklyn, New York. To discover your next adventure or share your favorite photo, visit www.AccidentallyWesAnderson.com.

Voracious
Little, Brown and Company
Hachette Book Group
1290 Avenue of the Americas, New York, NY 10104
littlebrown.com

First Edition: October 2020

Voracious is an imprint of Little, Brown and Company, a division of Hachette Book Group, Inc. The Voracious name and logo are trademarks of Hachette Book Group, Inc.

The publisher is not responsible for websites (or their content) that are not owned by the publisher.

The Hachette Speakers Bureau provides a wide range of authors for speaking events. To find out more, go to hachettespeakersbureau.com or call (866) 376-6591.

Jacket and interior design by Mia Johnson

ISBN 978-0-316-49273-7
Library of Congress Control Number: 2020939808

10 9 8 7 6 5 4 3

IM

Printed in China

HAPPY EXPLORING!

COVENT GARDEN STATION
London, England | c. 1907
Photo by Timothy Desouza